Photographing Children

*This volume is one of a series devoted to the art and technology
of photography. The books present pictures by outstanding
photographers of today and the past, relate the history
of photography and provide practical instruction in the use
of equipment and materials.*

LIFE LIBRARY OF PHOTOGRAPHY

Photographing Children
Revised Edition

BY THE EDITORS OF TIME-LIFE BOOKS

TIME-LIFE BOOKS, ALEXANDRIA, VIRGINIA

For information about any
Time-Life book, please write:
Reader Information, Time-Life Books,
541 North Fairbanks Court,
Chicago, Illinois 60611.

TIME-LIFE is a trademark of
Time Incorporated U.S.A.

Library of Congress Cataloguing in Publication Data
Main entry under title:
Photographing children.
 (Life library of photography)
 Bibliography: p.
 Includes index.
 1. Photography of children.
 I. Time-Life Books. II. Series.
TR575.P634 1983 778.9'25 82-16733
ISBN 0-8094-4424-0
ISBN 0-8094-4425-9 (lib. bdg.)
ISBN 0-8094-4426-7 (reg. bdg.)

ON THE COVER: Crawling along on all
fours with his sombrero perched on his
back, an intent youngster encourages his
amphibious pet to get going in the Tom
Sawyer Days frog jumping contest in
Hannibal, Missouri. Touching the frog is
grounds for disqualification, so the boy is
ever-so-carefully blowing on the frog's
hind end — an apparently effective trick,
for the boy and his frog won a trophy.

Contents

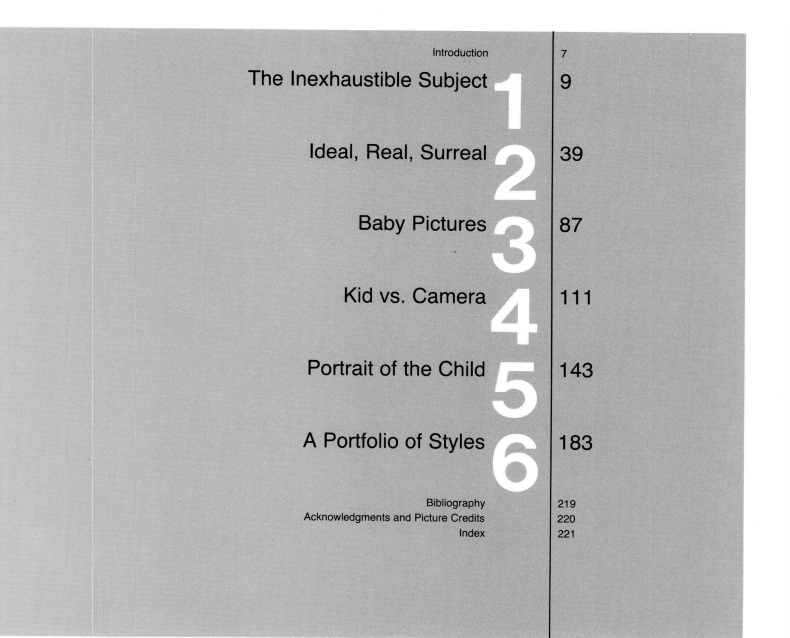

We have all been there in our own childhood—stationed in front of the inescapable camera and staring into its inscrutable eye—long before we ever got around in back of it. So the topic of this book should be familiar to us all. And yet familiarity can breed complacency. We grownups take more pictures of children than of anything else; still we manage to miss, all too often, the excitement, the emotion, the infinite diversity that is there for the taking.

The aim of this book is to open the reader's eyes and mind anew to the whole complex and fascinating subject of photographing children. The great cliché pictures are here, sturdy representatives of all the tried-and-true approaches that worked a century ago and frequently work today. The how-to-do-it pictures are here, spelling out the techniques of recording the expanding life and personality of the child, from the brand-new baby to the teenager. The creative, innovative pictures are here too, proving that the subject is broad and deep enough to challenge the wit and imagination—and, above all, the heart—of any photographer.

The real authors of this volume are not the editors who wrote the explanatory text, useful as we hope it is, but the scores of photographers whose work with children is represented in the pictures. Many of these photographers are accomplished professionals whose own children have put their parents' skills to the test. The results, and all the funny and sad, dramatic and quiet interactions between child and camera that the pictures on these pages disclose, speak louder than any words.

The Editors

The Inexhaustible Subject 1

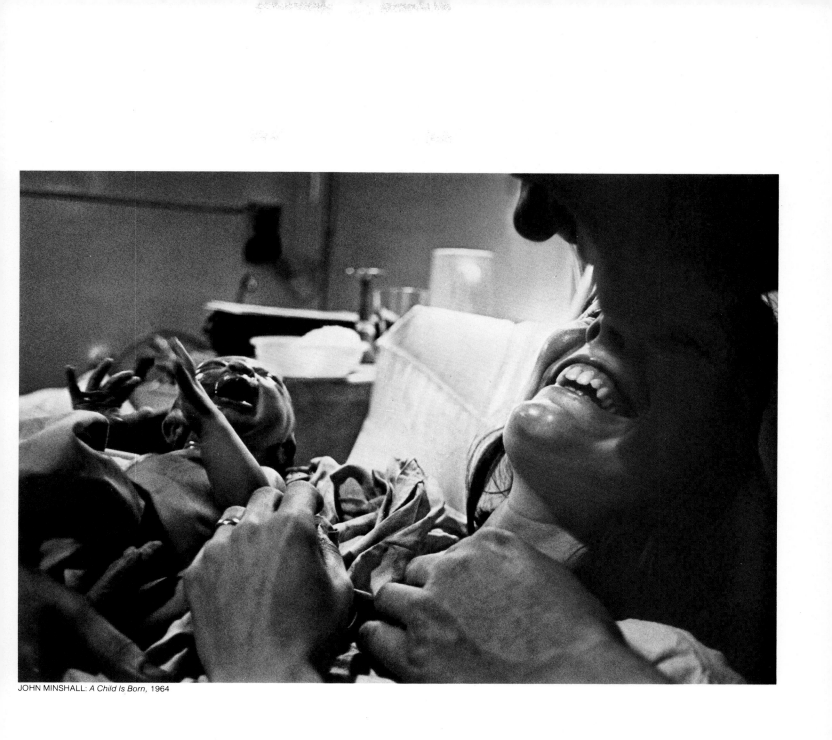

JOHN MINSHALL: *A Child Is Born*, 1964

Getting the Spirit of Childhood onto Film

The child and the camera belong together. Frequently the new father's second purchase, after the cigars, is a roll of film. From then on—through infancy, childhood and into adolescence—daughters and sons are forever followed by the camera. Usually they are willing subjects. Often they are too preoccupied to care. Almost always they make a good picture.

On the next 25 pages are examples of some better-than-good photographs of children—records on film of those moments in a child's life that most parents wish they could somehow preserve. These pictures were taken by professionals who may have brought no more feeling and understanding to the occasion than any parent does, but who have added technical expertise to that feeling. It is a matter of technique to capture on film, for example, that magic moment when an ecstatic mother confronts the yowling, squirming chunk of protoplasm that is of her own flesh and blood *(previous page)*. Every parent remembers the moment; it can be preserved in a photograph nearly as memorable as the moment itself.

So can every stage in childhood, every role the growing youngster plays: the tubby toddler and the little terror, the demure young lady and the hesitant explorer, the daydreamer and the warrior. Nowhere is there a subject so versatile, so artless, so beguiling, so ever-changing and so dependable as the child. Children are, as these pictures eloquently demonstrate, the photographer's inexhaustible subject.

And they are the most cooperative ones. Children readily enter into the spirit of photography. They love to pose and posture, and they are tireless subjects—if only because they *are* tireless; the child whose short attention span abruptly ends will almost always provide an even better picture as he dashes off into some other absorbing activity. "When I started a long time ago," says George Krause, whose photographs appear on pages 18 and 200 through 203, "I took nothing but children, like a lot of photographers do—it's such an easy way to start."

Of course, it is not quite so easy as it appears. There are many methods and techniques that are helpful in capturing that free and infectious spirit of childhood. While no one else can look through the viewfinder for you to compose the picture or catch the precise second to snap the shutter, there are guidelines that can lead to successful children's pictures. They have been useful to many of the photographers represented throughout this book, and they may be useful to you. Here are some of them.

1. Let the camera be a natural part of the child's life. The more often you use it, the more easily the child will accept it. As for strange children you want to photograph, approach them as you would a strange cat or dog—i.e., be friendly, not fawning, and wary.

2. Be relaxed and informal about your picture taking, rather than making the

child assume a just-so pose. Candid photographs of preoccupied children, taken unobtrusively, are often among the best.

3. There are times when you will want to stimulate a conscious reaction to the camera. But be sure you know what you want before you begin, as a child's attention span is short.

4. Do not stop a picture session too soon. Blowing out the first birthday candle is a photograph a grandmother will want, but she might equally cherish the picture taken five minutes later, when her three-year-old granddaughter has smeared the cake in her hair.

5. Vary the physical levels at which you photograph the child, as well as the angles. If you want the picture to convey your little boy's point of view, photograph him at his own eye level, or even from below it.

6. Do not be miserly with film. Children are so busy, their moods and their bodies flashing so rapidly from one point to the next, that you can be equally busy just trying to keep up with them. However, taking a large number of pictures does not necessarily mean that a few are bound to be good. Every exposure should be deliberate.

7. Fashion photographers play music to relax their models; the device also works for many children when you are trying to keep them calm for a portrait.

8. Talk about anything and everything — even about the photographs you are making. Professional photographer Marie Cosindas keeps up a running conversation with children about the pictures she is making; she finds that it gives them a feeling that they share in what is happening.

Most children like to please, and most find fun in being photographed. You yourself are apt to come in for a good deal more than fun. Photographer Tamarra Kaida speaks of the openness of the children she photographs, of the way they seem to be "right on the brink of themselves and the idea of themselves." Mark Goodman, who has returned to Millerton, New York, almost every year for more than a decade to document a generation of the town's children growing up, watched as one of his subjects went from prim Girl Scout to rebellious-looking teenager, complete with faded denims. To witness such things with the camera as well as with the human eye is to get out of life something that should not be missed. □

From Infant to Adolescent

The pictures in this section record experiences that, as numberless manuals for parents have explained, nearly every human shares on the journey through childhood. Fortunately for both subject and photographer, children do not read child-guidance books; they do not know in advance how they will react to each fresh stage in their lives—which means that they endlessly offer fresh opportunities for pictures. And observant photographers quickly recognize that they are photographing an individual in the progression from the helplessness of infancy to the independence of adolescence.

The photographers represented here have captured both the universality of childhood and the individuality of children. The full face of the baby sheltered by his mother's arm *(right)* is not seen, yet the picture conveys the contentment and security enjoyed by all loved infants. At the other end of the emotional spectrum is the little boy on page 21. He is doing a chore to help the family; but both his smile and his awareness of the admiring young ladies behind him say a great deal about his attitudes toward himself, work and life.

DOROTHEA LANGE: *Bringing Home the First Born*, 1952

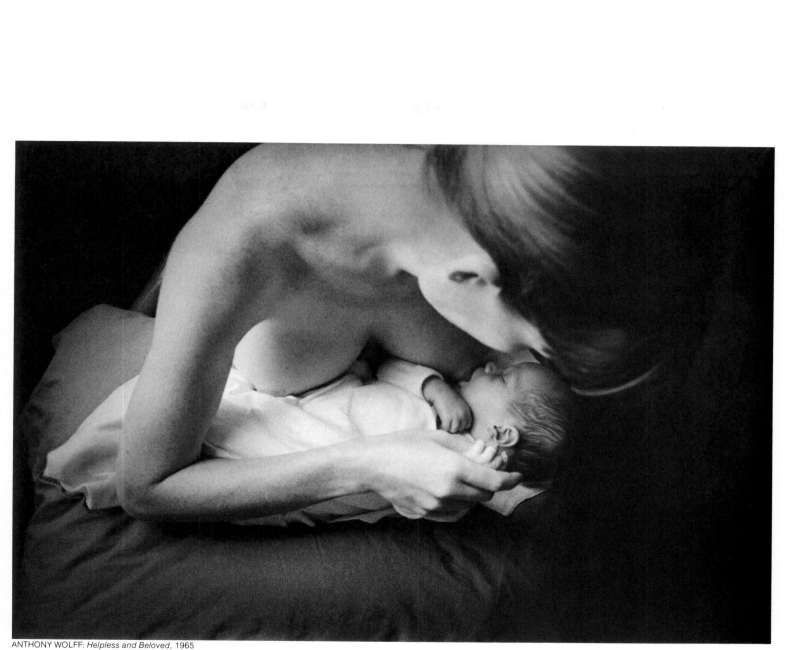

ANTHONY WOLFF: *Helpless and Beloved,* 1965

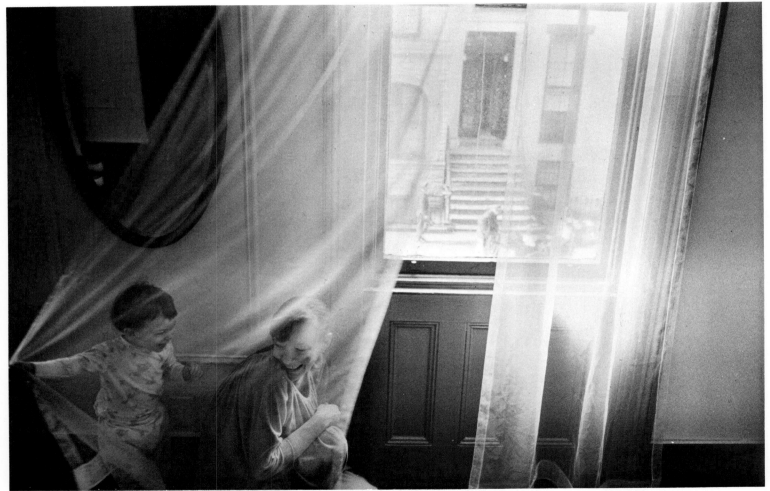

ANTHONY WOLFF: *A World inside the Window,* 1967

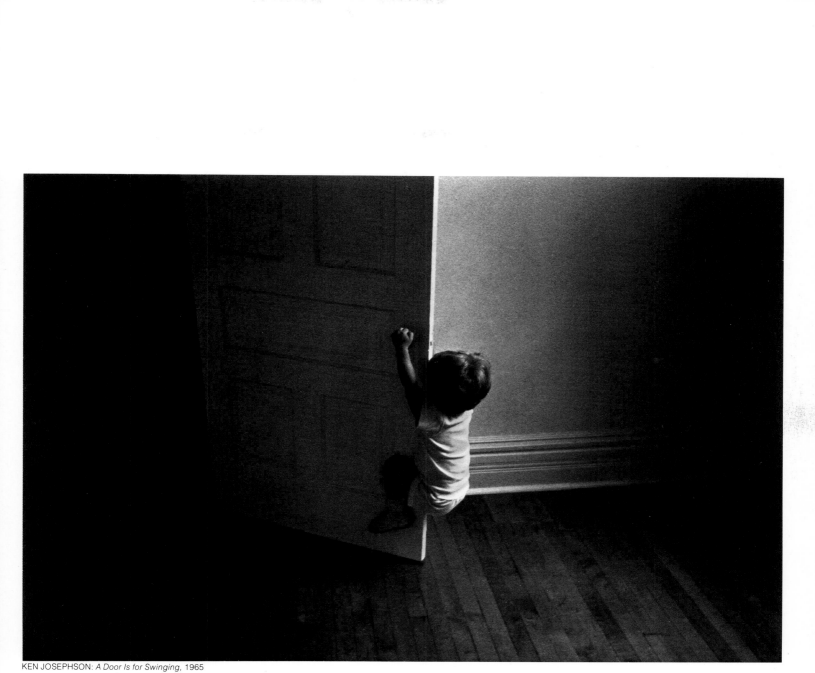

KEN JOSEPHSON: *A Door Is for Swinging*, 1965

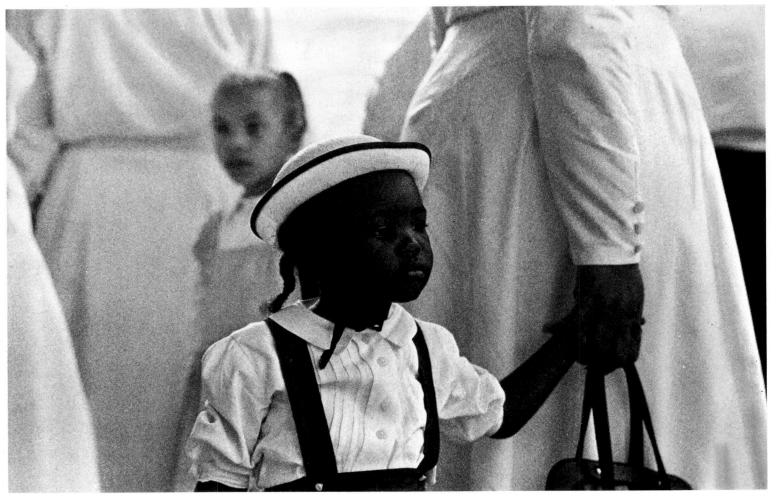

GEORGE KRAUSE: *A Safe Grip*, 1963

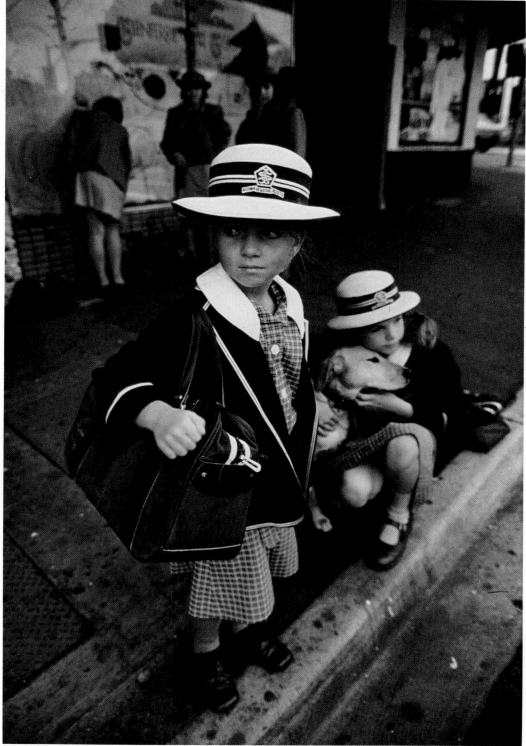

STEPHANIE MAZE: *Melbourne Schoolgirls*, 1981

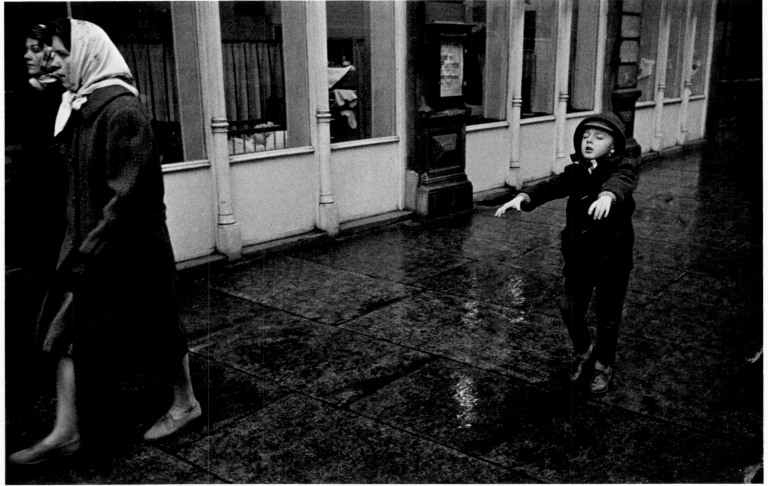

JOHN YANG: *Blindman's Bluff,* Strasbourg, 1960

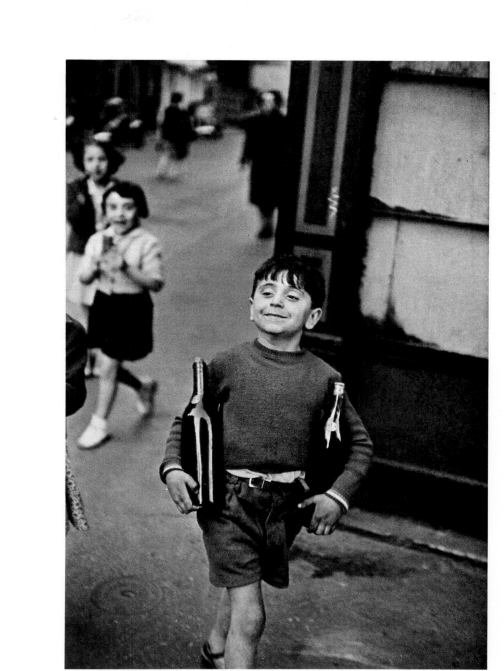

HENRI CARTIER-BRESSON: *Sunday Morning Errand*, Paris, 1958

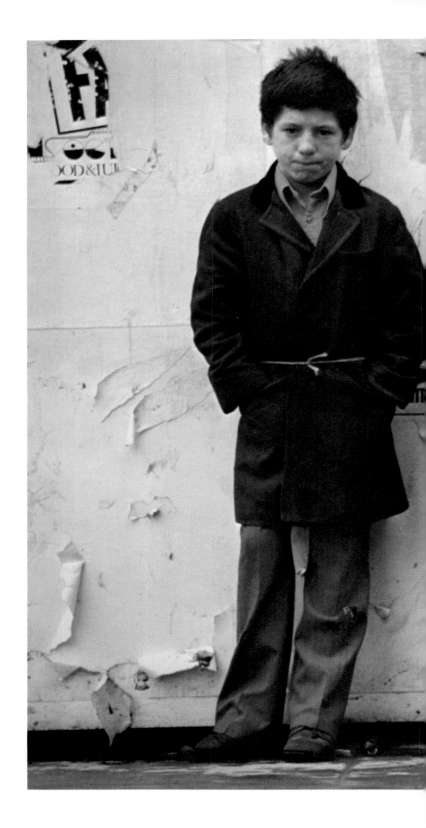

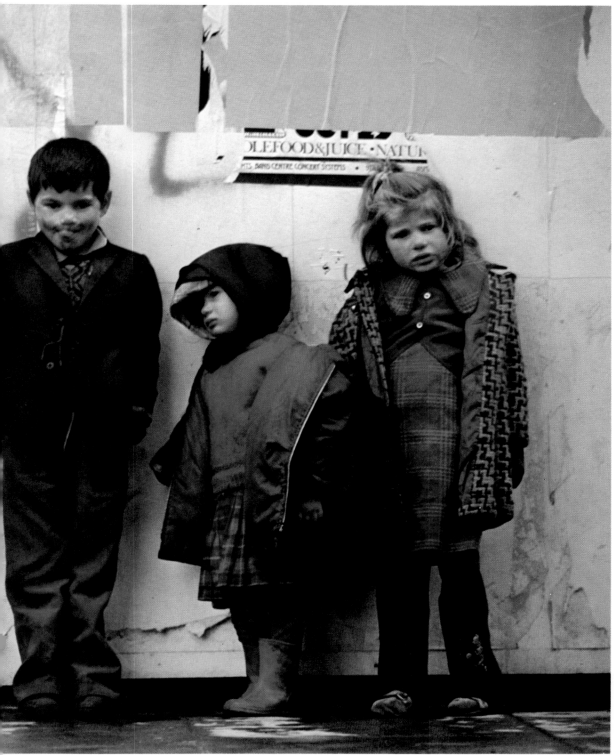

JOHN McDERMOTT: *Untitled*, 1977

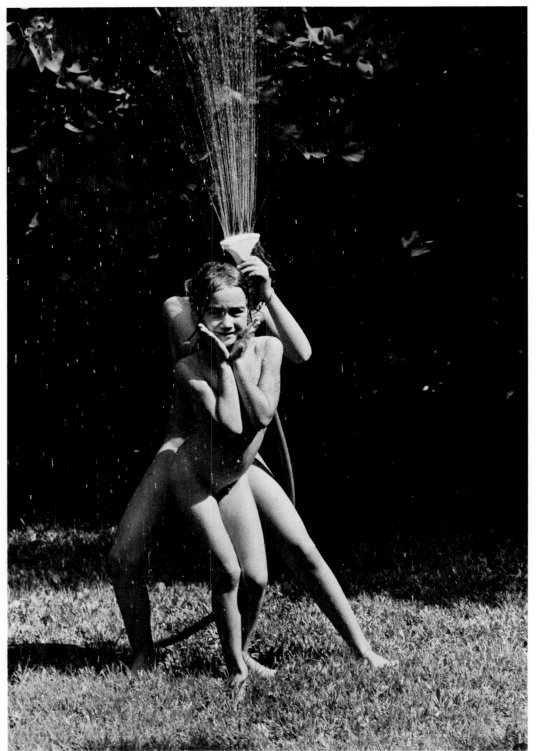

JOHNNY ALTERMAN: *Indian Summer Shower*, 1976

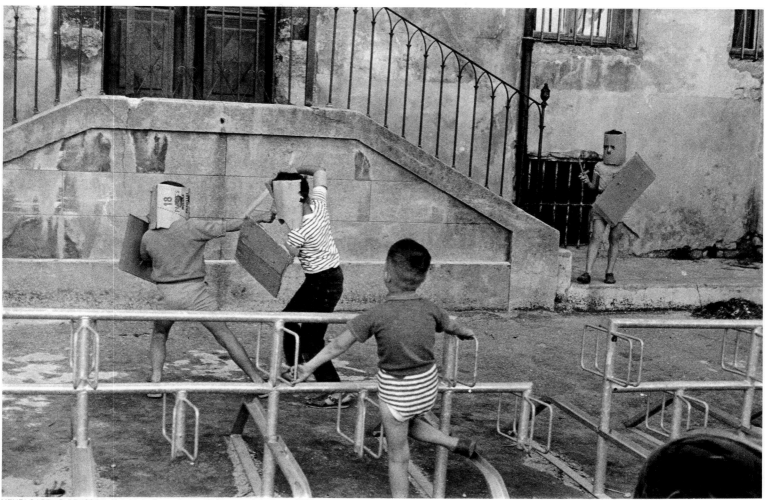

HENRI CARTIER-BRESSON: *Knights in Paper Armor,* Châteauneuf-du-Pape, 1960

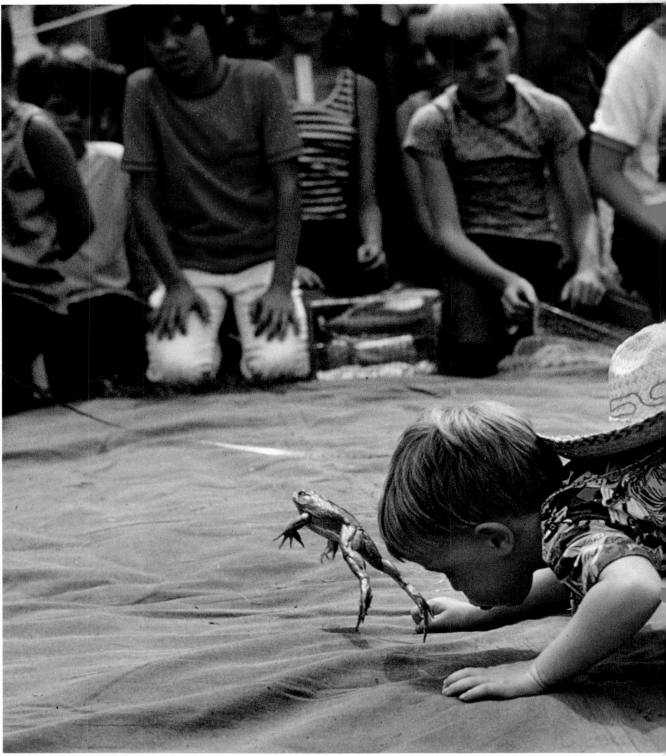

NATHAN BENN: *Frog Jumping Contest, Hannibal, Missouri, 1976*

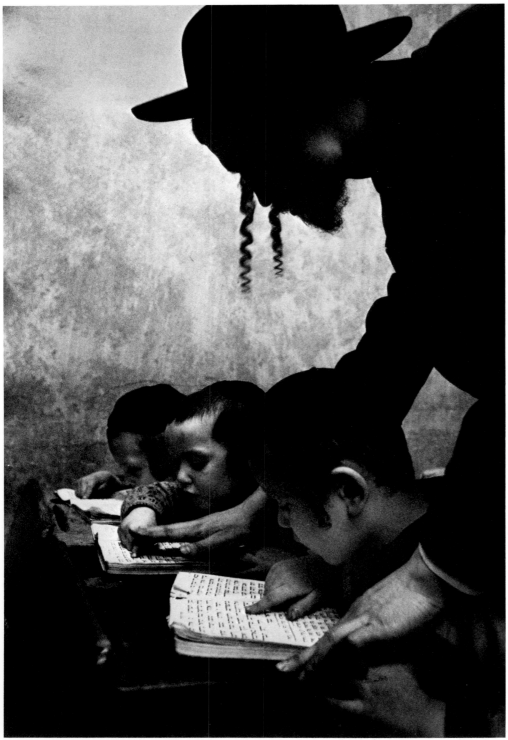

CORNELL CAPA: *Scholars of Tradition*, Brooklyn, 1955

28

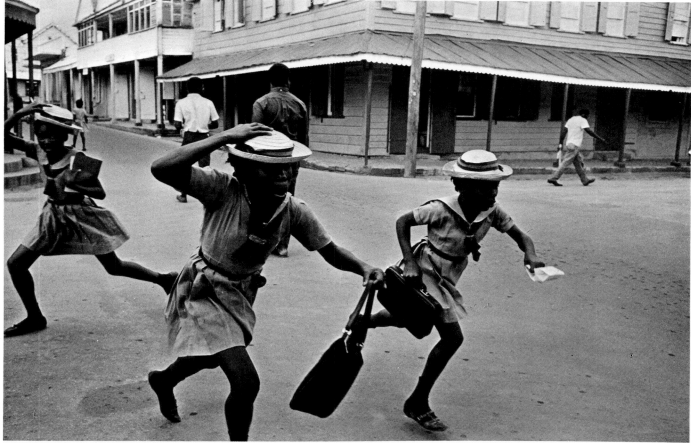

JOHN YANG: *School's Out*, Antigua, 1968

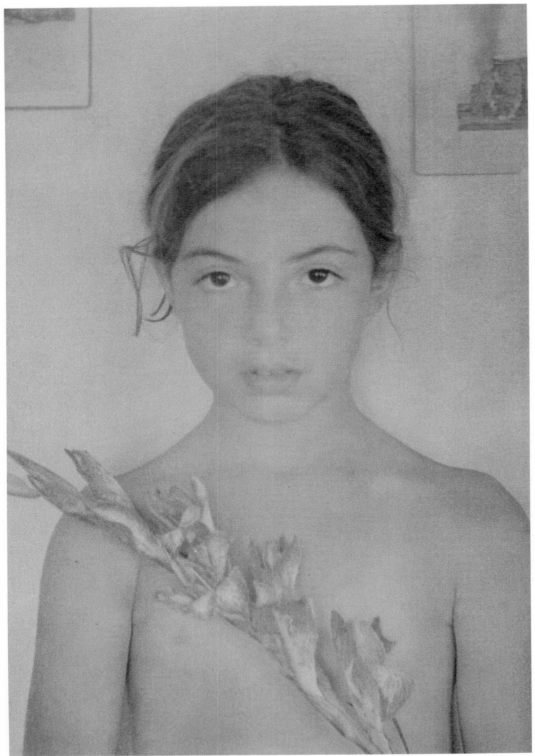

SHEILA METZNER: *Bega — Gladiolus,* 1980

30

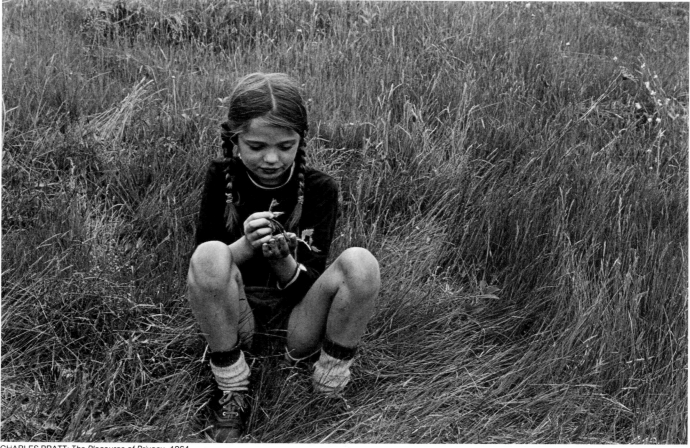

CHARLES PRATT: *The Pleasures of Privacy,* 1964

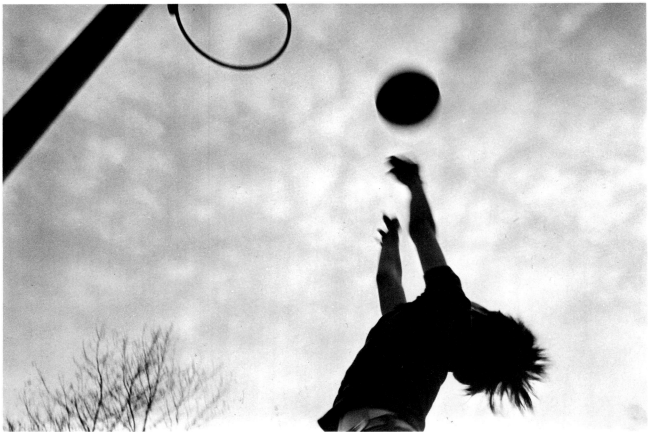

JAMES CARROLL: *Lonely Practice,* 1969

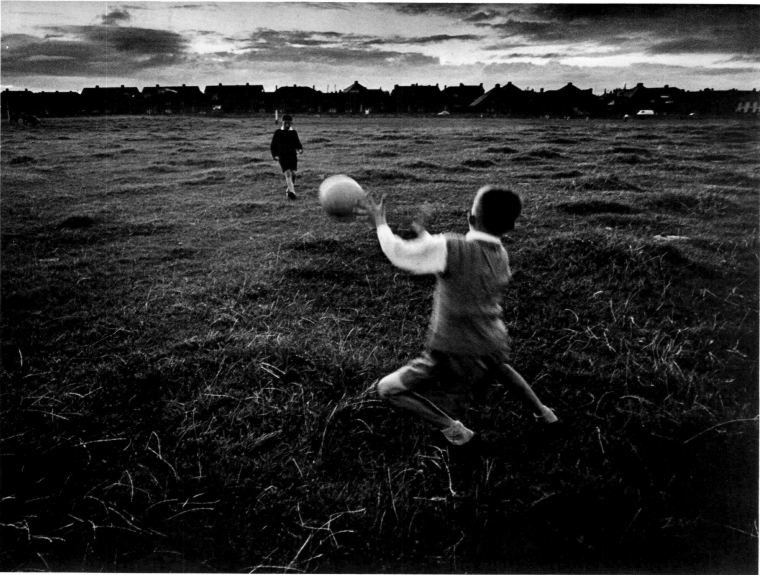

ULF SIMONSSON: *A Private Game for Two*, Sweden, 1966

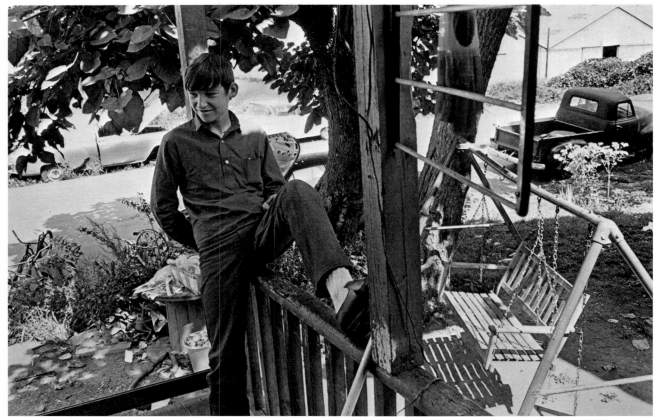

DANNY LYON: *Long Summer Afternoon,* 1967

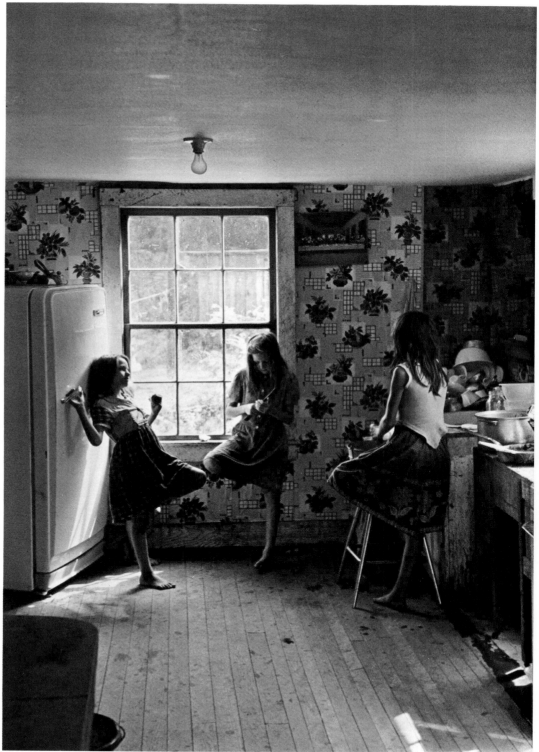

WILLIAM GEDNEY: *All the Time in the World*, 1964

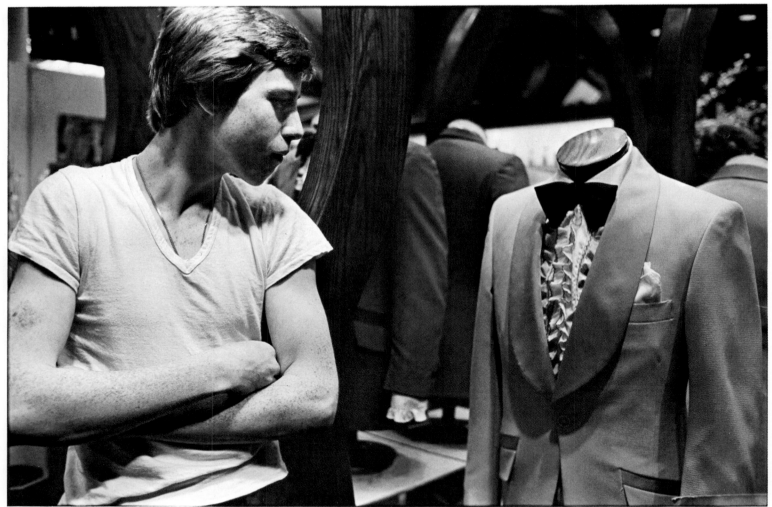

PATT BLUE: *Raymond*, 1980

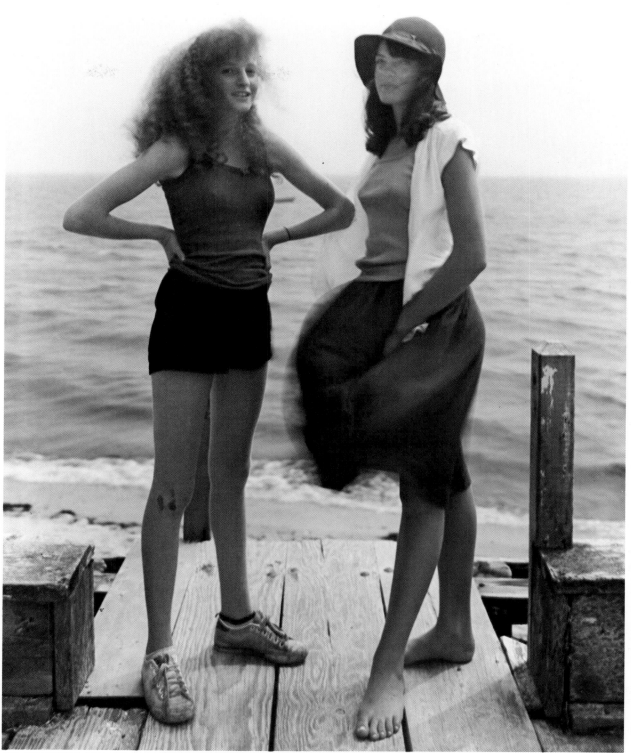

JOEL MEYEROWITZ: *Julia and Bronwen*, 1980

PAUL SCHUTZER: *Serious Conversation*, Rumania, 1963

Ideal, Real, Surreal **2**

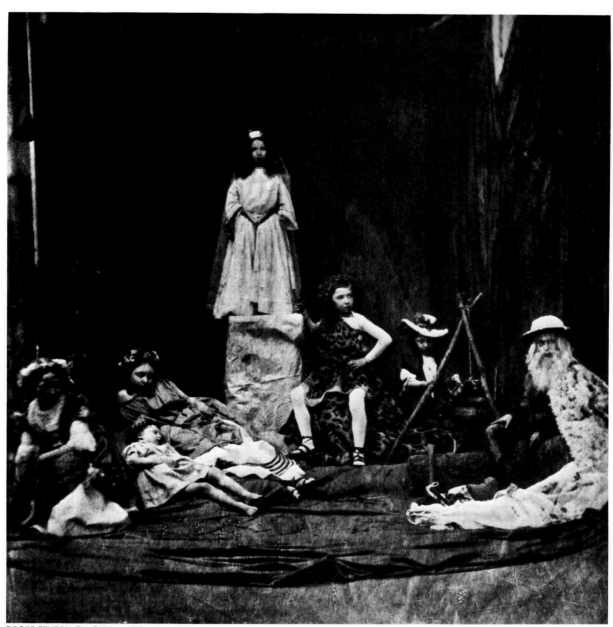

ROGER FENTON: *The Children of Victoria and Albert,* 1854

The Changing Adult View of Children

Grownups see in a child what they want to see — and if they are looking at their own offspring, they generally see something admirable. Most photographs of children accurately reflect this admiration, since the person behind the camera is usually either an obliging professional or a proud parent. Children themselves have little to say about how they are to be photographed. As infants they cannot express their opinion; by the thousands they have submitted to nude poses on bearskin rugs or sat like precious jewels on lace pillows. When they are old enough to know what they think, they are usually shrewd enough to humor adult preconceptions. Like dutiful dolls they turn the pages of a book or obligingly mount a Shetland pony. But although most photographs of children are thus idealized, they do not always represent the same ideal. The prevailing view of children has varied so much over the years that scholars can speak of "styles of childhood" as readily as they can refer to styles of dress or architecture.

When photography was born in the first half of the last century, the majority of the adults still regarded children as little adults. Miniature grownups, dressed and posed like their parents, impassively peer out at the viewer of early daguerreotypes *(pages 44-45).* By the 1850s and 1860s, however, when photography was in full swing, most Europeans and Americans had come over to the opinion that children were something special. And now that children were no longer regarded as little adults, they became little angels.

Angel-children, as William Wordsworth put it, came "trailing clouds of glory" from heaven, where they had lived until their birth. If children were angels, mothers were saints and the family itself was sacred. As for the Victorian father, he was a knight who ventured forth to do battle with the profane world, and then rushed back to the consoling purity of his hearth. Children were not only considered to be angelic; they were also instructed to be so. As Robert Louis Stevenson wrote in 1885 in *A Child's Garden of Verses:*

You must still be bright and quiet,
And content with simple diet;
And remain, through all bewild'ring,
Innocent and honest children.

Long evenings were passed *en famille* in front of the fireplace, reading out loud, performing charades and plays or re-creating scenes from history or art, which were called living pictures, or *tableaux vivants.* On occasion the children of Queen Victoria herself enjoyed posing in such tableaux *(previous page),* but Her Majesty thought such photographs were not suitably dignified as an image of royalty at play, and demanded that the photographer, Roger Fenton, destroy his handiwork (only one print has survived).

The narrow bounds of Victorian ideals so constricted everyday life that children and adults alike found escape in fantasy. Accordingly, when children were not photographed as their own innocent little selves they were pictured as characters from fiction and fairy tales or as children from other lands. Lewis Carroll, the author of *Alice in Wonderland,* photographed upper-class little girls costumed as gypsy beggars, Little Red Riding Hood, Turks, Romans and Chinese, and wrote in his diary that he had taken pictures of young Alexandra Kitchin "with spade and bucket, in bed, and in Greek dress." Such pictures fitted in neatly with the prevailing taste of the day as expressed by the painter Edward Coley Burne-Jones, who sought "a beautiful romantic dream of something that never was, never will be — in a light better than any light that ever shone — in a land no one can define or remember, only desire."

The Victorians, of course, were not alone in romanticizing their children. Every decade has committed its own excesses of photographic fad and fancy: Lewis Carroll's dreaming little maiden became a pseudo-sophisticated sub-debutante in the 1920s, the nation's sweetheart in the 1930s and a posturing little clown in the 1950s.

But must pictures of children always embody some adult view? Until children themselves become expert behind the camera, the record will perhaps always be biased; but at least some serious grownups now attempt to assimilate the child's own point of view. These photographers (some of whose work is shown in the latter part of this chapter) either have plumbed memories of their own childhood and re-created them, or have patiently studied and submitted to the reality of their young subjects — often catching them unaware. What distinguishes this work is its fidelity to the pain, curiosity and bewilderment of actual children. At their best such photographers reveal youngsters not as adults would have them be, but as they really are. □

Introducing the Model Child

The image of childhood at its least childlike is recorded in the daguerreotypes taken at the turn of the century. Frozen into position in the studio for agonizing time exposures, often with hidden clamps holding their heads, the young subjects tried to assume adult postures and adult expressions. Brother and sister stared at the camera as gravely as if they were newlyweds. If one judged solely by the evidence of surviving photographs, without any recourse to such observers as Mark Twain, one could only assume that the children of the late 19th Century were a generation of little prigs.

To some extent, and in some parts of the world, they were. At least they were urged to be. British and European children were dressed up in smaller-sized adult clothes. They played adult games and discussed adult topics, and many became prodigies: Four-year-olds gave sermons, six-year-olds became Latin scholars and 12-year-olds researched and wrote learned books.

Rousseau had written in 1762 that "Nature wants children to be children before they are adults." But it was more than a century before the natural childishness of children was permitted and encouraged, and an even longer time before photography responded to the changing view. It is almost impossible to imagine any of the children on these two pages climbing a tree in bare feet. No doubt the young gentleman at far right shortly gave his squirming sister a wallop on the arm. But it would be more than another generation before any photographer would consider such a childish display an honest, lifelike and therefore worthwhile picture of children.

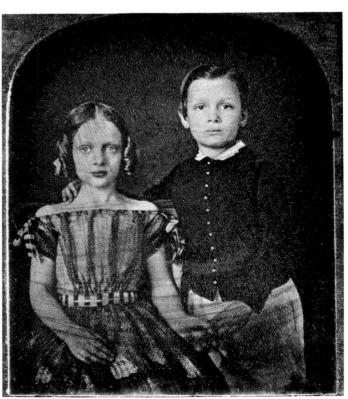

ANONYMOUS DAGUERREOTYPE: *New York Children,* date unknown

Anonymous images from a century past, two sister-and-brother pairs stare with equal impassivity at the camera. The children above held still enough; but in the picture at right the little girl has moved, and her fierce expression also indicates that she did her best to escape the restraining arm of her brother. Daguerreotypes were often used by portrait painters as a visual aid, particularly when dealing with models as restless as children.

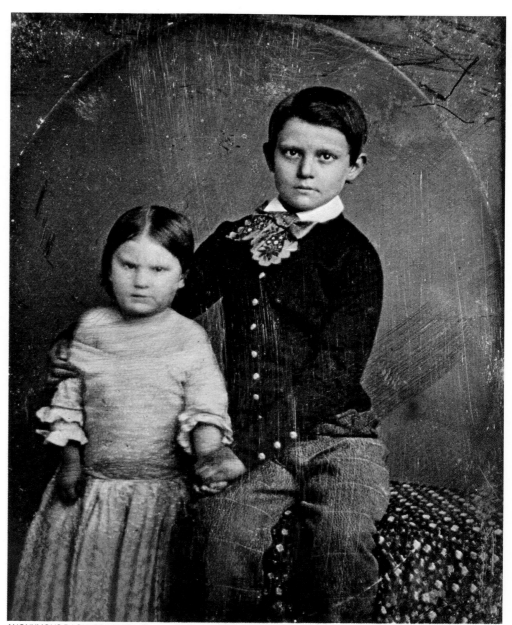

ANONYMOUS DAGUERREOTYPE: *German Brother and Sister*, date unknown

Little Angels, One and All

The cult of sentiment, which might be described as the soft, sweet center of romanticism, led Victorian photographers to pose their young models as heavenly beings, sacred and profane. In such pictures the emphasis is not on the individual child, but upon fervent innocence, as in the picture at near right, or upon an odd mixture of serenity and sensuousness, as in the photograph of Cupid at far right.

Both pictures are the work of the eminent Victorian photographer Mrs. Julia Margaret Cameron. Sitting for the brisk, ambitious Mrs. Cameron could be a trying experience for her little subjects. As her niece, Lady Troubridge, recalled in later life: "To me, I frankly own, Aunt Julia appeared as a terrifying elderly woman, short and squat . . . dressed in dark clothes, stained with chemicals from her photography (and smelling of them, too), with a plump eager face and piercing eyes, and a voice husky and a little harsh, yet in some way compelling and even charming. We were at once pressed into the service of the camera. Our roles were no less than those of two Angels of the Nativity, and to sustain them we were scantily clad and each had a pair of heavy swan wings fastened to her narrow shoulders, while Aunt Julia, with ungentle hand, tousled our hair to get rid of its prim nursery look. No wonder those old photographs of us, leaning over imaginary ramparts of heaven, look anxious and wistful. This is how we felt."

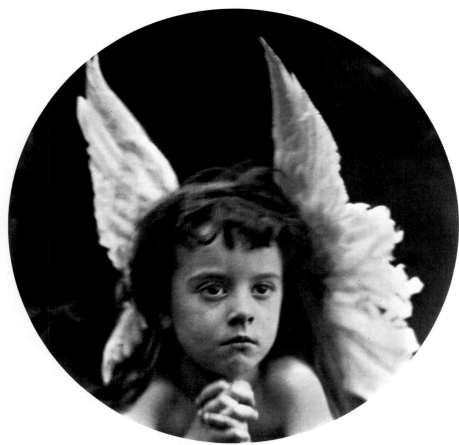

JULIA MARGARET CAMERON: *The Rising of the New Year,* c. 1872

Appearing tired and apprehensive, a young girl thought to be Julia Margaret Cameron's niece (who later became Lady Troubridge) poses as the angelic spirit of the New Year a century ago, with her hands clasped prayerfully and wings strapped onto her shoulders. Mrs. Cameron thought nothing of making her subjects—either children or adults—pose for hours on end until she obtained the photograph that she wanted.

Even though Mrs. Cameron loved to dress her child subjects as inhabitants of her fantasy world, she always managed to catch some realistic quality in them. This young girl is costumed as an ethereal cupid, but her pose, pouting lips and drooping eyelids transmit the languid, worldly sensuality of a real person beyond her years.

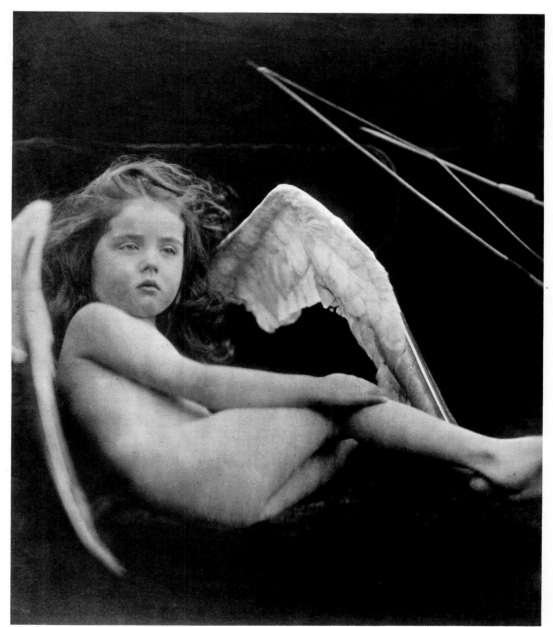

JULIA MARGARET CAMERON: *Cupid Reposing*, 1872

The Parent's Proudest Possession

One adult way of viewing children is as little dependents — as timid, clinging creatures looking to their parents for guidance and for protection against a world full of evils. This attitude was repeatedly exhibited in Victorian photographs during a period when children often had no other playmates than their brothers and sisters and when Father was the autocrat of the breakfast table, and of the lunch and dinner table too.

Queen Victoria, an accomplished autocrat in her own right, once recorded in her journal: "They say no Sovereign was ever more loved than I am (I am bold enough to say) and *this* because of our domestic home, the good example it presents."

The good example was clearly understood in millions of 19th Century homes: In return for parental guidance, protection and love, children gave unquestioning obedience to every parental wish. The duty of children was to be seen and not heard, not because they were a potential nuisance but because attentive silence helped them absorb the wisdom flowing from parental lips. That is how children were photographed, as their parents' proudest (and, ideally, least troublesome) possession. The picture at right shows that the tradition has been alive in this century as well.

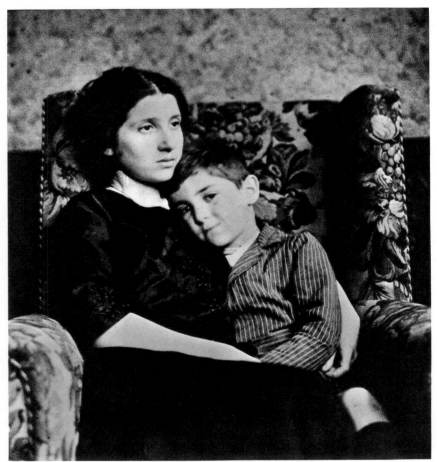

LUDWIG SILBERSTEIN: *Mother and Son,* 1913

The concept of the child as a chattel of the parent did not go out of style — photographically or otherwise — with the Victorians. Although this mother-and-son pair, snuggled together with appropriate affection, faced the camera two generations after the picture at right was made, the air of maternal authority is unmistakable.

One of a pair of identical pictures shot for ▶ the stereoscope, The Geography Lesson (right) re-creates an 18th Century painting by Pietro Longhi. In the original the students were women, but to make a point about filial respect the photographer replaced the adults with little girls. (They are not the children of the tutor, but models.)

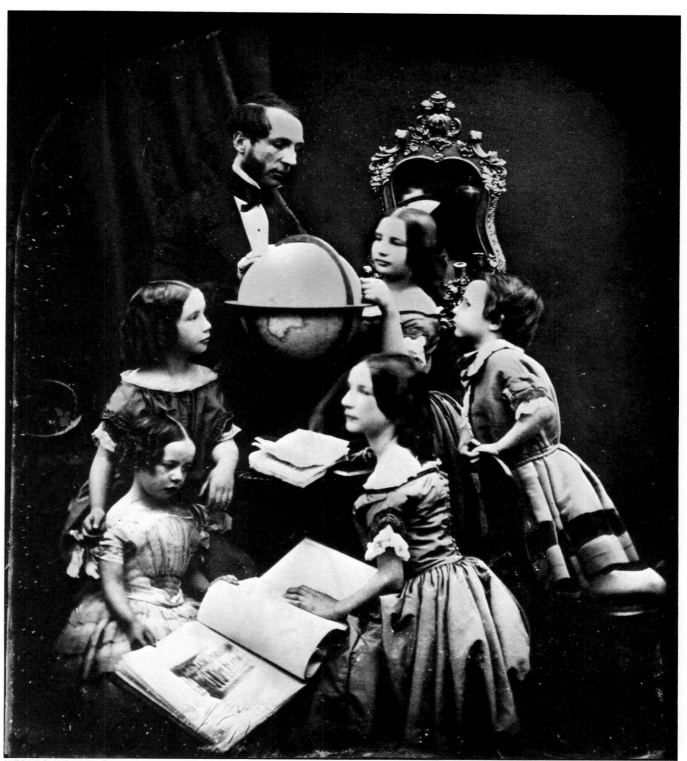

ANTOINE CLAUDET: *The Geography Lesson*, 1851

Innocence and Impishness

The noisy high spirits that we associate with childhood today were abhorrent to the Victorians. What they thought admirable—and often photographed—were reflective children with quiet confidence and good manners; if anything as childlike as curiosity overcame them, it took the form of a rational spirit of inquiry.

All of these qualities characterize the favorite heroine of Victorian fiction, Alice. Her creator, the Reverend C. L. Dodgson (a mathematics don at Oxford who wrote under the name Lewis Carroll), was also a talented photographer. Dodgson's pictures of well-bred little girls captured the same innocent spirit that he immortalized in his fiction.

However, the author of *Alice in Wonderland* was too good an observer of children to render them lifeless. By today's standards Lewis Carroll's pictures are not really "natural," for even puckishness can be idealized. Yet he captured more on film than did most Victorian photographers of children. He avoided stereotyped poses and expressions, and he also was one of the first to see the little devil that lay just below the surface of the little angel.

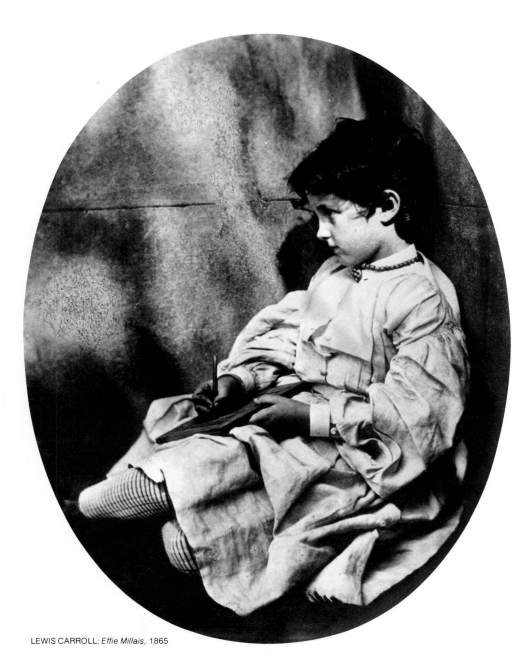

Effie Millais looks up from the slate in her lap, an image of self-possessed good manners. Effie was the daughter of Sir John Everett Millais, one of the leading portrait painters of the Victorian era. Her mother, a celebrated beauty of the day, had previously been the wife of John Ruskin.

LEWIS CARROLL: *Effie Millais,* 1865

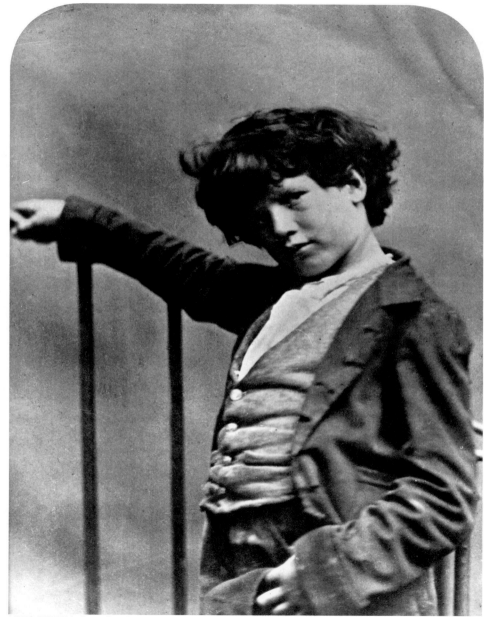

Lewis Carroll preferred girls as his models, announcing once with unintentional humor, "I am fond of children, except boys." But he expertly caught the puckish spirit of this boy —clothes rumpled, hair tousled and clearly concocting some piece of mischief. On one occasion, when asked to teach mathematics to boys, Carroll refused. "To me they are an unattractive race of beings," he declared.

LEWIS CARROLL: *Angus Douglas,* c. 1865

An Object of Adoration

At the turn of the century, when the young photographer Edward Steichen wanted to portray the theme of mother and child, he used his own wife and daughter as subjects. His emphasis was not on a particular woman and her baby, however, but on motherhood, idealized and generalized. At the time, Steichen's approach to his subjects was that of a painter; and like most artists of the day, he assumed there were only two modes of expression: realism, which depicted things as they were, and idealism, which showed them as they ought to be.

Photography was well suited to portraying reality. When faced with an ideal theme like motherhood, however, it was at a disadvantage: a painter or sculptor could suppress distracting details with ease; a photographer had to deal with all the idiosyncrasies of a real woman and child. Steichen surmounted this obstacle by the deliberate use of soft focus and by experimenting with a number of photographic treatments such as platinum, silver and the new gum-bichromate process. The experiments freed his photographic images from servitude to the literal—and enabled him to convey the ethereal themes he envisioned.

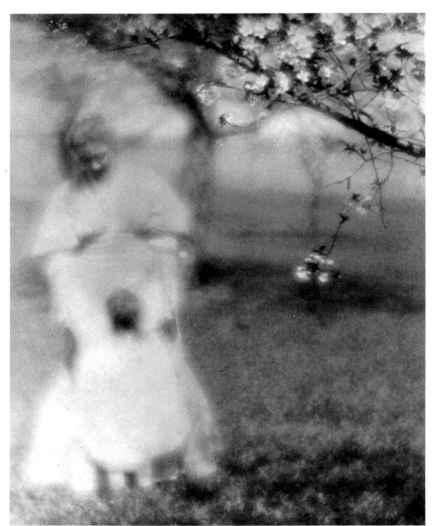

EDWARD STEICHEN: *Mary and Her Mother*, 1905

On a soft spring day, Steichen's first wife, Clara, plays with her daughter, who grew up to become the distinguished doctor Mary Calderone. The photographer deliberately took the picture out of focus and manipulated the light during printing to create a universal statement about motherhood.

Clara Steichen gazes at her daughter, in a picture ▶ taken at the same time as the one above. Using soft focus, Steichen re-created the diffused tone of an Impressionist painting, leading one critic to rave that such images "represent the highest point to which photographic portraiture has yet been brought."

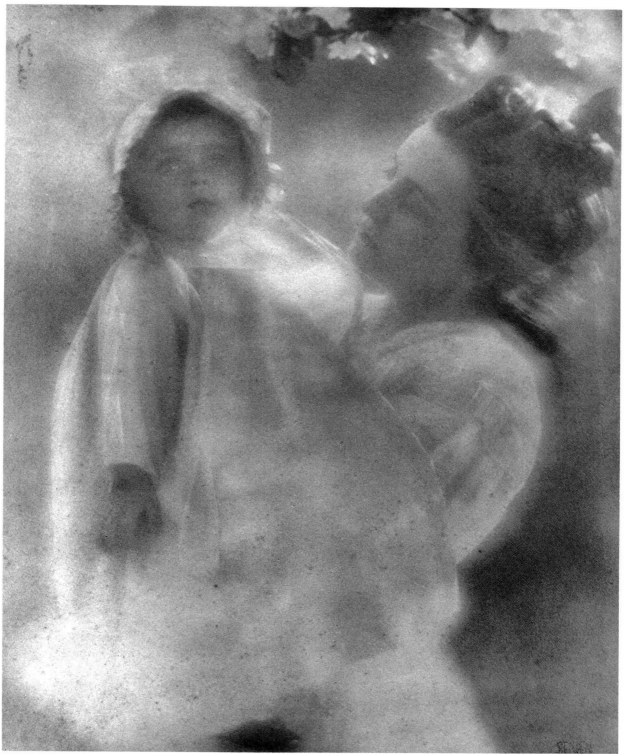

EDWARD STEICHEN: *Mary and Her Mother*, 1905

The Famous Clichés

Starting nobody knows how, in the late 19th Century, small-town American photographers ground out thousands of apparently interchangeable views of bare babies, sprawled on bearskin or sheepskin rugs. The pose became one of the great family-album clichés of all time. Then along came another cliché maker: the itinerant "pony photographer" whose tiny-tot subjects were posed clinging to the mane of a long-suffering Shetland.

Even in crowded New York City, pony photographers patrolled the sidewalks in search of families out for a stroll. Once a family had been lined up, the photographer gave the child a free pony ride, and then snapped a few pictures with a battered view camera. A few days later the photographer would deliver the finished prints—but the family was free to refuse payment if not completely satisfied.

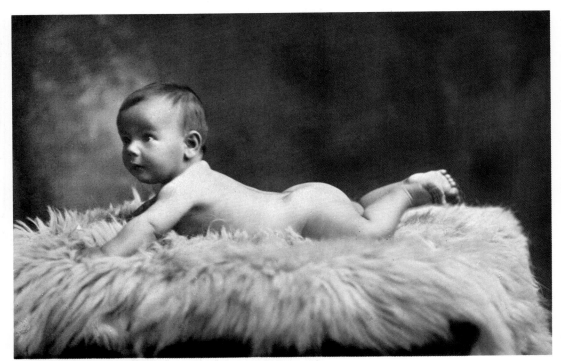

ANONYMOUS: *Baby on a Rug,* c. 1900

Some long-ago photographer nicely caught the raised head, alert look and curled toes of the bright-eyed baby above lying on the ubiquitous sheepskin. Today the picture is in the Culver Service archives—and the identity of the small subject is long lost. At right, propped up by the photographer's assistant, plump little Mary McGee sits astride a patient pony. Some itinerant photographers who could not afford ponies posed their subjects in goat carts instead.

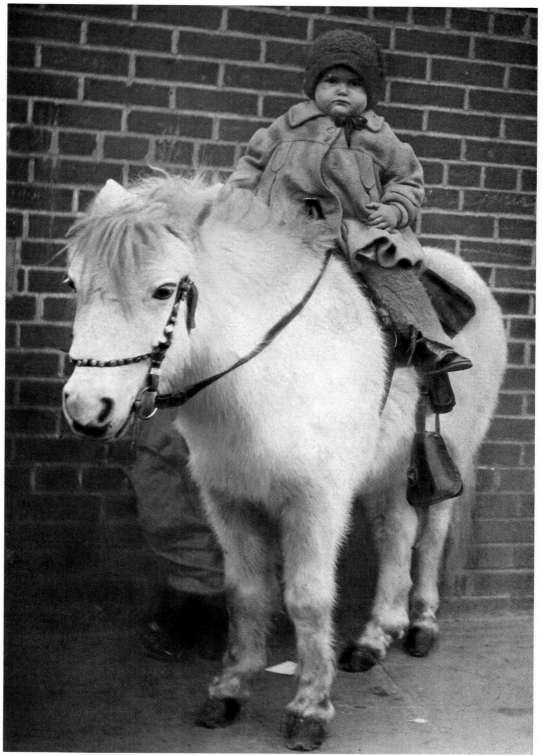

A PONY PHOTOGRAPHER: *Mary McGee,* Jersey City, 1926

A Doll to Dress Up

Parents have thought up many ways of indulging their vanity, and a favorite method is to present their children, particularly little girls, as leaders of fashion. The smart junior miss is admirable in herself; more important, she attracts admiration to her proud parents.

Blatant snob appeal marked many of the photographs of the first three decades of this century in America. Thus the *Vogue* fashion photographer Gayne de Meyer placed the chic young model at right amid expensive, if somewhat eclectic, surroundings.

Professional portrait photographers also conspired with mothers to make little girls look as though they were always about to climb into a limousine and head for a lavish birthday party. Sometimes, as in the portrait at far right, the results were a bit confusing. The girl was only ten years old, but her organdy dress, sausage curls and careful pose make her appear years older. The real cow pasture behind her has been so retouched that it looks like a painted backdrop. The end product, however, was only conforming to the credo of the photographer's company, the Bachrach Studios: "People do not want a likeness, they want an idealization that will fill in their inadequacies."

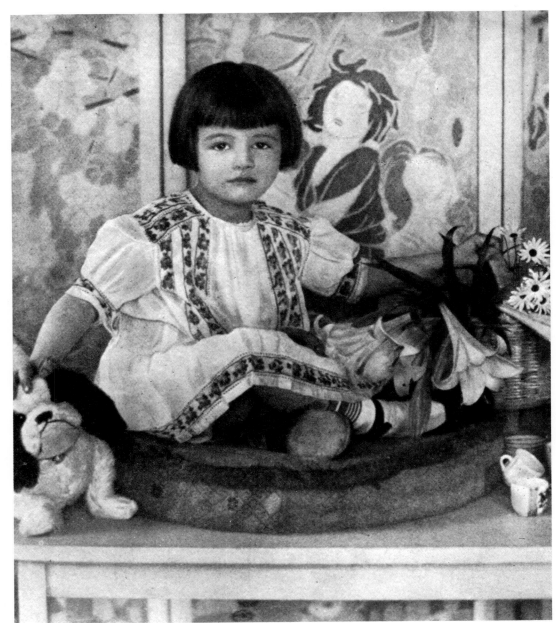

Posed in front of a Japanese lacquered screen, beside daisies and Easter lilies, a little girl displays, as the original Vogue caption put it, "the immaculate charm of a white batiste frock."

GAYNE de MEYER: *Fashion Illustration*, 1920

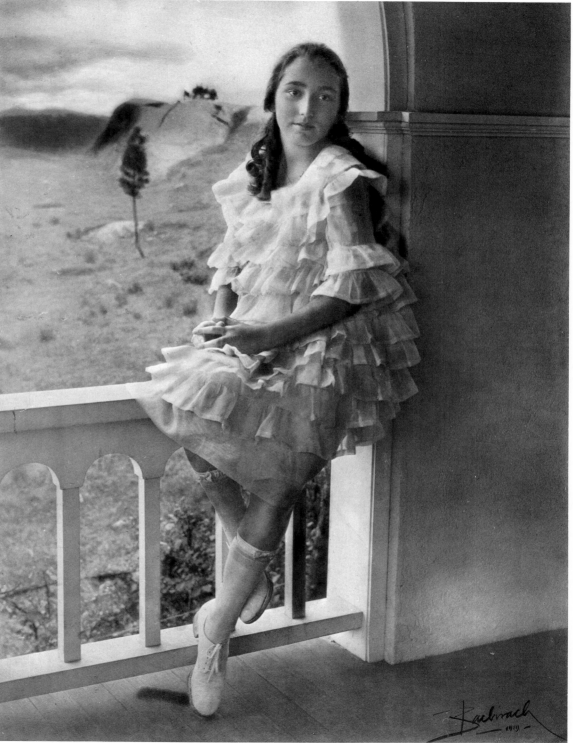

Assuming a dreamy look, a young lady from Boston poses on her porch for a Bachrach photographer. The Bachrach Studios, founded in 1868, have also photographed American Presidents for more than a hundred years and specialize in making portraits of society weddings, family groups and business executives.

BACHRACH STUDIOS: *Selma Strauss*, 1919

The Nation's Sweethearts

The 1930s was the decade of the winsome child, overflowing with smiles, charm, talent and bright sayings. Advertisers pushed products by linking them with photographs of fat babies; the healthy specimen at right posed for an orange-juice advertisement. The movies helped establish the trend, and the symbol and inspiration of all aspiring cuties was the nation's sweetheart, Shirley Temple *(far right)*.

Shirley became a star at the age of five in the 1934 film *Stand Up and Cheer.* During the next three years she became America's biggest box-office attraction, made three or four pictures a year and earned an annual salary of about $300,000.

Soon the country was awash in Shirley Temple dolls, doll clothes, soap, books and hair ribbons. Thousands of straight-haired little girls were regularly subjected to permanent waves in order to achieve Shirley's ringleted look, especially if they were to have their pictures taken. Juvenile beauty salons opened and thrived in many towns. Studio photographers also contrived to lend the Temple image of bouncy insouciance to even the dullest of girls, but it was not always easy: Not all mothers knew how to give directions the way Miss Temple's mother did. She would call to her daughter just before each shooting session: "Sparkle, Shirley, sparkle!" And Shirley did.

WILL CONNELL: *Sunkist Baby,* 1933

This was the Sunkist Baby of the 1930s, a baby girl photographed in all her chubby-cheeked charm for an orange-juice advertisement. To California orange growers and their advertising agency, her wholesome joviality and bright-eyed confidence promised just the right image to help reassure—and sell orange juice to—a nation troubled by the hardships of the Depression.

The dimpled smile that brightens the gloom of ▶ the 1930s Depression (at least in movie houses) belongs to Shirley Temple, the child star who easily won the affection of America and much of the world. From her ringlets down to her polished tap-dancing shoes, Shirley was the ideal little girl and a photographer's ideal model —bright, pert, precocious and confident.

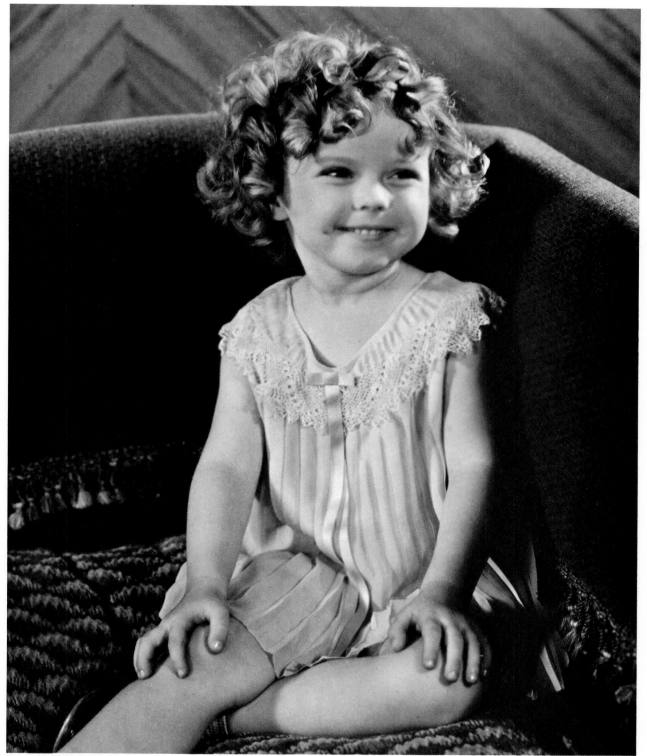

PHOTOGRAPHER UNKNOWN: *Shirley Temple*, 1932

Wisecracks and Nostalgia

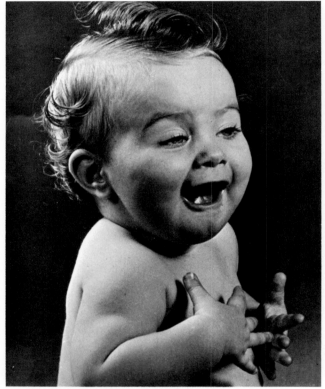

Postoperative braggart: "The doctor said mine was the most outstanding case he'd ever heard of."

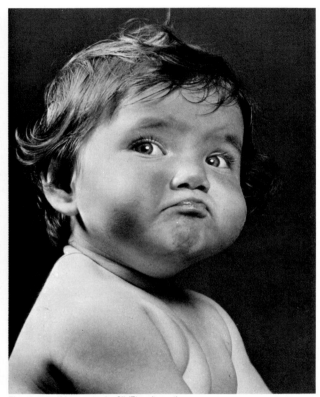

The skeptic: "You wanna bet?" (The alternative caption was "That's what you say.")

Pictures of children are clearly used to fulfill the fantasies as well as the vanities of adults. For a time during the 1940s and 1950s, a photographic fad invented by Constance Bannister was widely popular. Starting as a syndicated comic strip and continuing as illustrations on everything from boxtops to desk calendars, "Baby Banters by Bannister" offered pictures of frowning, leering or grinning babies like the two shown above, out of whose mouths would come precocious wisecracks dreamed up by adults.

This use of children as vehicles for adult expression evolved in the more turbulent 1960s into their use as vehicles for adult nostalgia. Carefully costumed and posed children were turned into photographic souvenirs, evoking not their own past and not always their parents' past but some even-more-remote and golden time gone by.

Dwarfed by the handiwork of his great- ▶
grandfather, architect Stanford White, a young subject sits in a sailor suit on the heart-shaped staircase at Rosecliff, a French Renaissance palace in Newport, Rhode Island. White designed the sumptuous Rosecliff for Tessie Oelrichs, a turn-of-the-century mining heiress.

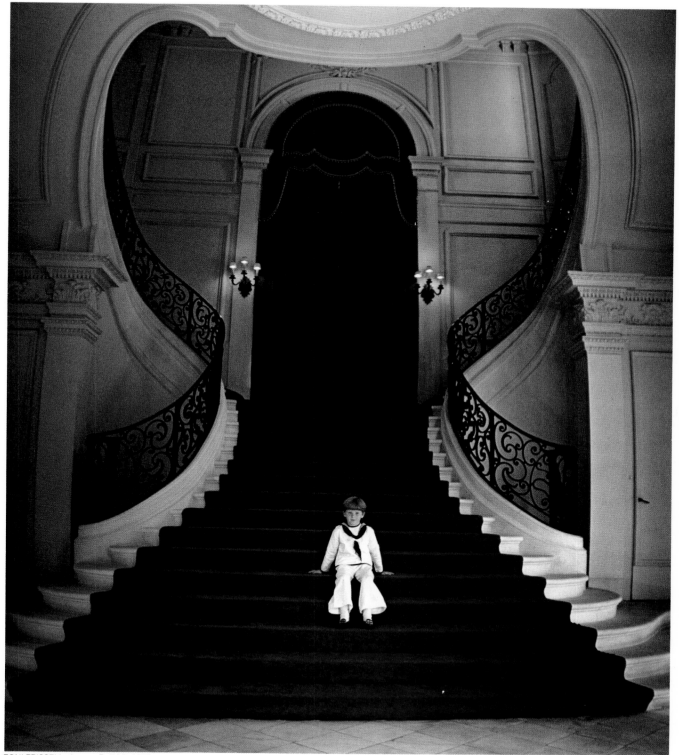

TONI FRISSELL: *Jerome Buttrick,* 1965

In Their Own Right

By the 1970s, photographers of children were becoming more adept at allowing their subjects to speak for themselves: whatever the situation, and whether or not the child is aware of the camera, the intent of the photographer is to permit the child's emotion or state of mind to reveal itself to the viewer.

A master of this approach is Joseph Szabo, who teaches photography and art at a Long Island, New York, high school. Szabo takes pictures of the students because he finds that "there is something I want to know about them that as a teacher in a classroom I just can't get." His portraits are not necessarily candid, unposed shots; the girls in the picture at right, for example, were positioned by the photographer. But the pictures capture something candid and intimate that is possible only because Szabo brings to the session a willingness to let the youngsters be themselves. □

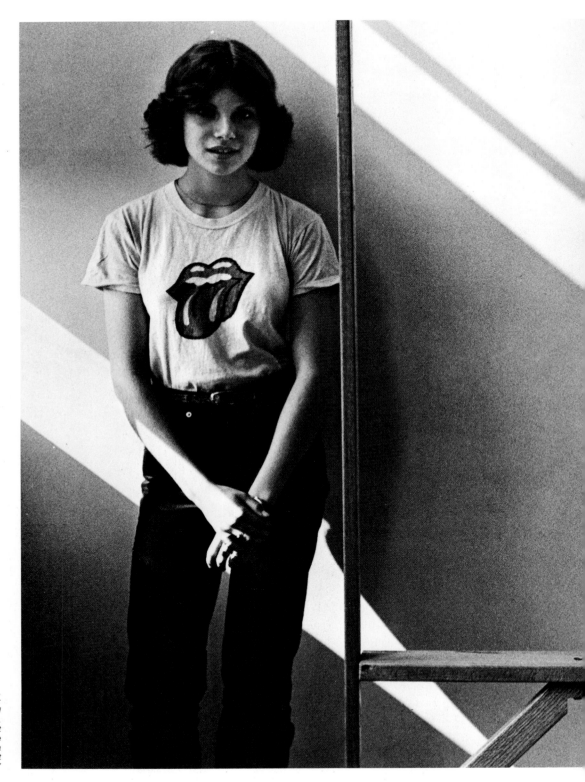

Standing against a wall in an empty classroom, two high-school girls are a classic study in contrasts: one radiant with self-confidence, her friend seemingly ready to slide out of the picture entirely. The friend's obvious discomfort, Szabo said, "set up an interesting duality." He deliberately placed the outgoing girl outside the wooden frame of a blackboard and the other girl behind it, sensing that "she would have liked to hide behind anything."

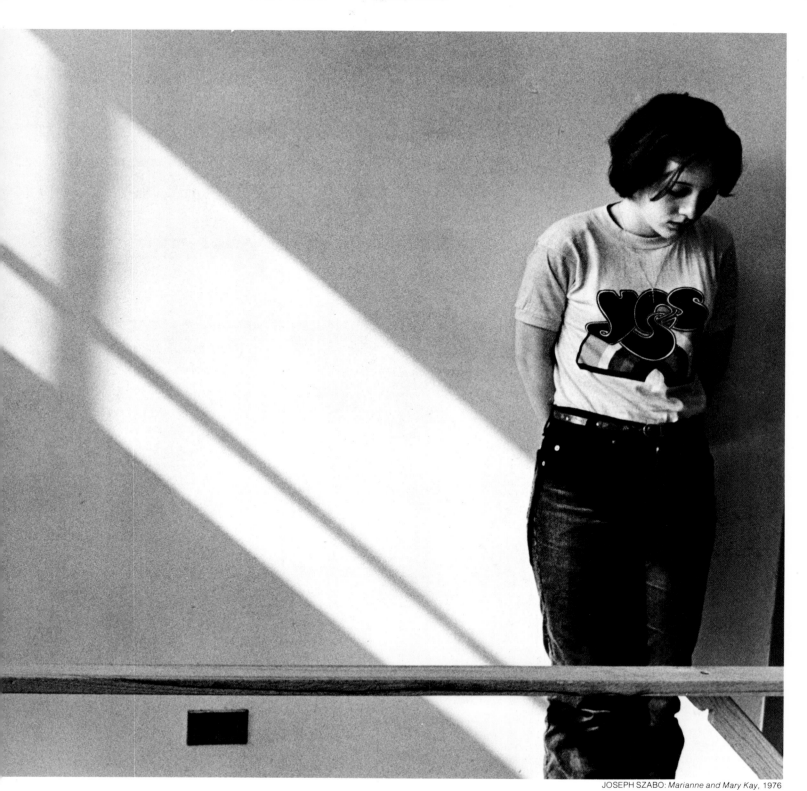

JOSEPH SZABO: *Marianne and Mary Kay,* 1976

A More Honest View

The urge to idealize childhood in pictures persists today and probably will always have its advocates. But child portraiture has gone on into the realms of realism and even surrealism.

The movement toward realism began at the end of the last century as photographers saw the appeal of children at their natural daily pursuits—playing, fighting and discovering the simple pleasures of petting animals, singing in the rain or wearing new shoes. But realistic photography also revealed a lot more. It delved into the private sorrow of family grief, into shocking scenes of forced labor and into the numbing savagery of war. In all these pictures the presence of children adds poignancy to the impact of the scene.

Among the first naturalistic photographers of children was an international group that called itself the Linked Ring. Formed in 1892, this group of men applied their techniques to a large range of other subjects as well. Its members selected as their mentor the brilliant and contentious physician-photographer Peter Henry Emerson, who announced: "Whenever the artist has been true to Nature, art has been good; whenever the artist has neglected Nature and followed his imagination, there has resulted bad art."

Emerson inspired such disciples as Frank Sutcliffe *(pages 66-67 and page 69)* to take pictures of poor children, naked children and children so absorbed in their activities they were oblivious of the camera. These were not pictures to adorn a grand piano; not many parents would have been likely to commission them. Many were actually documents of urban-industrial life of the time, of ragged slum children in pursuit of their homely pleasures.

Soon after the formation of the Linked Ring a solitary French boy, Jacques-Henri Lartigue, began to record his own comfortable, upper-class childhood. He had never heard of the Linked Ring and took no interest in esthetic questions. He simply wanted souvenirs of his day-to-day life. His lively, imaginative photographs *(page 73)* demonstrated that realism need not concentrate on downtrodden subjects.

In America, in contrast to that real but happy view, a number of photographers in the opening decades of this century trained their cameras on children laboring in factories, coal mines and fields. One of the best of these American realists was Lewis W. Hine *(pages 70-71)* who realized that no matter how direct and simple his pictures might be, they inevitably expressed his personal point of view. He confessed his subjectivity by calling his pictures "photo-interpretations." Hine's subjective realism helped set the tone for the many talented photographers who were to follow his lead.

From this concern with realism in the 20th Century there grew, first with artists and then with photographers, a desire to express inner truths that transcended reality. This called for a surrealistic approach; pictures did not have to show either the literal person or the idealized child, but rather could sketch the landscape of the child's experience. By placing emotion, state of mind, attitude and impressions on film, the surrealist photographer found a haunting, sometimes even chilling, way of exploring the mysterious realm of childhood, as shown in the pictures on pages 82 through 86.

If the camera had been placed closer to the subject, this photograph would have been a formal study of the son of Napoleon III on a pony. But the photographer moved the camera back so that the backdrop, the groom holding the pony, and even the Emperor and a pet dog are part of the picture. The change of camera position thus turns the photograph into a realistic view of how the idealized portraits of the time were made.

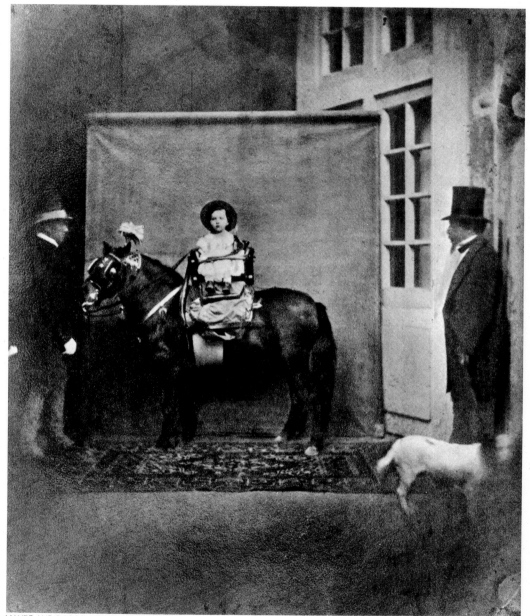

MAYER AND PIERSON: *The Prince Imperial, Paris,* c. 1859

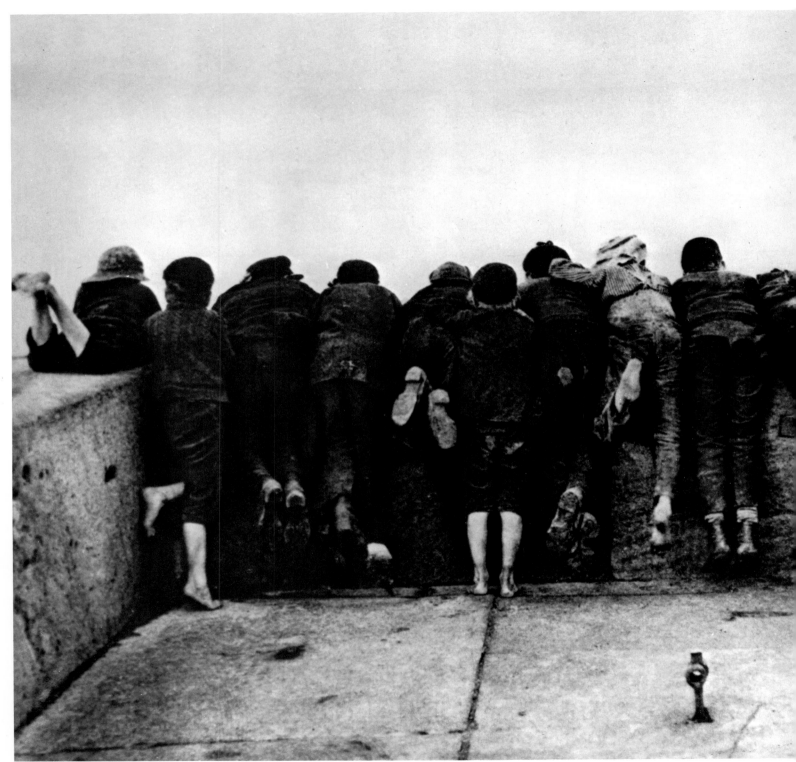

FRANK M. SUTCLIFFE: *Excitement,* 1888

Excited by some event on the other side of a wall, a ragtag band of English boys displays a motley assortment of caps, footwear, bare feet and trouser seats in this humorous picture by 19th Century English photographer Frank M. Sutcliffe. One of the Linked Ring photographic group, Sutcliffe worked to take photography away from the popular, highly stylized views of children and show them as they actually were in daily life.

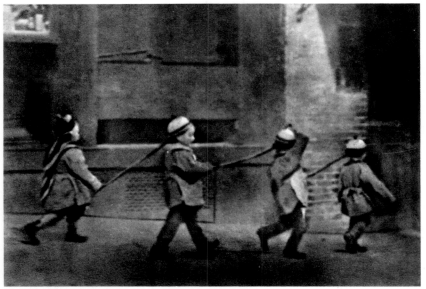

ARNOLD GENTHE: *Pigtail Parade*, San Francisco, c. 1897

Clinging to each other's pigtail, four children
wend their way through the streets of San
Francisco's Chinatown. At the turn of the century,
the neighborhood was a small replica of
Canton, complete with paper lanterns, Oriental
architecture, opium dens — and pigtails for males,
old and young. It was a favorite site for Arnold
Genthe, an early exponent of candid photography
who later became famous through his pictures
of the San Francisco earthquake of 1906.

Transfixed by the spell of an airless summer day, ▶
three boys lounge on a beached fishing boat, their
clothes draped on the gunwales. Although
Sutcliffe and other members of the Linked Ring
thought of themselves as naturalists, they
nonetheless sought a poetic quality in their
pictures, achieving it through rendering in soft
focus everything in the photograph except
its subjects — in this case the boys and the boat.

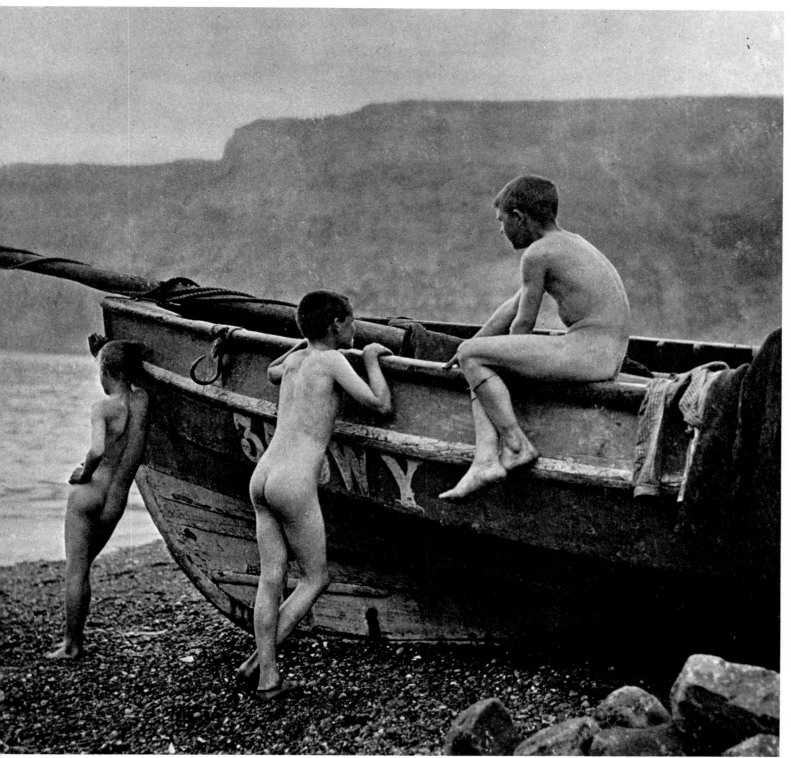

FRANK M. SUTCLIFFE: *Natives of These Isles,* 1885

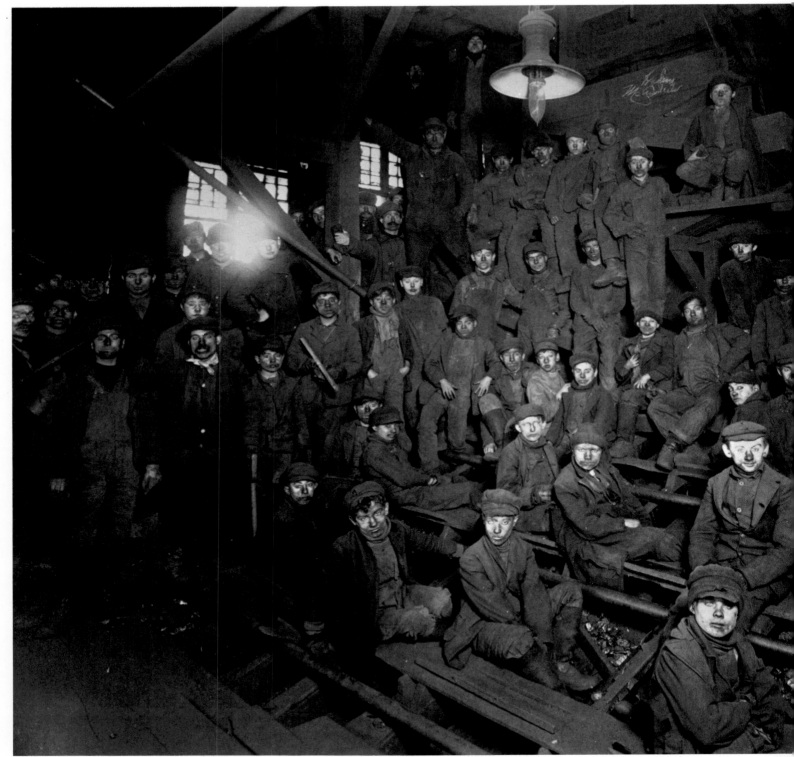

LEWIS W. HINE: *Breaker Boys inside Coal Breaker*, 1909

A crew of Pennsylvania breaker boys, who picked the slate out of the coal, stare into the flash of Lewis Hine's camera, their blank faces smudged by their work. Hired by the National Child Labor Committee to document the working conditions of children across the country, Hine pictured young workers in mines, sweatshops and harvest fields. His photographs helped bring about the child labor legislation enacted before 1920. Beyond being documents on which to base social reform, his works caught the spirit of his young subjects, their resignation underscored by quiet courage —even jauntiness—in the face of adversity.

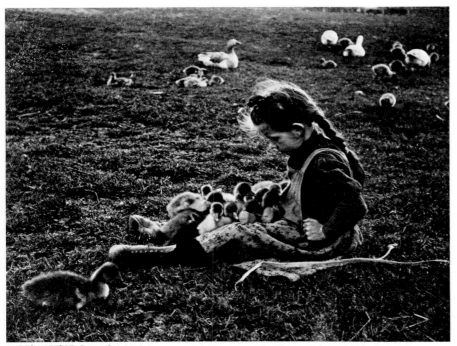

ANDRÉ KERTÉSZ: *Goose Girl*, 1918

A young Hungarian girl cannot hide a trace of apprehensiveness as she studies a lapful of goslings. André Kertész was a soldier in the Austro-Hungarian Army during World War I when he saw this unposed scene as his marching column paused for a rest in the countryside.

In her shiny boots and fashionable chapeau, a ▶ little Parisienne receives a riding lesson along the Avenue des Acacias in the Bois de Boulogne. The photographer, Jacques-Henri Lartigue, was scarcely more than a child himself—he was 16 and evincing a strong interest in women of all ages. Perched on an iron chair similar to those beyond the teacher, he photographed the passing beauties. "Everything about them fascinates me," he confessed, "above all, their hats."

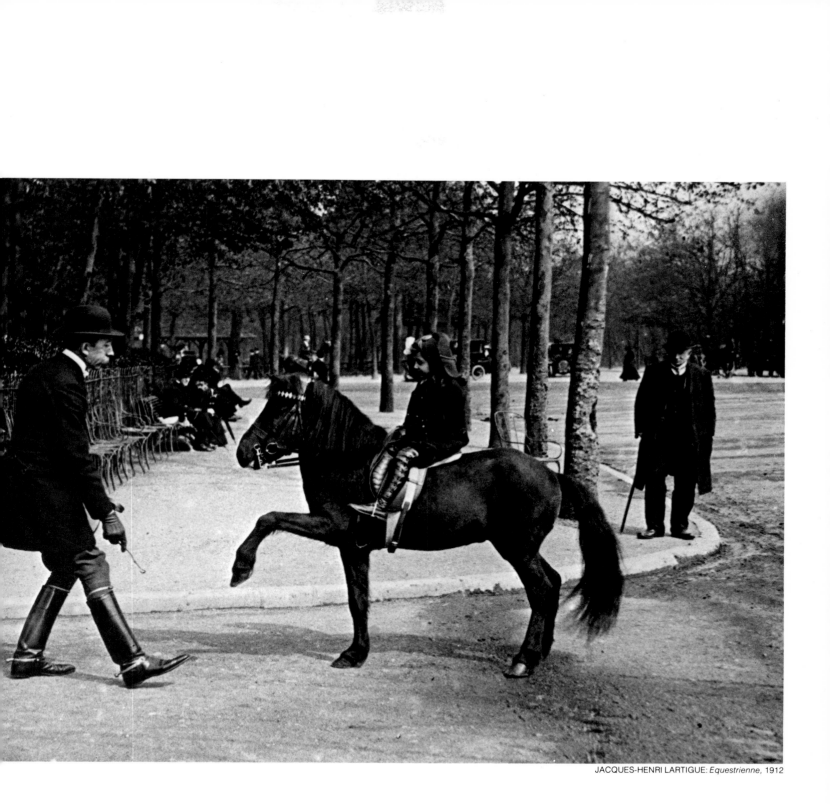

JACQUES-HENRI LARTIGUE: *Equestrienne*, 1912

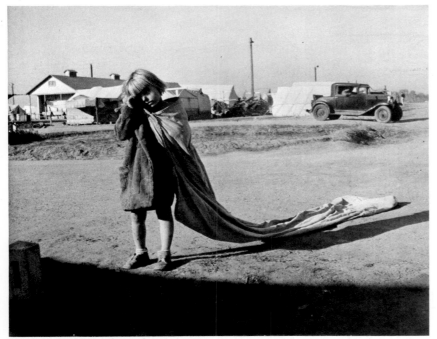

DOROTHEA LANGE: *Kern County, California, 1936*

Still half asleep, a weary child from Oklahoma drags an empty sack into the cotton fields of California on her way to work at 7 a.m. The girl was one of the thousands of people who fled the drought, depression and dust storms afflicting their native state in the 1930s. Dorothea Lange, working for the Farm Security Administration, followed them out to California, thereby becoming the first person to document for public inspection the lives of America's migrant working families.

In a famous study in contrast, Spanish slum children cavort happily amid the grim ruins of a building in Seville. Even the boy picking his way through the rubble on crutches is grinning, and nearly everyone is laughing and scuffling. ▶

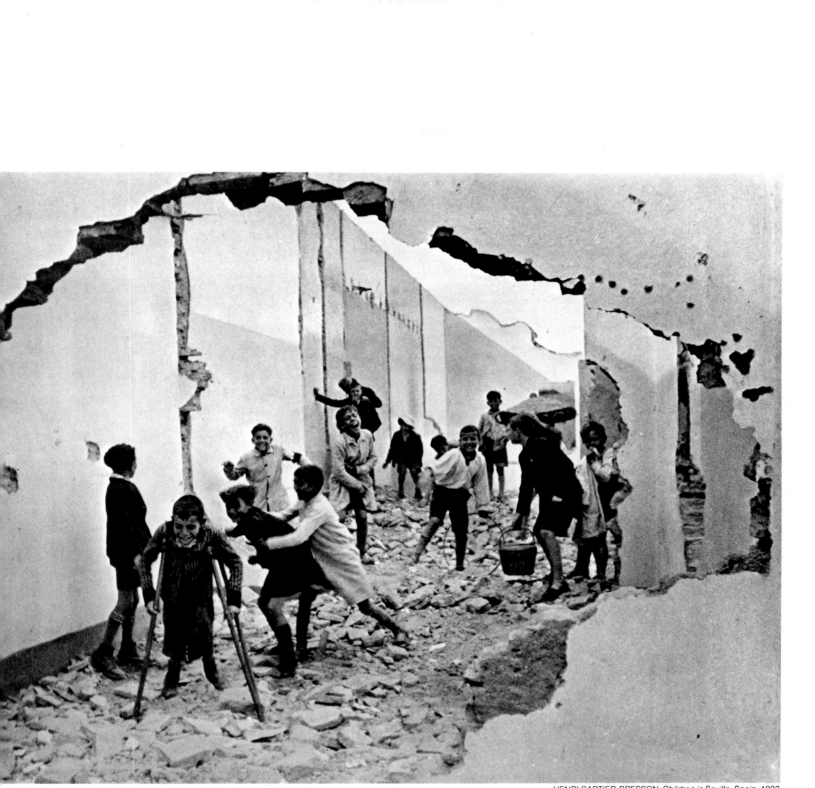

HENRI CARTIER-BRESSON: *Children in Seville, Spain,* 1933

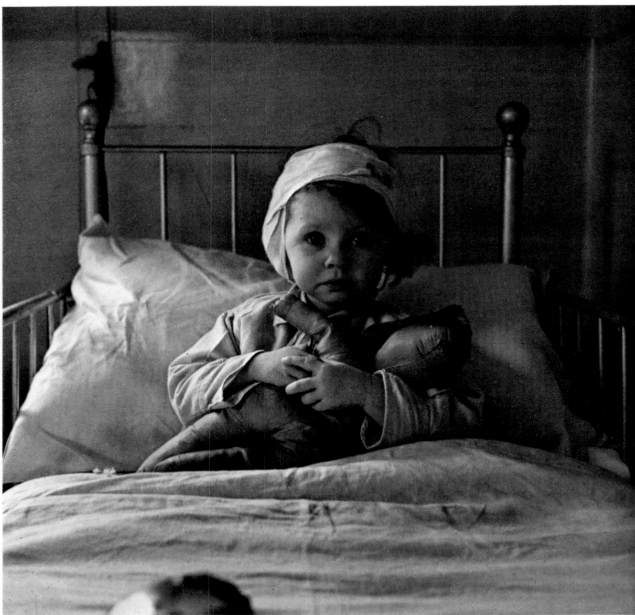

CECIL BEATON: *Eileen Dunne*, 1940

A young English victim of World War II recuperates in a hospital from shrapnel wounds suffered during a German bombing. This picture, which appeared on the cover of Life on September 23, 1940, represented an unexpected turn toward simple realism by the English photographer Cecil Beaton. Until the War he had been known primarily for his glossy, fanciful fashion pictures and portraits of beautifully dressed society women. Beaton says of the picture, "When I saw this strange little child, grave-faced, immobile, staring in front of her, I knew that I was about to take the best picture of my life. Would she move? The miracle happened. She remained still; shocked, wide-eyed and utterly memorable. I shall never forget the pathos."

Another World War II victim is this Polish girl who survived the bombing of Warsaw. When asked to draw a picture of her home, she scrawled these chaotic lines on a blackboard. The picture was taken by David Seymour, who had been born in Poland himself and had covered wars on assignments. It was part of a pictorial report commissioned by UNESCO, in which Seymour showed the War's effect on European children.

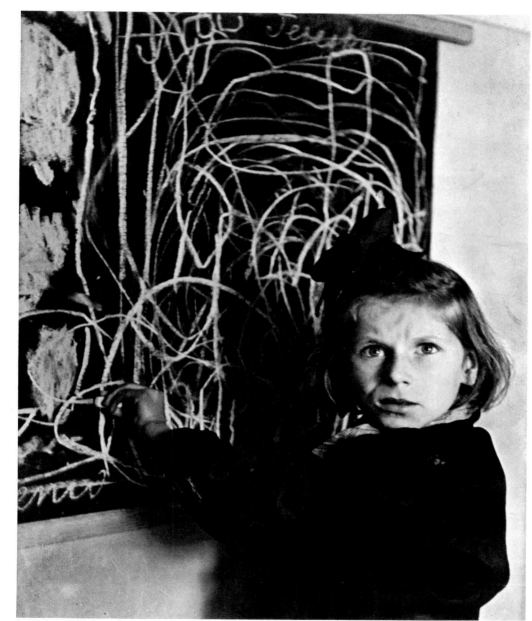

DAVID SEYMOUR: *Polish Girl,* 1948

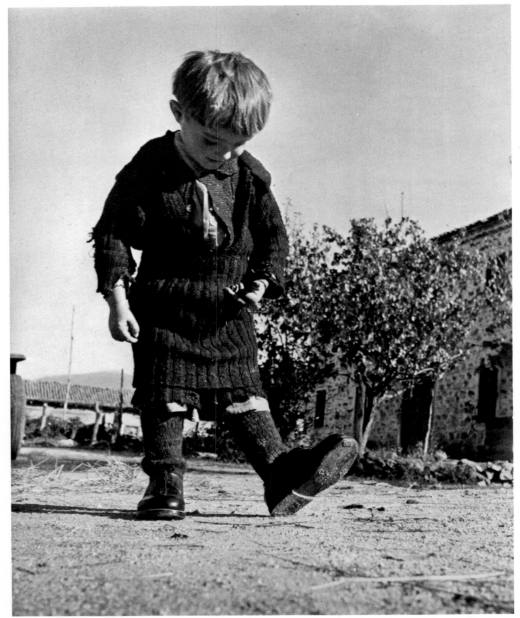

Taking a first step in a new pair of shoes, a Greek girl concentrates on the big, sturdy, unladylike and unfamiliar objects —made even larger by the camera's low angle of vision. David Seymour was a bachelor who befriended children throughout the world, always remembering their birthdays with a card or gift no matter where he was.

Three campers in hats and slickers open their ▶ mouths to let in the cool raindrops of a summer shower. The photographer made this picture near Lake Placid, New York, for a book about children at camp. Shot over several seasons, the photographs show that children soon overcome their self-consciousness before a camera and carry on with their games and normal activities even when a photographer is always on hand.

DAVID SEYMOUR: *Greek Girl,* 1949

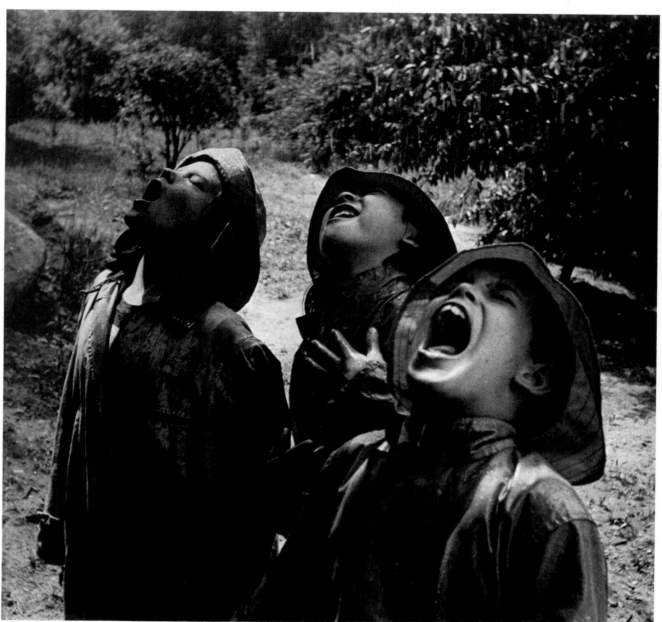

BARBARA MORGAN: *Singing and Drinking Rain*, 1950

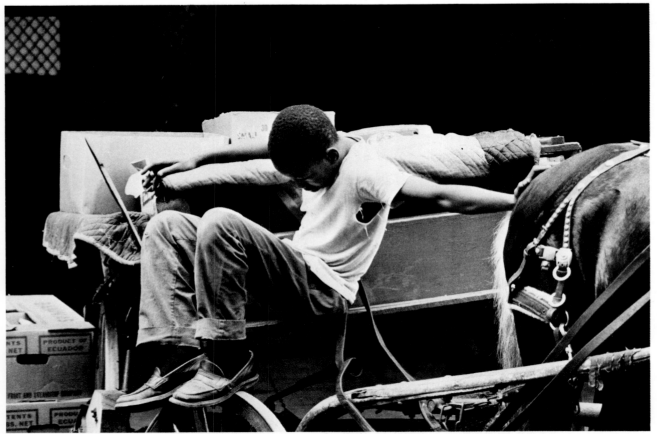

ROLAND L. FREEMAN: *Araber's helper,* 1969

*Old-style street vendors in Baltimore — a
disappearing breed known locally as "Arabers" —
often take on helpers like this young boy, who
slumps wearily between jobs, one hand dangling a
cigarette and the other resting on the broad back
of the Araber's horse. For Roland Freeman, once an
Araber's helper himself, taking the picture was
"like reliving my childhood."*

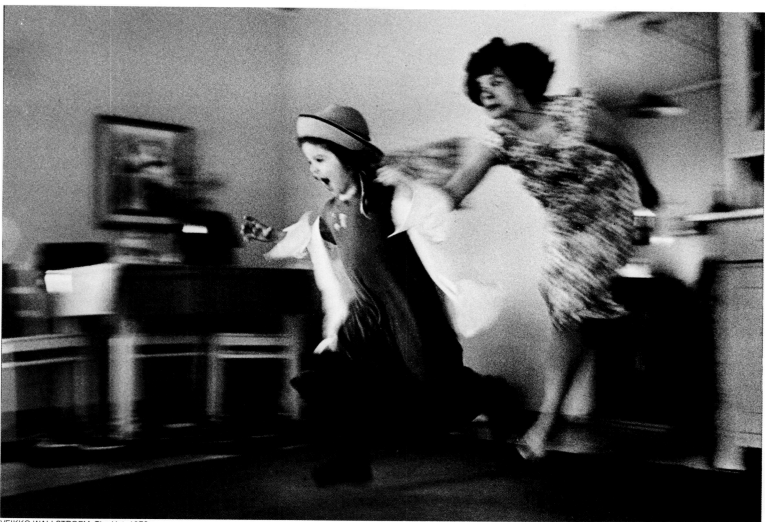

VEIKKO WALLSTROEM: *The Hat*, 1976

A little girl playing dress-up gives voice to the excitement of the chase as she flees with her mother's prized summer hat. "It was a lucky stroke," says Veikko Wallstroem of the impromptu shot of his wife and daughter. "Only the hat came into focus." The rest of the image blurs with the speed of the child's flight —and her mother's speedy pursuit.

Reaching beyond Childhood's Reality

When he moves from realism to surrealism, the photographer leaves behind the naturalistic scenes of youth and enters a realm that is dominated by moods, emotions, ideas and impressions. The photo-surrealist depicts the child's inner life as a dreamlike environment full of odd juxtapositions, distortions of scale, and other visual effects that convey the mystery—sometimes the menace—of childhood.

Surrealistic pictures can be made in a spare, simple setting ornamented by a single, unexpected piece of furniture—like the piano stool in Irving Penn's composition at right—or in a setting much more elaborately conceived. To capture the two-dimensional look of early American folk art for the photograph opposite, Lawrence Robins built an entire set in his New York studio. The floor is white canvas with the squares painted in reverse perspective: widest squares at the back and all lines converging toward the camera. The chair, with its optically distressing flame-stitch seat cover, was built deliberately askew. Even the false graining painted on the wall, an element borrowed from American primitive painting, contributes to the almost dizzying effect. The resulting flat image lifts the child out of the present and into an eerie space—or time—where the most familiar things seem strangely out of kilter.

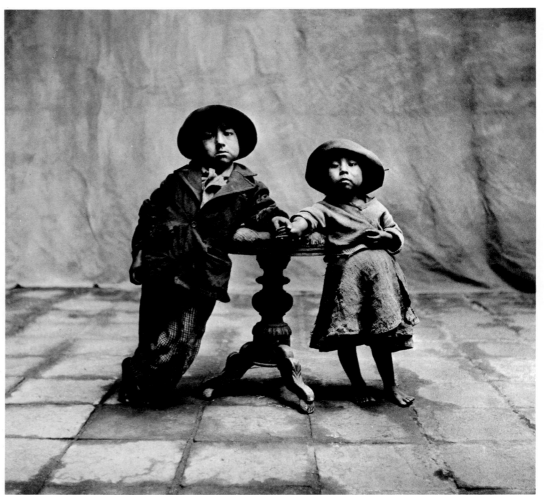

IRVING PENN: *Children in Peru*, 1948

The grave-faced pair above are as solemn as any grownups, but in fact are two children posed with a piano stool by photographer Irving Penn, in a studio he rented in Cuzco, Peru. Their mature, careworn expressions, adult-style clothes and the affectionate way in which their hands are joined all cast a surreal tone over them and make them appear old beyond their years.

Wearing an old-fashioned dress and cradling an ▶ apple in her hand, a 15-month-old child seems apprehensive in her contrived surroundings. Lawrence Robins built this set full of clashing patterns and distortions in perspective to create a photograph with the two-dimensional effect of a primitive painting. Even the spaniel seems wooden and askew in this weirdly disorienting world.

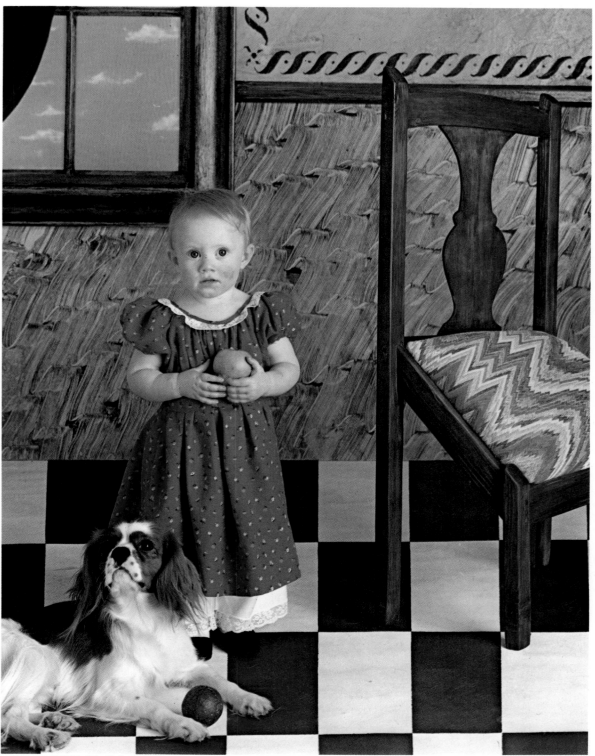

LAWRENCE ROBINS: *Girl with Apple*, 1981

A boy who had hoped to net fish with a colander sits on the bank of the polluted Passaic River, the colander on his head, his only catch a duck decoy retrieved from the oily waters. Arthur Tress took the picture during a project to document environmental conditions around New York.

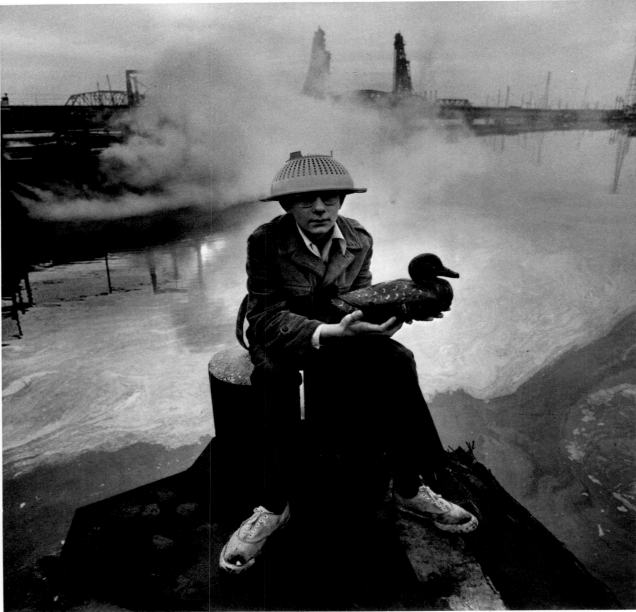

ARTHUR TRESS: *Boy with Duck and Colander,* 1970

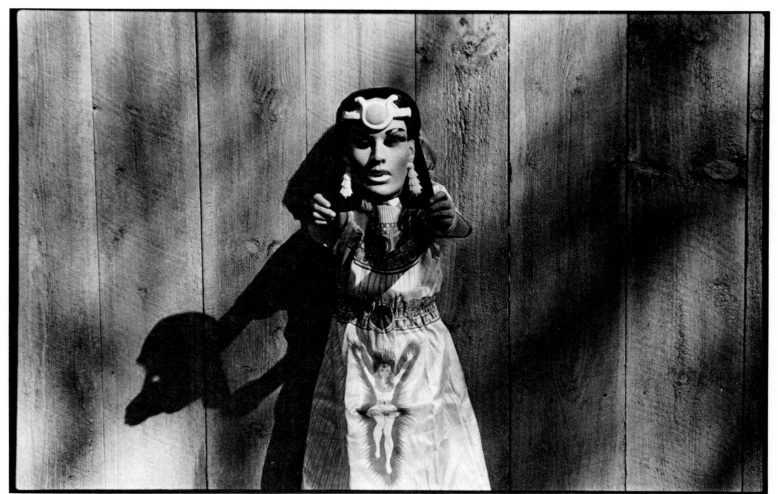

SARAH BENHAM: *Susie — Halloween 1979*

Holding a Wonder Woman mask at arm's length before her face, the photographer's eight-year-old neighbor shows off her costume and projects her make-believe persona for the camera. By shooting at the child's eye level, Sarah Benham participates in Susie's fantasy but uses the shadow on the fence to reveal the shape of the child behind the mask.

JOYCE TENNESON: *Girl with Church*, 1981

A young girl wearing a veil gazes at a miniature church in this photographic metaphor for Joyce Tenneson's Catholic childhood. Printed on specially treated paper, the silvery image achieves what Tenneson calls "a marriage of form and content."

Baby Pictures 3

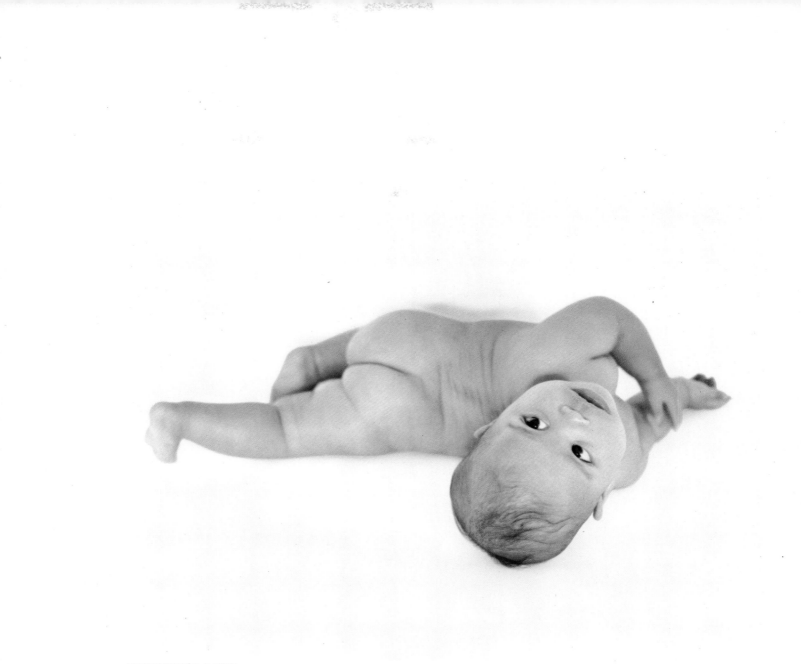

STARR OCKENGA: *Joe 1981*

The Rewarding Record of a New Life

Child photography begins with the newborn baby. And now that fathers — and their cameras — are widely welcomed into the delivery room, the first pictures are being taken earlier than ever, capturing the very moment of birth. But there are also many other opportunities for rewarding shots in the wave of exuberance and relief that sweeps the delivery room following a birth. In many hospitals, the custom is to place the baby almost immediately on the mother's belly, offering a chance for a first portrait of mother and child that may be more evocative of the occasion than a shot of the birth itself.

Though photographs taken in the delivery room are precious documentary records, they tend to be catch-as-catch-can shots. Unhurried, thoughtful images that are taken a little later are likely to be not only more esthetically pleasing but also more revealing. The photographer may move in for a tight head shot of the hours-old infant, or capture the tenderness of the mother nursing her baby for the first time.

Once the infant comes home, the opportunities for picture taking expand enormously. All too often, however, as the excitement of the birth subsides and the reality of diapers and night feedings sets in, a hasty snapshot seems sufficient to send to relatives and friends. After that, picture taking often falls into a stereotyped pattern. On scheduled occasions, the baby is scrubbed, dressed up, and — willing or unwilling — placed before the camera while the parents struggle desperately to coax a smile or at least a pleasant expression.

This method of photographing babies, although it has a long tradition, seldom succeeds in reflecting a child's personality and distinctive manner. Baby photography need not be limited to noteworthy occasions and standard poses. Nor does it have to be a boring chore for either photographers or children. Quite the contrary, its rewards and pleasures are immeasurably greater when it becomes a warm, spontaneous act that captures babies in all their naturalness and complexity.

A baby's determination to learn the business of living is evident in the first months of existence. Things that will be taken for granted by a venerable two-year-old are sources of infinite curiosity to the infant. Discovering that hands are for grasping, identifying a sound with its source, rising on two arms to take a look at the world — all these are revelations whose excitement a baby can communicate not only through cries and gurgles, but also through facial and body expressions that can be captured photographically. The very lack of spoken language makes such pictures eloquent, for they openly reflect the emotions of the subject.

Although all babies develop at their own pace, it is possible to predict a general itinerary of the rapid journey from infancy and babyhood into childhood. Each stage of development, of course, provides new fare for photography. Among the triumphs of four-week-old babies is their ability to lift their head

while lying on their stomach. At eight weeks, babies can be photographed delivering their first social smile. At about 12 weeks they attempt sitting up, chuckling and cooing; and at 16 weeks they play with their hands and reach for things. At 20 weeks, babies will laugh at their image in a mirror, and at 28 weeks will pat their reflection. A child's first attempt at standing—an exciting moment for child and parent and a milestone in development—comes at about the 32nd week.

The picture possibilities keep cropping up thereafter: caroming excursions in a walker, the intense concentration of a baby learning to scribble with crayons, the first tentative solo steps. By the time children reach the age of two, they are walking up and down stairs, feeding themselves with a spoon, putting on simple clothes and even mimicking other people. And at whatever age, babies in repose are appealing photographic subjects. Sleeping children, seen against the background design of the crib or with a pattern of shadows falling across them, are the perfect subject for a still life.

But how to make these pictures? Most parents, busy running a home and earning a living, do not have the time to be always on watch, endlessly clicking a shutter. An easy and convenient answer is simply to accept the camera as a familiar, utilitarian part of the household, to be picked up whenever a scene or activity calls for it, and not to be locked away in a cupboard. With the camera always handy, parents can take pictures at will. Moreover, if the camera is treated casually, it will become part of the normal environment and babies will react to it naturally.

The photographer seeking more striking images should also be ready to break the rules if it will help the picture. One widely circulated formula exhorts photographers to place the camera at the baby's level and move in close. Yet many of the most effective pictures on the following pages were made from an adult's level. And although a child's face can be very expressive, some equally expressive and appealing pictures can be made with the face not showing at all. The key is to worry less about the rules and more about the picture. Babyhood, one of life's most active and challenging times, is crowded with picture-worthy events. A good honest photographic record of these first years is certain to be a cherished addition to the family history. □

Delivery-Room Shots Made Simple

Although pictures of a child's first moments in the world are among a family's most treasured souvenirs, the unfolding drama of the birth itself is so emotionally involving that a photographer-father does not usually pay meticulous attention to composition and exposure. Moreover, the illumination—often a relatively dim, overall fluorescent light, augmented during labor and delivery by a spotlight on the mother's pelvic area—is too low for fast exposures or else so uneven that it produces highly contrasty images.

The photographer's usual tool in such circumstances, an electronic flash, is frequently banned because a strong direct burst of light may damage a newborn's eyes. The only alternative is high-speed film, a camera that has automatic exposure—and advance planning.

A film with a rating of ISO 400/27° will usually be sufficiently sensitive, but it can be pushed to 800/30° or higher, with the underexposure compensated for in development. The subdued lighting used in some natural childbirth may require recording film *(opposite page, bottom),* which can be pushed to 4,000/37°.

Color film is at a disadvantage in most delivery rooms because the fluorescent tubes produce a red-deficient light that causes the final image to appear unexpectedly greenish. But appropriate filters can produce natural-looking results by blocking wavelengths of green light.

Delivery-room lighting can be inspected and metered in advance on the orientation tour that the hospital offers expectant parents, and the final stages of labor usually allow plenty of time for planning shots and exposures. After the birth, a nurse or aide is usually more than willing to snap a first family portrait of mother, father and newborn. ☐

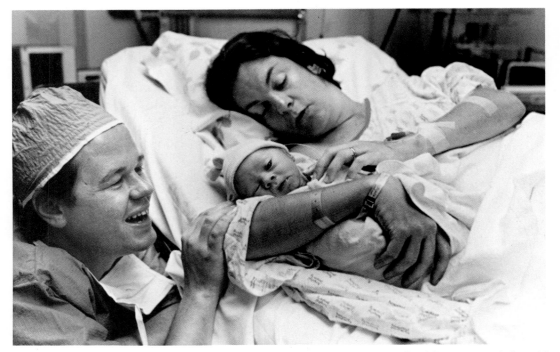

This delivery-room portrait of parents' exhilaration after the birth of their baby was shot on color negative film rated at ISO 400/27°. A special filter was used to compensate for the shortage of red wavelengths in the fluorescent light, and the exposure was f/2.8 at 1/60 second. Color negative film is a safer choice than slide film in such situations because any color imbalances are more easily rectified in the darkroom.

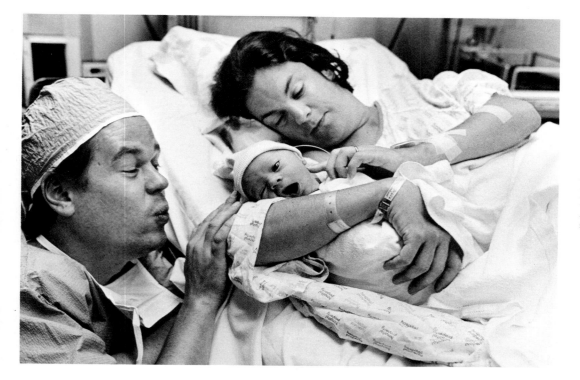

A fast black-and-white film with a rating of ISO 400/27° produced this sharp, fine-grained version of the same scene. Although the film's speed is the same as for the color film used opposite, no color-adjustment filter was needed and the exposure was therefore one stop less —f/4 at 1/60 second. The smaller aperture provides more depth of field, giving the photographer more leeway in focusing.

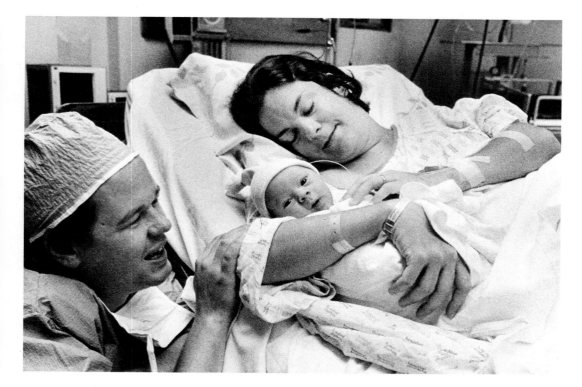

This moderately grainy rendition of the scene was taken with recording film, a special high-sensitivity film originally developed for low-light surveillance shots. At its normal rating of ISO 1,000/31°, the film required an exposure of f/5.6 at 1/60 second. At a larger aperture it could be used in a room with two or three times less light and, if pushed to 4,000/37°, could conquer quite dim light, although with extremely grainy results.

Stratagems for Taking a Formal Portrait

The making of a formal portrait of a bare-bottomed baby is not as simple as it sounds. A photographer can expect an older child to hold a pose while the lamp positions and camera angles are fine-tuned, but a baby is most unlikely to oblige. The best strategy, therefore, is to keep everything as flexible as possible.

The background for this kind of portrait should be plain and unadorned: a few yards of fabric, a length of seamless photographic backdrop paper, or even an old-fashioned bearskin rug. Whatever is used, it should be ample enough so that the baby can move around without spoiling the picture.

Relatively strong, evenly diffused light will permit easy shifts in the camera's viewpoint. It can be obtained by mounting sheets of fabric or milky plastic in front of studio lamps, or by bouncing flashes off umbrellas or the ceiling. In warm weather, another solution is to work outdoors. A bright day when the sun's light filters through clouds is best; but on a clear day, the sunlight can be softened by hanging a piece of cloth or plastic between the sun and the subject. A light-colored backdrop will automatically function as a reflector to bounce light into shadowed areas; but with a dark background, a reflector card may be needed in order to prevent shadows from becoming dark pockets. With a light-absorbent backdrop like the one in the photographs at right, it may be necessary to resort to a light-bouncing prop. □

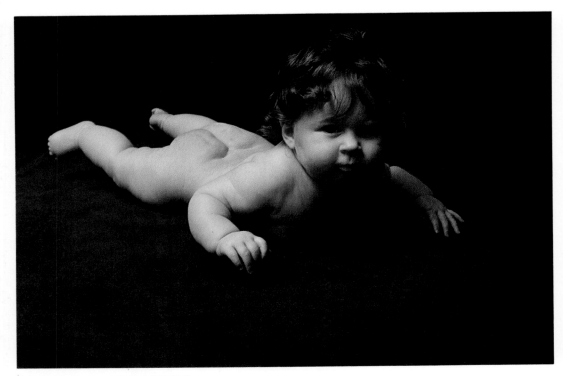

To isolate his daughter against a solid field of black, the photographer placed her on the material that portrait and still-life photographers traditionally use for such an effect: black velvet. The fabric is so light-absorbent, however, that no sunlight was reflected into shadowed areas, leaving the lower half of the baby girl's face in darkness.

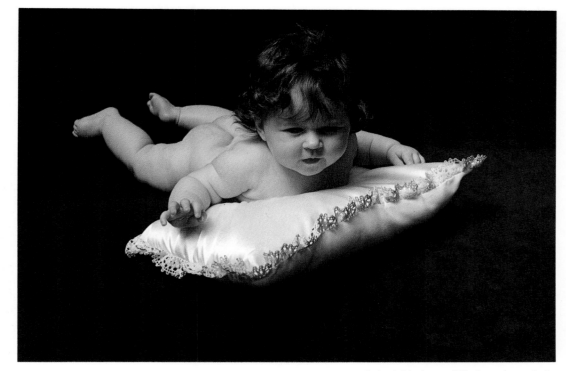

Instead of rigging up a fill flash, or using a reflector card that would have been awkward to handle, the photographer placed a white pillow under the baby's chin. The lace-trimmed prop was perfectly in keeping with the old-fashioned flavor of the picture — and reflected light where it was needed.

Recording the Earliest Days at Home

Once home and removed from the restrictions of the hospital, the new baby instantly becomes the subject and the source of infinitely broader photographic opportunities. The family's reaction to the baby's arrival and presence in the house, the infant's growing abilities and awareness, all combine to supply rich inspiration for pictures.

Wolf von dem Bussche and his wife Judith began to discover all this as soon as they brought their firstborn son Nicolas home to their New York apartment and started to chronicle on film the adventures of the new arrival. The task had an especially compelling incentive—Nicolas being the first child of a professional photographer who knew an appealing subject when he saw one. But instead of plunging into a crash program entailing scores of pictures on dozens of rolls of film, von dem Bussche found that he spent most of his time watching and waiting. His loaded camera was never far from hand, but seldom was it at work. The result, instead of a frantic chronicle of Nicolas' every twitch, was a slowly evolving series of photographs that unmistakably record the unhurried growth of a child during his first few weeks of life.

In line with his low-key approach, von dem Bussche did not burden himself with a complex array of cameras and lenses. He used only one 35mm camera and one highly versatile lens, a 50mm f/1.9 macro with a range of six inches to infinity. At close range he could of course have fitted a 50mm lens with a close-up attachment. But the advantage of his fast macro lens, which combined the advantages of close-up and normal lenses, was that he could shoot at any distance without pausing to add or remove any attachments.

Like many parents who watch their baby's development, von dem Bussche found that he was actually recording a "trip of discovery." The pictures on these and the following pages preserve the earliest stages of that exciting trip, beginning with the first photographs of Nicolas at his home and continuing through his routines of feeding, bathing and visiting the doctor—all taken during those exceedingly eventful first two months of his life on earth.

As in any such intensely personal photographic venture, the pictures were their own reward. Yet there were some other parental dividends. The pictures tended to clarify and reinforce the father's participation in the experience of watching his son develop. Thus, in a subtle way, the act of taking pictures of his baby made him even more deeply involved than usual in the process of rearing a child.

In quest of an unusual father-and-son photograph, Wolf von dem Bussche held Nicolas up in front of a mirror and started snapping pictures. After several exposures, the baby started to yawn—and his father caught this amusing comment on the proceeding. The photographer deliberately failed to show his entire face or head, letting his arm around his son convey the sense of a protective parental presence.

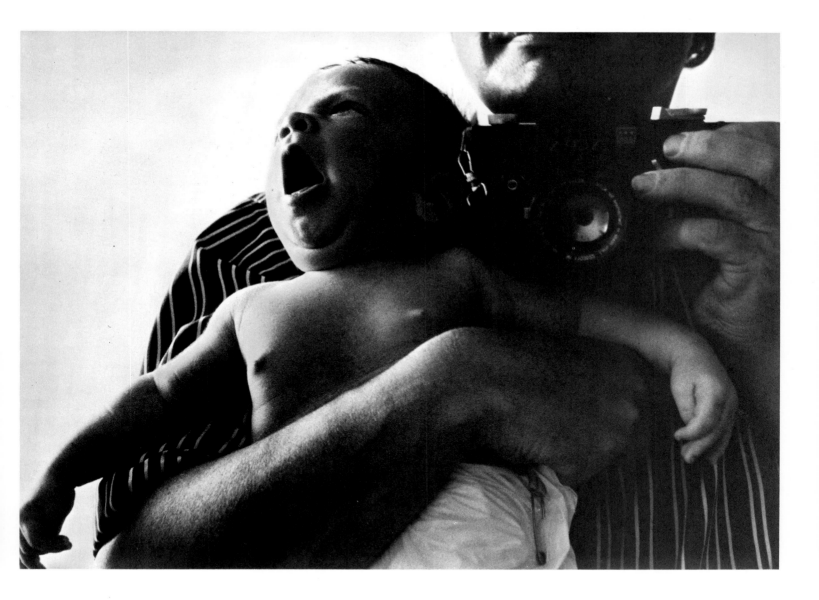

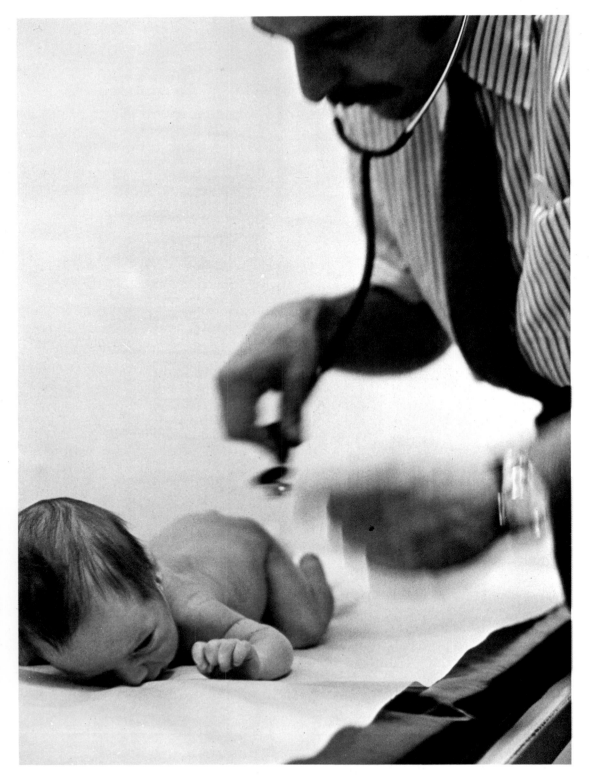

During his first visit to the pediatrician, Nicolas lay slightly humped up but still as the doctor examined him. To heighten the contrast between quiet baby and active doctor, the father slowed the exposure time to 1/15 second so that the adult hands blurred while the child remained in focus. The fluorescent lights overhead provided enough illumination for the picture to be made at this speed without flash.

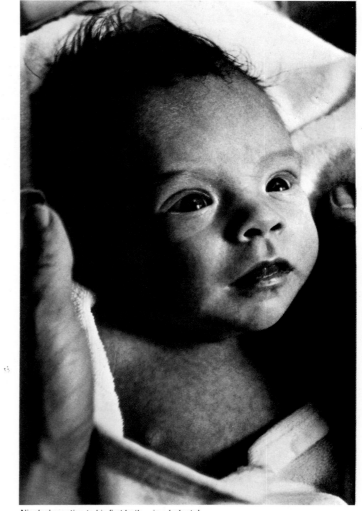

Nicolas' reaction to his first bath—in a baby tub placed in the bathroom sink—was wide-eyed apprehension. Afterward, held by his mother and wrapped in a towel, he is still wide-eyed but content.

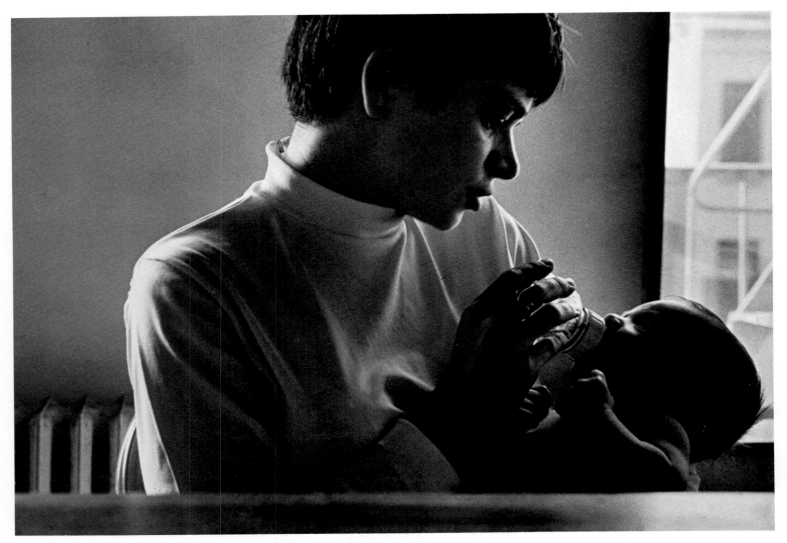

*Responding to the baby's hungry call, Nicolas'
mother brings his bottle and the comfort of her arms.
Mother and child were photographed in natural light
coming through windows behind and on either side
of them. The backlighting gave the picture a softness
in keeping with the quiet serenity of the moment.*

On Nicolas' first outing from home the bundled-up baby dozed off in the car. When his father stopped at a red light, he noticed the snoozing face and the expressive hands. Picking up his camera, he snapped the shutter just before the light changed.

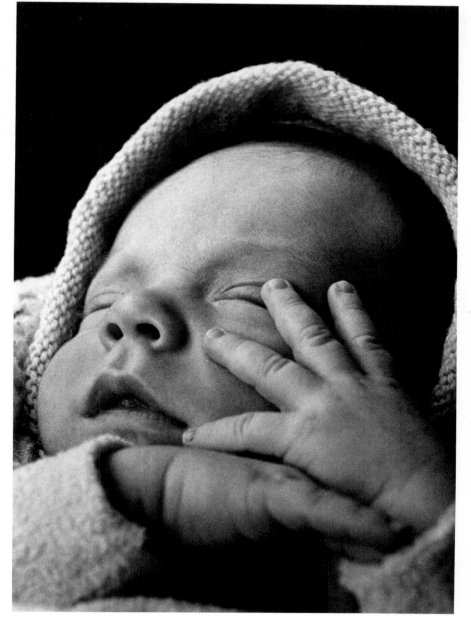

Capturing a Unique Period of Life

After the first months, as babies begin to exert their independence—holding their own bottles, crawling, ultimately taking their first faltering steps—photographs of them tend to become more mannered. They are posed formally and are encouraged to show expressions that adults want rather than the natural, if occasionally quirky, attitudes that are their own. Or if the child is caught in an odd expression, it is too frequently used to produce a clever shot rather than a realistic portrait. In this way the youngster is lost as an individual.

The fact is that during the early years, while babies are busily engaged in discovering how they fit into the world, they make perfect subjects for informal pictures taken from whatever distance or angle seems to be appropriate. As in photographing newborn infants, photographers should keep the picture simple and themselves as unobtrusive as possible. And since the babies become more active as they grow older, photographer-parents should be ready to make plenty of exposures, in order to be sure of capturing the critical action or expression.

A photographer should also be ready to break the rules if it will help the picture. One widely circulated formula, for example, exhorts the photographer to place the camera at the baby's level and move in close. The picture at right shows how effectively that rule can be broken. This is a shot taken from an adult's height and not particularly close to the subject. Yet the result is a superb study, filled with warmth and joy.

Another traditional rule is to use plenty of light; flash bulbs have long been regarded as indispensable for baby pictures indoors. Yet most of the pictures on the following pages were shot in soft natural light. Also, although photographers are usually admonished to concentrate on the child's face and expression, some of the most expressive and appealing pictures on these pages were made without showing the face at all.

The rules were not made just to be broken, of course. Parents will make a rewarding record of the baby's development even at the baby's level, with lots of light and emphasis on the subject's face—so long as they let the child dictate what pictures are taken, and look for the natural and spontaneous moments.

No one could expect Amanda, celebrating her first birthday, to sit still long enough for a portrait. Instead, her father deliberately capitalized on her joyous agitation. He used a Rolleiflex wide open at f/3.5 with available light coming from overhead. The slow exposure softened her smile and caught the graceful curve described by her busy hands.

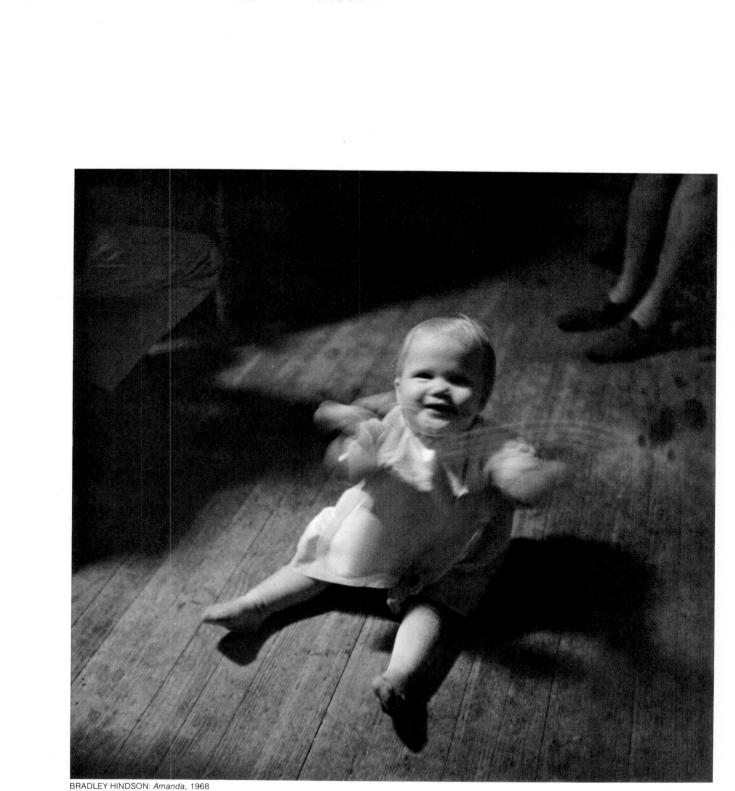

BRADLEY HINDSON: *Amanda,* 1968

Describing the Look of a Baby

By taking close-ups of his son's torso and limbs,
Russell Banks reveals the physical proportions
characteristic of all babies. The stubby fingers,
protruding belly, bowed legs and small, chubby feet
of infancy are set off by the plain backdrop.

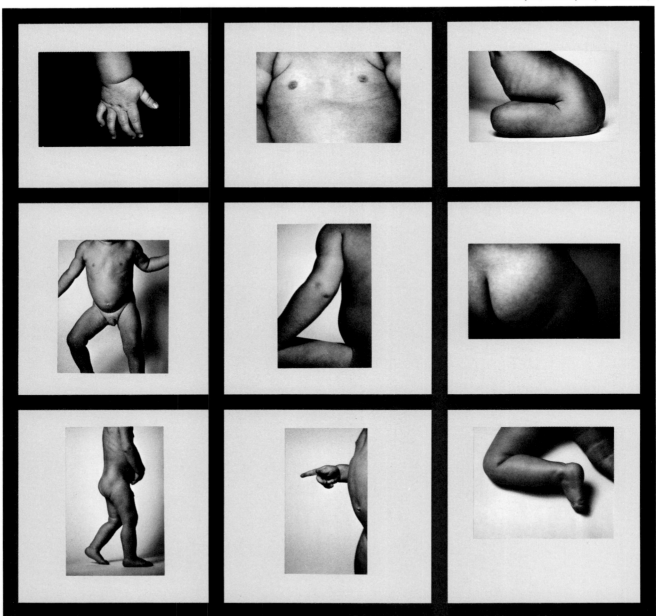

RUSSELL BANKS: *Infant Series,* 1981
104

Cradled in gentle, gigantic hands, a newborn nestles against a grown man's muscular chest. By not showing the man's face, Jan Saudek leads the viewer's eye to the baby's wrinkled forehead and tiny fist, emphasizing the vast physical difference between adult and infant. Saudek's hand tinting and delicate toning enhance the image's timeless quality.

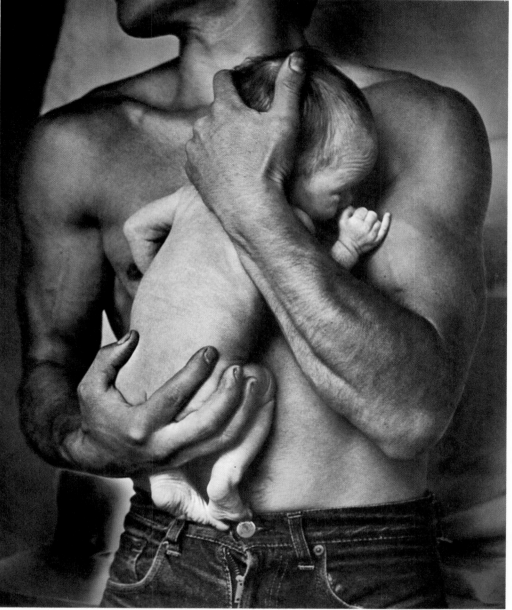

JAN SAUDEK: *Image 35 (Another child, David, is born. I embrace him)*, 1966

The Crawler's Floor-bound World

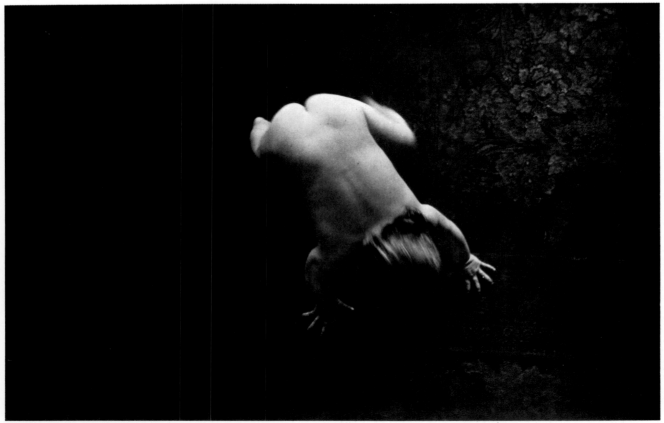

GEORGE KRAUSE: *Baby Crawling*, 1966

To suggest the triumph of self-propulsion in a crawling child, the photographer used a slow exposure (1/15 second), producing a slightly blurred effect in his daughter's moving legs. Her hands, being still, are in sharp focus.

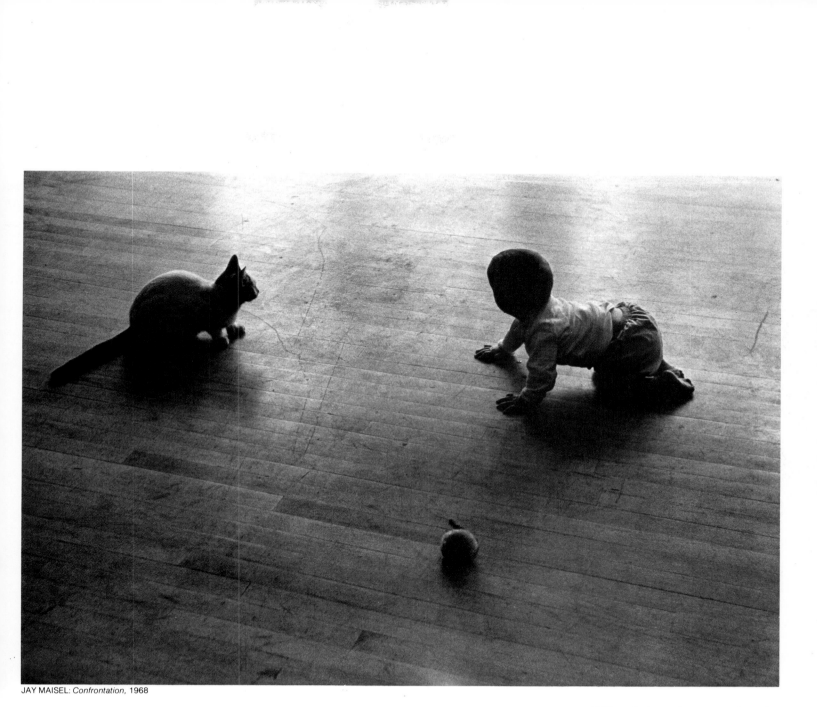

JAY MAISEL: *Confrontation*, 1968

Babies and pets seem to exert a mutual attraction, perhaps because they are smaller than others around them and spend much of their time down on all fours. Here the photographer caught cat and baby in the same posture, and emphasized their relative smallness by shooting down on them.

Focusing on Gesture and Expression

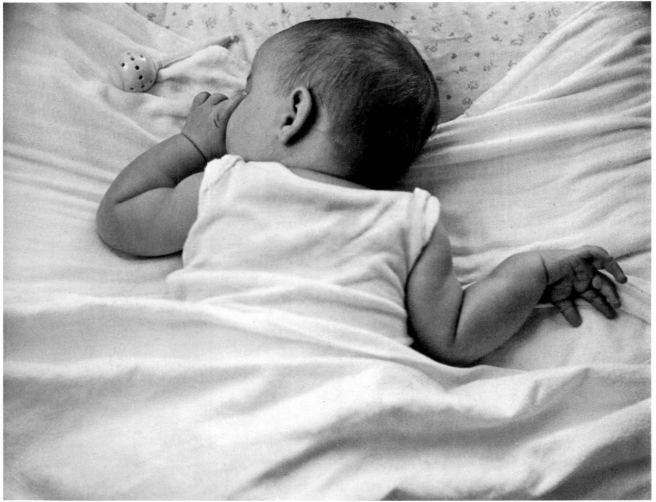

BILL BINZEN: *Baby Sucking Thumb*, 1960

The baby's face is mostly hidden, but her hands tell the story: The fist to the mouth reveals that she is contentedly sucking her thumb, and the open fingers of her other hand show her total relaxation.

The look of utter peace on the face of a half-day-old boy fills the frame in this image by German photographer Walter Schels. A professional who often photographs children for a parents-oriented magazine, Schels made the shot in the maternity ward of a hospital, moving in close with a macro lens.

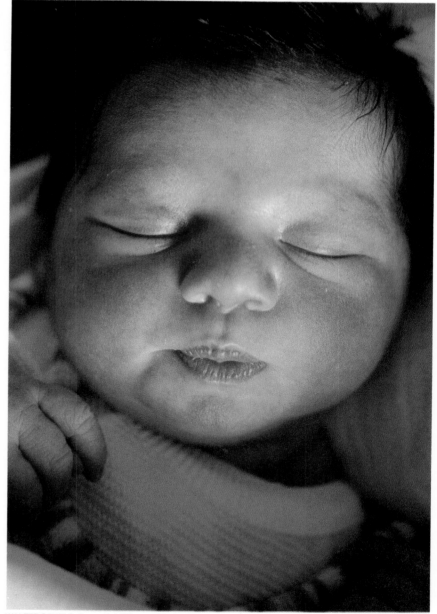

WALTER SCHELS: *Tranquil*, 1979

A Camera Trick to Set the Mood

To heighten the Yuletide atmosphere of this portrait, Rhoda Baer first made an exposure with a flash to freeze a sharp image of the boy and the light string. Leaving the shutter open for a half second more, she moved the camera in a small, down-and-around motion, causing the lights — the only things still bright enough to be recorded — to trace paths on the film.

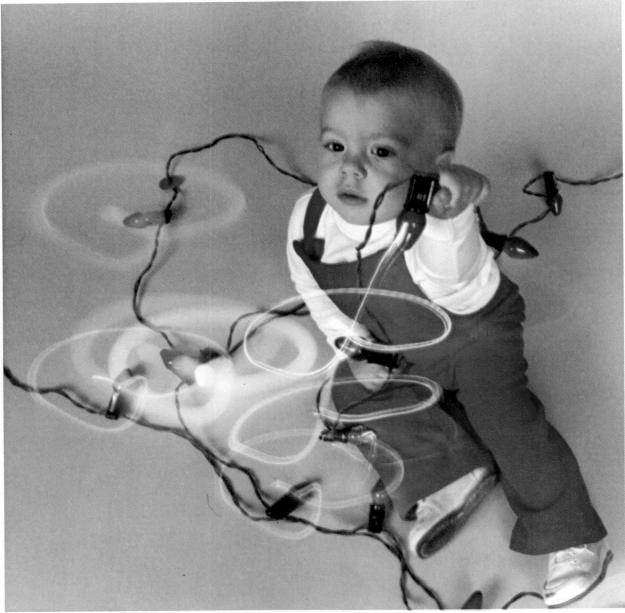

RHODA BAER: *Matthew — Christmas,* 1981

Kid vs. Camera

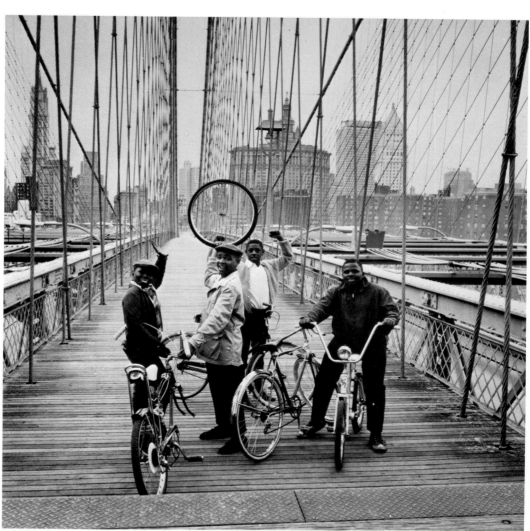

A. DOREN: *Boys on Brooklyn Bridge*, 1967

Dealing With the Aware, or Unaware, Subject

As the baby is inevitably transformed into a child, day-to-day growth is imperceptible; yet photographers of children must watch closely as their subjects gradually grow more competent, more independent, more complicated — and more interesting. Liberated from cribs, bottles and diapers, children range farther afield and become less predictable in their comings and goings. Their bodies — risen from all fours onto a pair of rubbery legs — coordinate into engines of ceaseless locomotion. Their minds — lately so insular and self-absorbed — connect with the outside world through omnivorous senses and expressive speech. Children move mentally and physically around a constantly expanding universe, obeying the urge to explore their estate and the temptation to try the ways of the grown-up world. Sometimes appealingly, sometimes implacably, children assert themselves as *persons*.

These changes offer new opportunities to the photographer — and new challenges. One problem is that as children become more and more aware of the world around them, they become more aware of the camera. That can be a serious drawback if it makes children self-conscious, stiff and unnatural; or it can be a boon if the child can be induced to participate naturally in the photography. Most children are easily persuaded to cooperate, at the very least by making sport of posing and sometimes even to the extent of helping compose the pictures. "Ask for the child's help," says Baltimore photographer Susie Fitzhugh *(pages 122 and 142)*. "Let him know what conditions you need, let him feel he is helping with the production of a photograph that can be understood at first glance."

Sometimes children are too self-conscious or shy to cooperate. The alternative then is to take pictures without letting them become aware of it. This feat is easier with children than with adults because children throw themselves into their own activities with such absorption that they may not even know — or may come to forget — that the camera is near. This obliviousness can occur especially if the photographer spends enough time among the same children, like Starr Ockenga on pages 204-207, so that the children will go about their own affairs, knowing the camera is there but accustomed to it and at ease.

Either way the possibilities are unlimited. No professional on a dream assignment to some exotic end of the earth could hope to find subjects more mysterious and alive and expressive than these proto-people who are right at hand everywhere. It does not follow, however, that availability makes the job easier. In many ways, photography is a simpler matter on either side of childhood. Babies can be immobilized in someone's arms or in a high chair; adults come to the camera with a catalogue of habitual expressions, gestures, postures and props that have become their own through long use. But the people in between — the children — are still in that unfixed, formative and ambiguous state that makes photography a challenge.

The same child may be one thing—dependent, active, naïve—or the opposite—self-sufficient, passive, knowing—or sometimes all these at the same time. Children can be all angles and awkwardness—and the epitome of grace. Rapt in daydreams, they are frequently creative when they seem to be doing nothing. And when they seem finally to be one thing, they are already on the way to becoming something else. "A glimpse of what a child may become," remarks Melinda Blauvelt, "is more fascinating to me than the most creative costume."

What can the photographer accurately say in a fraction of a second about such a paradoxical subject? As with all photography, it is less a matter of cameras and lenses than of the photographer's attitude. And the photographer's most productive attitude toward children is to let them be themselves. In the beginning of photography, almost 50 years and nobody knows how much photographic emulsion were devoted to portraying children as little men and women *(pages 44-45)* and later as little angels *(pages 46-47)*. The development of modern candid photography coincided with still another perception of children, and examples of that attitude are shown in this chapter. The photographers represented here have portrayed children, as nearly as grownups can, in the children's own world. Some of the subjects were fully conscious of the camera; others were absorbed in quiet play or heated activity. But in every case the photographers have tried to see children as the children see themselves, to respond to them as people in their own right. To capture an image of childhood on these terms requires of the photographer the skill of a craftsman, the eye of an artist, and—most important—all the enlightened insight and best instincts of a friend. □

Putting On an Act

Photographers trying to catch a child in the act of being a child often get caught in the act themselves. Face hidden by the camera and feeling very much the unobserved observer, they suddenly see the child's eye meeting their own through the viewfinder.

But the picture need not be lost simply because the child becomes aware of the camera. Such a confrontation can be turned to the photographer's advantage, as in the classic example at right. Henri Cartier-Bresson, the photographer who encountered the boys, ordinarily makes a fetish of working inconspicuously, concealing his own identity while revealing his subject's. He forbids photographs of himself, partly for fear that his appearance will become as widely known as his name and work and thus make his candid photography more difficult. In this exception to his own rule, he let the children (who did not know him anyway) use his camera, as it were, to reveal themselves as they would like to be seen.

A group of schoolboys are surprised in the act of scribbling on a wall in Montreal. But instead of running away or hiding their faces, they flaunt themselves in poses that proclaim: "Here I am and what are you going to do about it?"

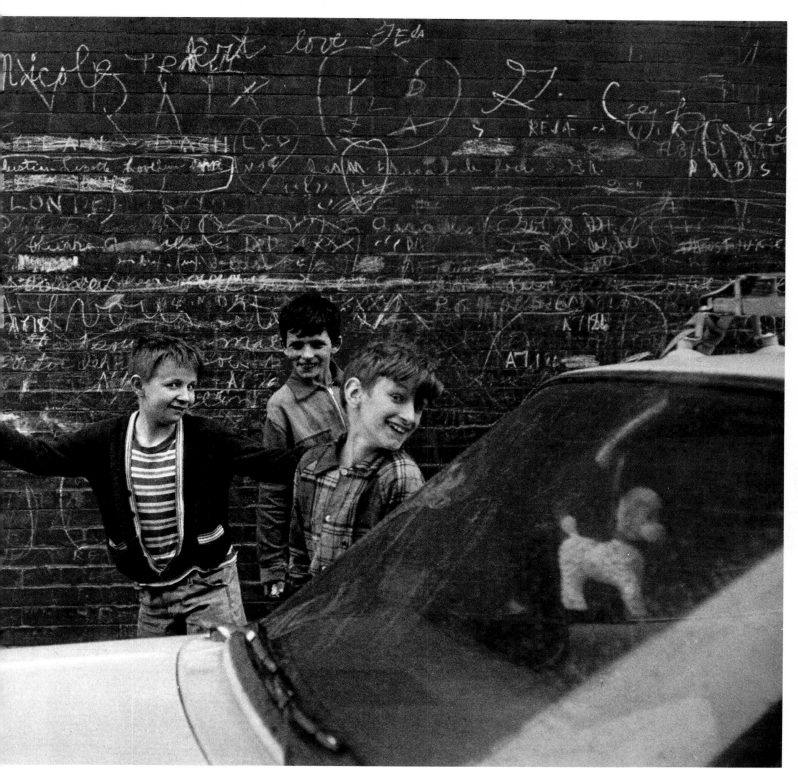

HENRI CARTIER-BRESSON: *Boys with Graffiti,* Montreal, 1955

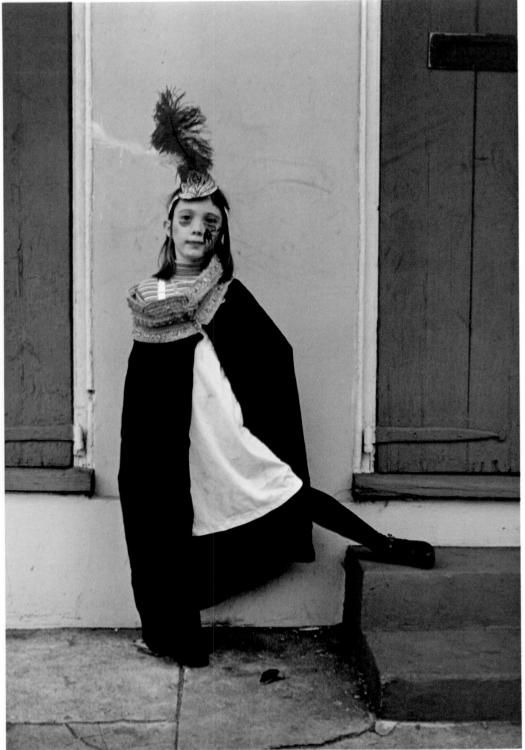

The personal fantasy of this painted and exotically costumed girl in the French Quarter is a microcosm of the city-wide fantasy that grips New Orleans during Mardi Gras. Melinda Blauvelt, who values children as subjects because she finds them "skillful at playing, but inexperienced at deceit," has made a specialty of photographing the rituals associated with urban festivals in the U.S.

MELINDA BLAUVELT: *Young Girl, Mardi Gras, New Orleans,* 1981

A hot summer day in Maryland and a visit to the local swimming pool helped create the relaxed, spontaneous atmosphere that inspired this youngster to ham it up with his burger when the photographer started shooting. John Aikins used a wide-angle lens up close to enhance the deliberately comic effect of his subject's pose.

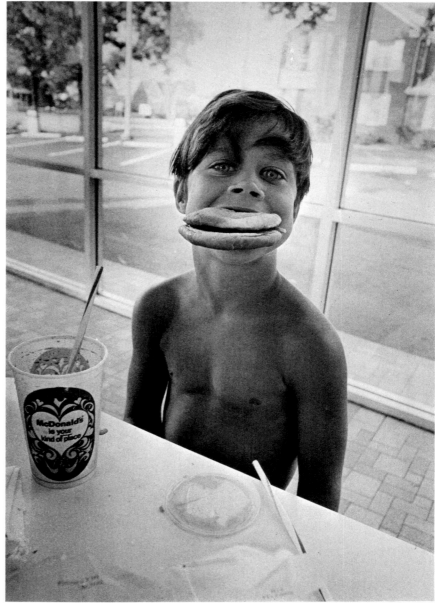

JOHN P. AIKINS: *Hamburger Grin,* 1968

Local children playing in a courtyard in the Mala Strana section of Prague show off their acrobatic prowess for the camera, availing themselves of whatever props the setting provides—including an artificial tree fashioned of ropes. The unrestrained action filling the photograph is in keeping with Dagmar Hochova's credo that "pictures of children should reflect their freedom before the world of adults restricts them."

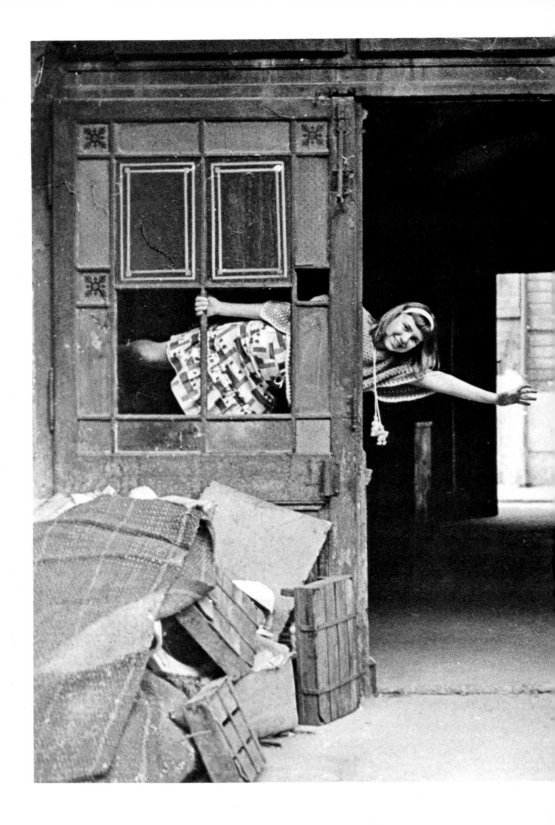

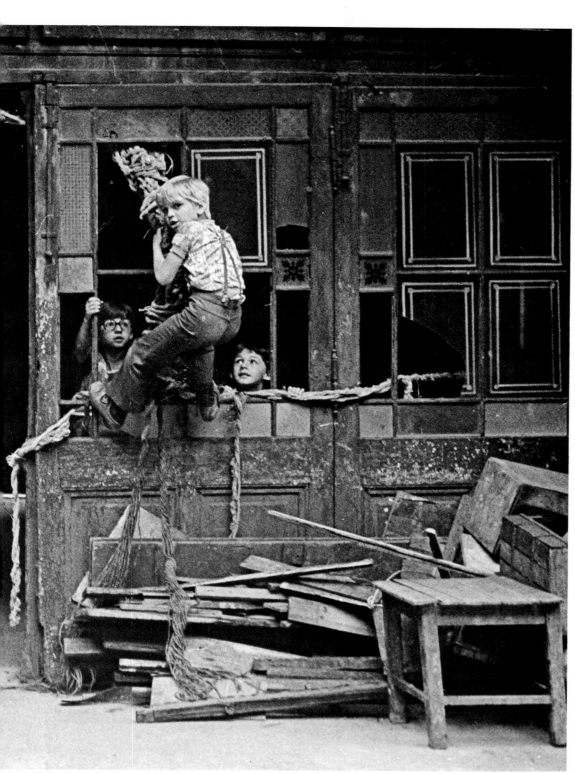

DAGMAR HOCHOVA: *Untitled*, 1981

Decked out as a firefighter for his nursery school's costume party, a young boy opens his coat to display with equal seriousness his shiny boots and the cartoon characters on his sweatshirt. Susie Fitzhugh, concerned that "human drama takes second place to the vibrancy of the hues" in a great deal of color photography, prefers to make children's portraits in black and white.

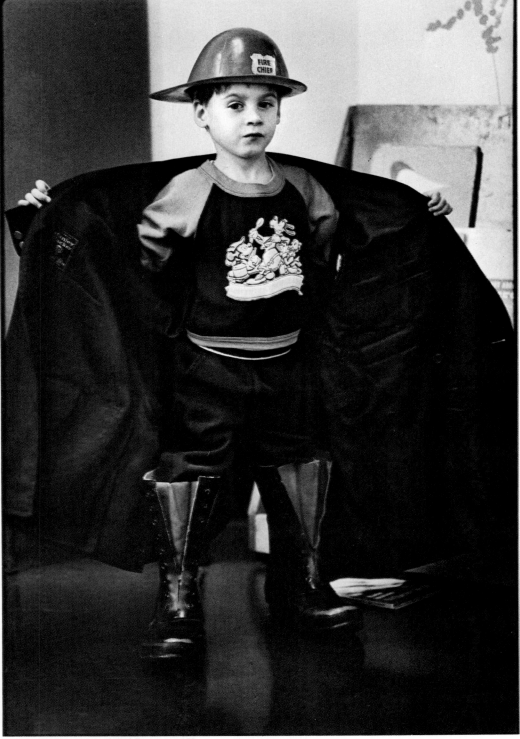

SUSIE FITZHUGH: *Nursery School Dress Up,* 1978

In an unrehearsed response to seeing a camera
lens pointed her way, a Mississippi youngster strikes
a pose that mocks adult glamor photography.
William Eggleston was working on a large group of
scenes along the Mississippi River, not
specifically looking for photographs of children,
when he encountered his lighthearted subject.

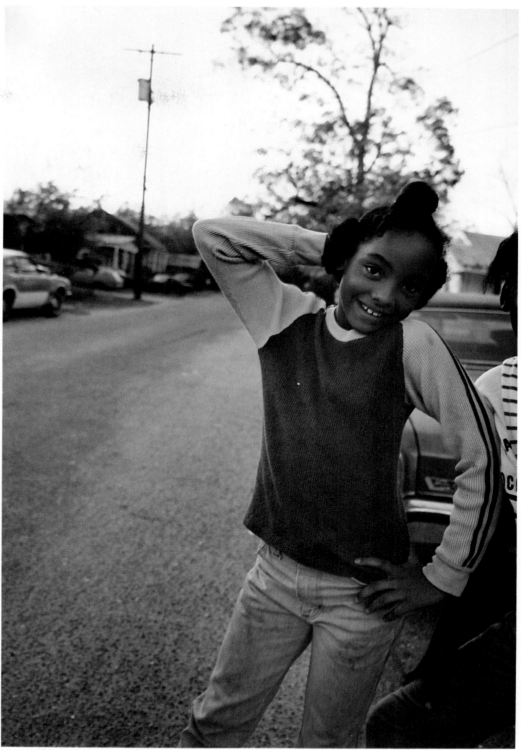

WILLIAM EGGLESTON: *Untitled*, 1981

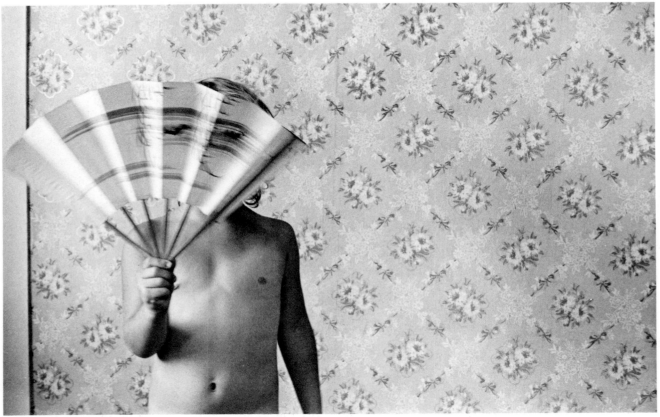

MARCIA LIPPMAN: *Aileen,* 1979

The photographer and her model together concocted this shot in an ideal fantasy environment—an empty old New England house with closets full of hats, fans and other costume items. Marcia Lippman chose the background because the floral wallpaper reminded her of her childhood. But posing with the fan concealing her face, a sophisticated touch that gives the image its surrealistic flavor, was Aileen's idea.

A romping child, although a charming subject, ▶ *can be a frustrating and elusive one. Ken Josephson found a way to keep his normally hard-to-pin-down son Matthew both restrained and preoccupied by photographing him literally wrapped up in the Sunday funnies. Not much of the boy himself is visible, but the paper—its surface already alive with the exaggerated action of the comic strips— crackles with the energy of his entire frame.*

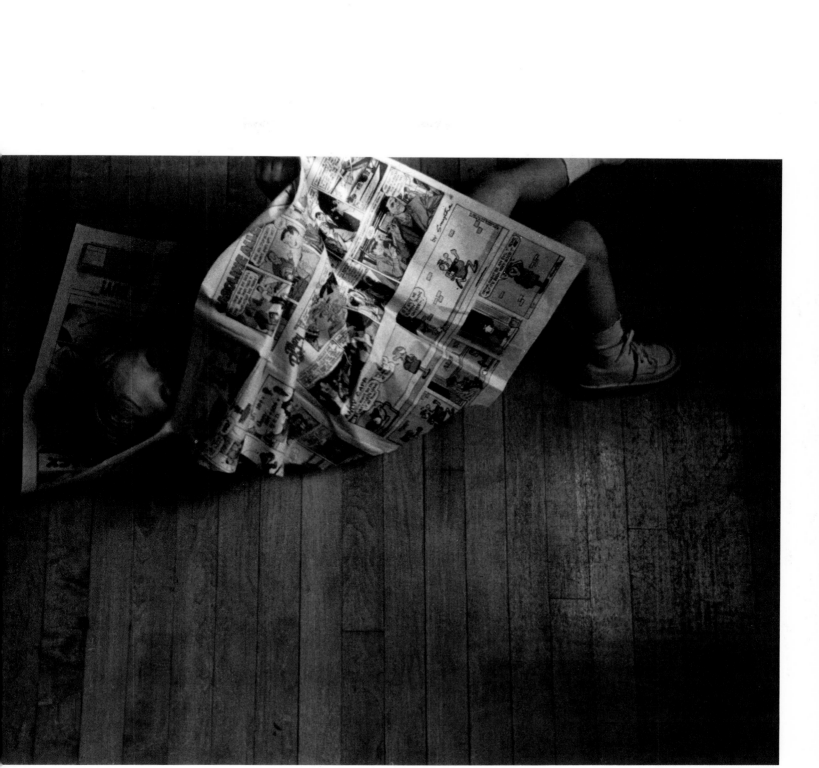

KEN JOSEPHSON: *Matthew, 1965*

Sometimes a child's obstinate determination not
to cooperate with the camera is an effective
deterrent and the photographer gives up. But in
the case of two boys at an outdoor picnic table, Jack
Schrier capitalized on their refusal to pose by
making their antiphotogenic strategies —the face
turned away, the sour mouth and weirdly rolled-
up eyes —the subject of his serio-comic composition.

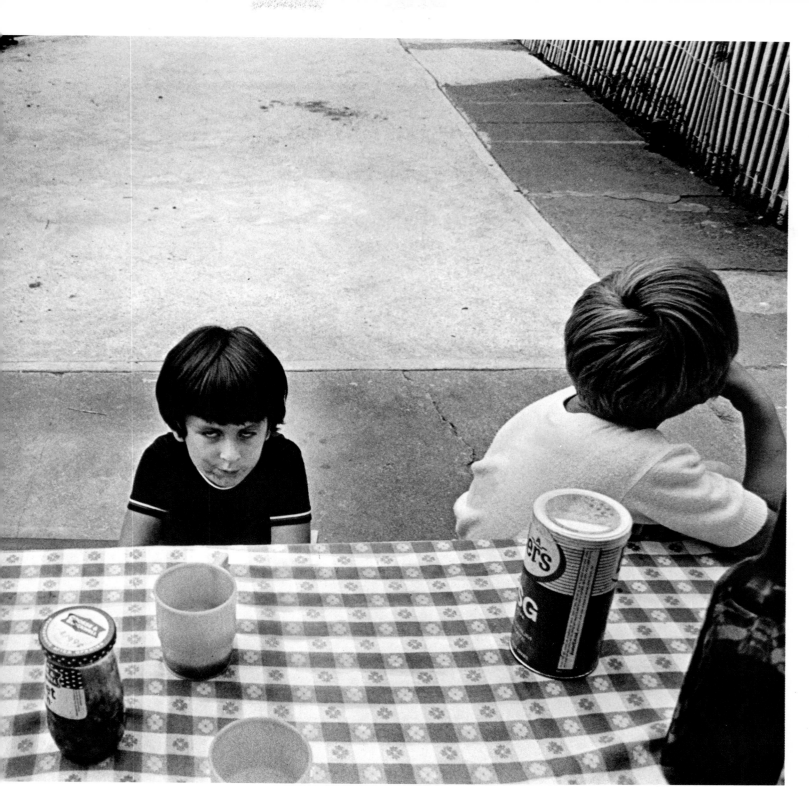

JACK SCHRIER: *Turning Off*, 1970

127

Doing What Comes Naturally

A youngster mugging for the camera can make a beguiling picture, as the previous pages demonstrate; but the more normal state for most children is absorption in some other activity—and that is the way candid photographs are made. Since a healthy child is the closest thing known to a perpetual-motion machine, photographers rarely have long to wait before some form of preoccupation puts children off guard and at their ease, in a situation where they cannot help being themselves. The pictures that result may not be so striking as some of the more self-consciously posed ones, but they are more natural—and often they are more revealing of the child.

Although the photographer may subtly suggest some diversion, the child's own high-powered metabolism and untrammeled imagination will inspire a range of action beyond adult invention, often involving objects that are beneath adult notice. The child can turn scraps of wood and tatters of cloth into the stuff of drama, transform an ordinary chair into a launching pad, or ride a bicycle right out of this world—and into a picture. Even when they seem to be in suspended animation, doing nothing at all, children may be concentrating hardest, daydreaming whole universes into vivid existence and revealing their fantasies for the camera through a rapt expression.

At such moments, when the child is most quiet and his mood seemingly most fragile, the photographer is tempted to retreat to a respectful distance and use a long lens. But in many of the pictures that follow, the photographer has chosen a bolder approach, counting on the child's self-absorption to make possible photography at close range without distraction.

When the youngster is on the run, photographers may find their ingenuity taxed even more. To keep the elusive subject in camera range, they can follow on foot or with the long reach of a telephoto lens. They can choose a shutter speed fast enough to freeze the action completely, or a slower one to allow the blurring that suggests motion. Panning with the subject will blur the background while keeping the subject in clear focus; holding the camera steady will blur the subject and keep the background sharp. Even after he has made such technical determinations to achieve an overall effect, the photographer still must make the most crucial choice of all: that split-second selection of the time during the activity when subject and action coalesce—the magic moment when the movement reveals the child.

From a rooftop overlooking a New York City park Raimondo Borea photographed the children below without calling attention to himself. His high point of view in this telephoto shot also let him silhouette the legs of the boys striding in step—an unconscious affirmation of their comradeship that was copied by the little one following them.

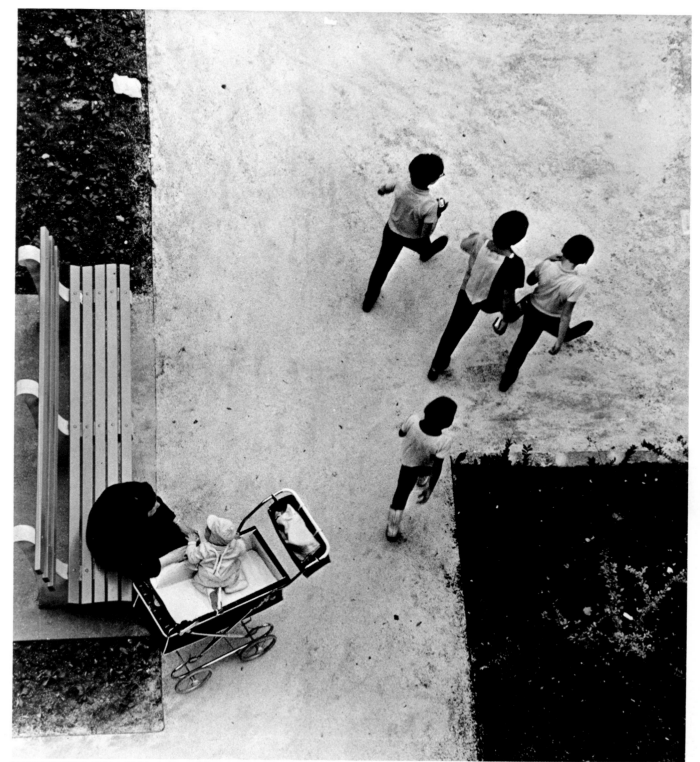

RAIMONDO BOREA: *Children Walking in Step*, 1966

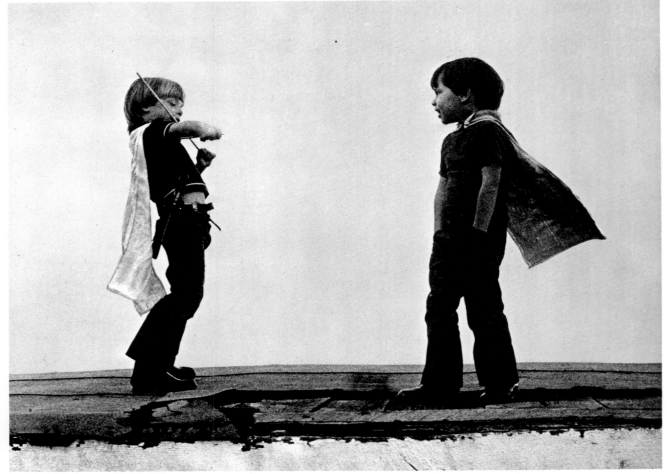

TERRY BISBEE: *Batman and Robin*, 1970

Her sympathy with children's make-believe made Terry Bisbee an accomplice of the pair of juvenile imposters above. Shot from below to isolate them against the sky, the would-be Batman and Robin loom larger than life in the eye of the camera, just as they do in their own minds.

A long day at the pool has wearied two youngsters ▶
playing with Mama's high-heeled shoes. One stands pensively on one leg, a too-large strap limp about her ankle. The other, in shoes and nothing else, sits hugging her knees as if chilled. Alena Vykulilová took the picture at a summer camp south of Prague.

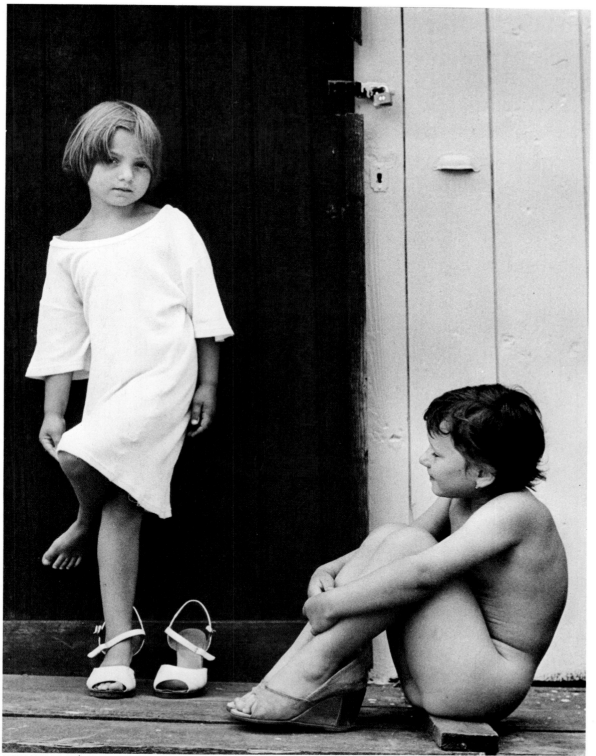

ALENA VYKULILOVÁ: *Mother's Shoes*, 1978

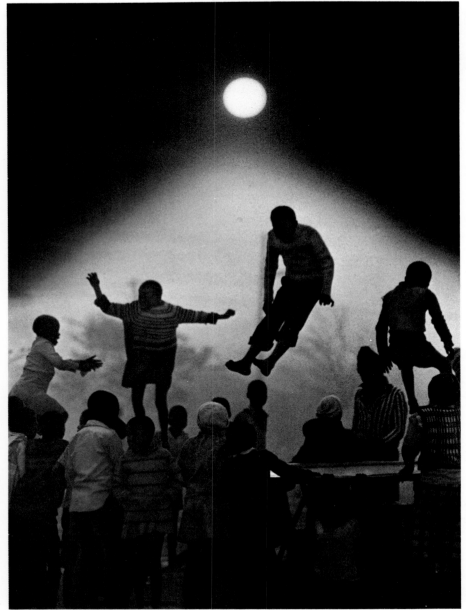

Silhouetted against the hazy smoke of cooking fires in Soweto, a section of Johannesburg, South African children cavorting on a trampoline seem to fly toward the setting sun while the trampoline's owner, in the striped shirt (lower right), collects a few pennies each from his customers. Peter Magubane burned in the sky around the sun in order to heighten the dramatic impact.

PETER MAGUBANE: *Trampoline Jumping*, 1979

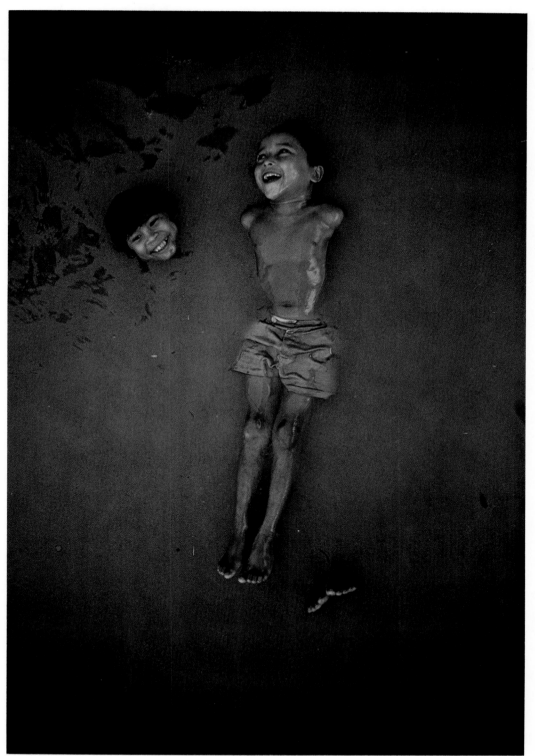

Shooting from directly overhead with a wide-angle lens, Bruno Barbey obtained this view of two Brazilian children enjoying a dip in the Amazon. The dismemberment effect created by the muddy water gives this playful childhood picture a slightly sinister subtext. Barbey prefers to shoot in color because it "renders reality more fully."

BRUNO BARBEY: *Amazon,* 1966

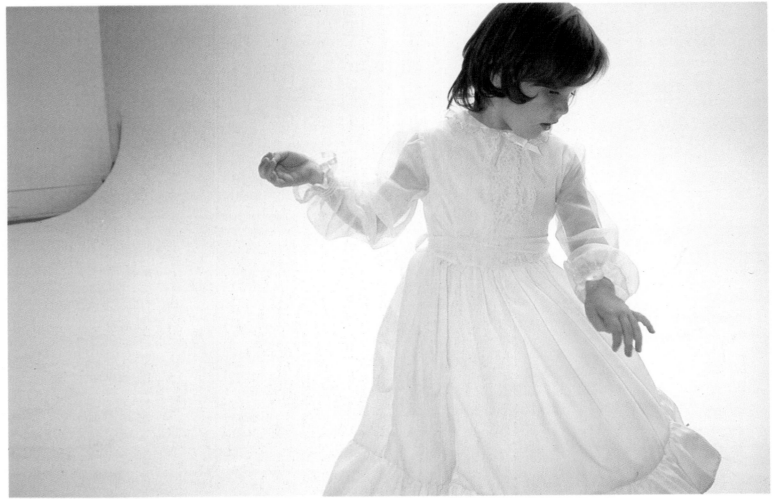

THOMAS IVES: *Briana Dancing,* 1982

Against a white seamless-paper backdrop, a young girl in white improvises a dance of ethereal grace. Thomas Ives captured the delicate, solitary dancer while she was absorbed in a world of her own, oblivious of the noisy adults all around who were celebrating her mother's wedding.

A child with all the poise of a veteran high diver perches on the edge of a chair as if about to take flight —a fantasy that adds action to an otherwise odd still life of chair and melon slice. Melissa Shook calls such portraits of her daughter "obsessive documents, talismans against loss."

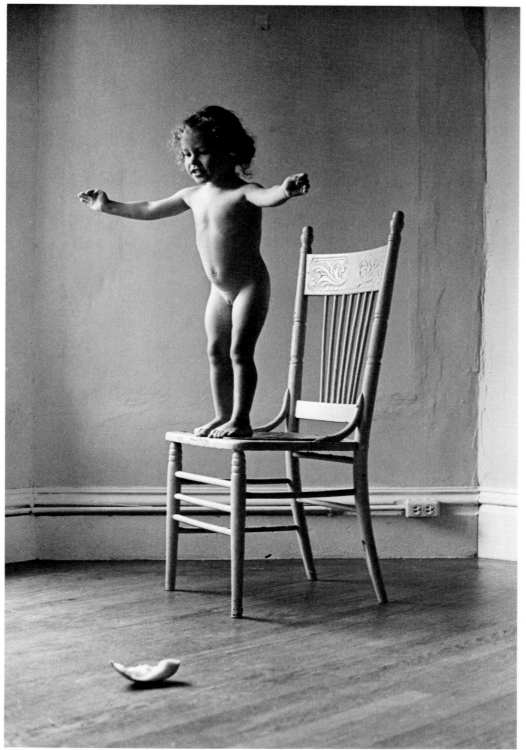

MELISSA SHOOK: *Page Street, San Francisco,* 1967

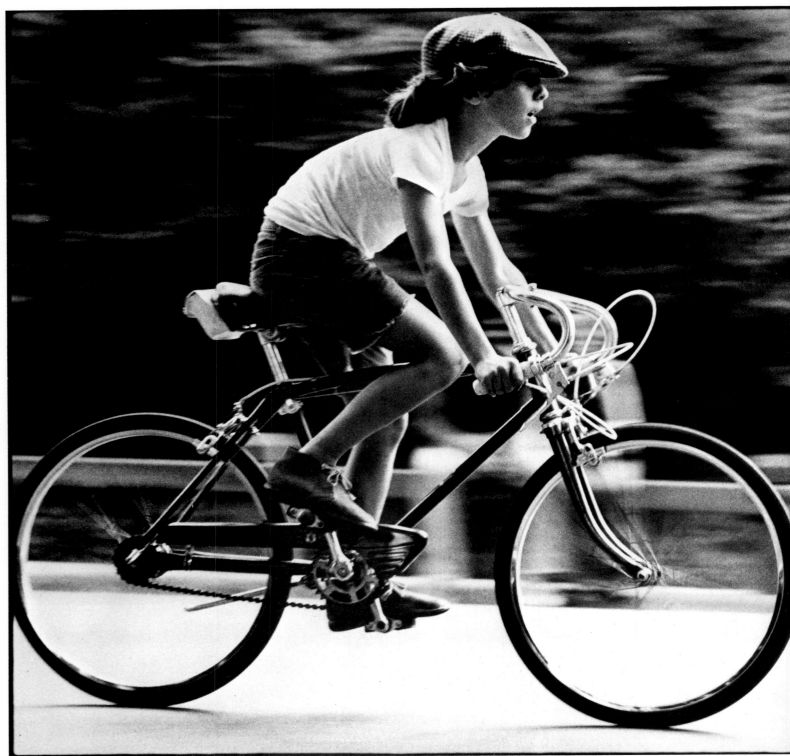

ARMEN KACHATURIAN: *Boy on a Bike,* 1970

The Boundless Energy of Childhood

The blurred background (the result of shooting at a slow shutter speed while panning to keep the subject in focus) says the bike is going fast. The forward pitch of the boy's taut body and his straight-ahead look say he is too intent on driving and on the road ahead to be camera-conscious.

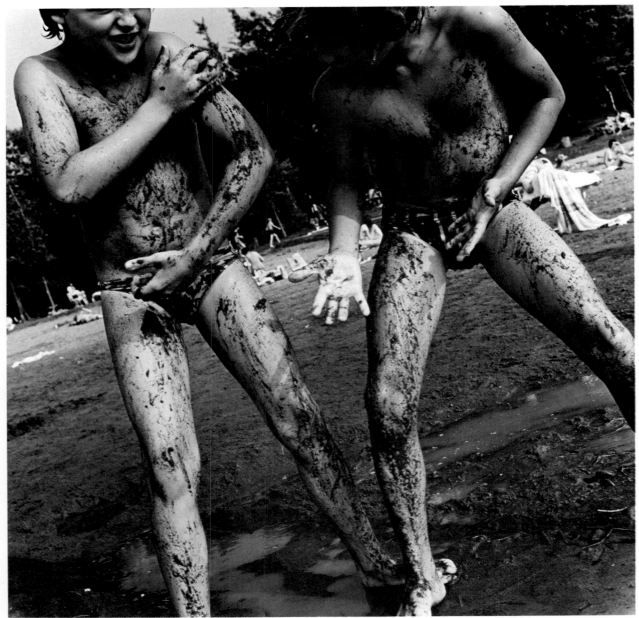

TAMARRA KAIDA: *Kris and Kroun Age 10 and 11, 1979*

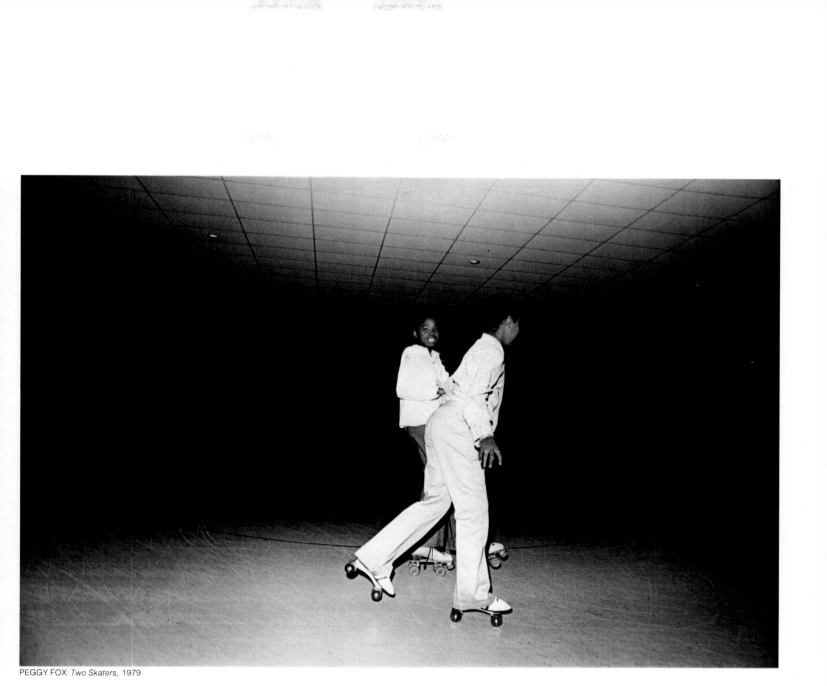

PEGGY FOX: *Two Skaters,* 1979

◄ *Two friends who have just enjoyed a swim together savor the gooey sensation of splashing themselves with mud. The use of black-and-white film creates some ambiguity about the dark streaks and smears on their bodies — the resemblance to blood, Tamarra Kaida says, hints at the danger that lurks at the edge of childish fun.*

The photographer's flash obliterates the other skaters at an all-night rink, isolating these two smooth rollers in an eerie void between floor and ceiling. Although one of the boys has glanced at the camera, the pair are skating purely for themselves, enjoying the night and their own graceful movement.

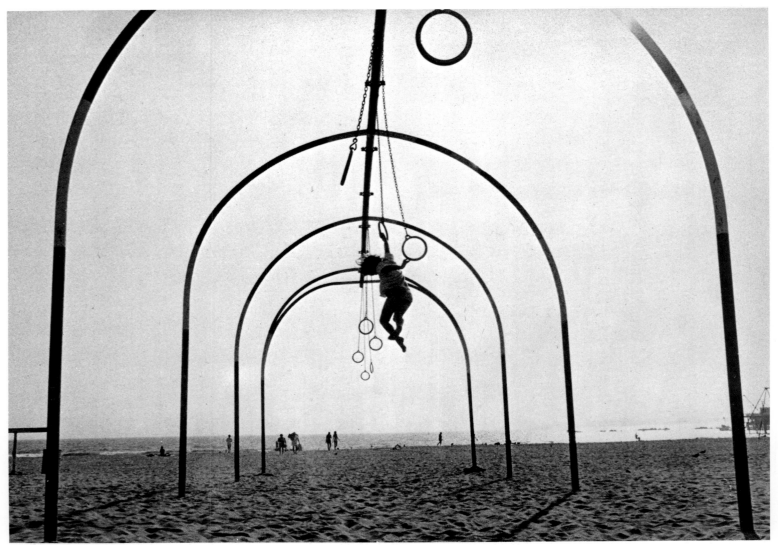

RON MESAROS: *Muscle Beach*, 1968

Children often show off their physical prowess. In this picture of a girl engrossed in gymnastics on a California beach, Ron Mesaros shot to exaggerate the size of the arcade and make the figure appear small as a doll, suggesting a childhood ritual in a monumental setting.

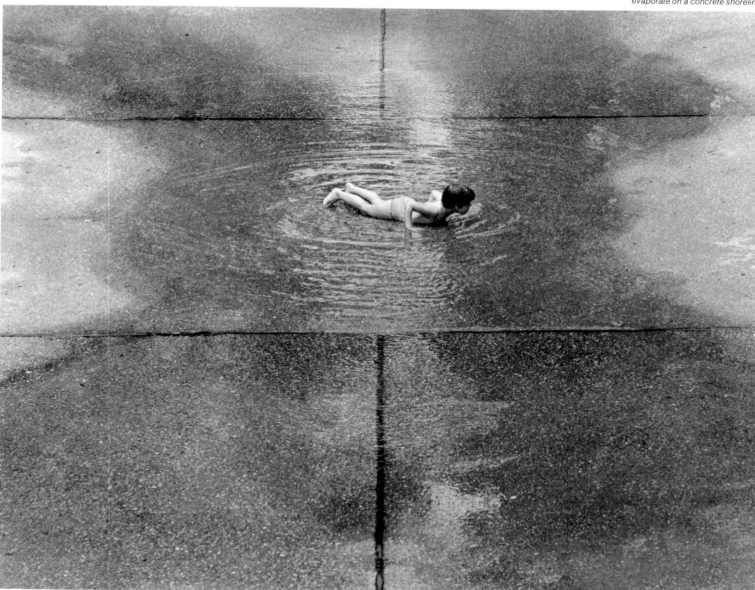

A long-focal-length lens and an overlooking terrace allowed Raimondo Borea to zero in on this child pretending to swim in a puddle. Only the texture of the pavement suggests the urban setting of this shallow pool, where concentric ripples evaporate on a concrete shoreline.

RAIMONDO BOREA: *Child Lying in Water,* 1968

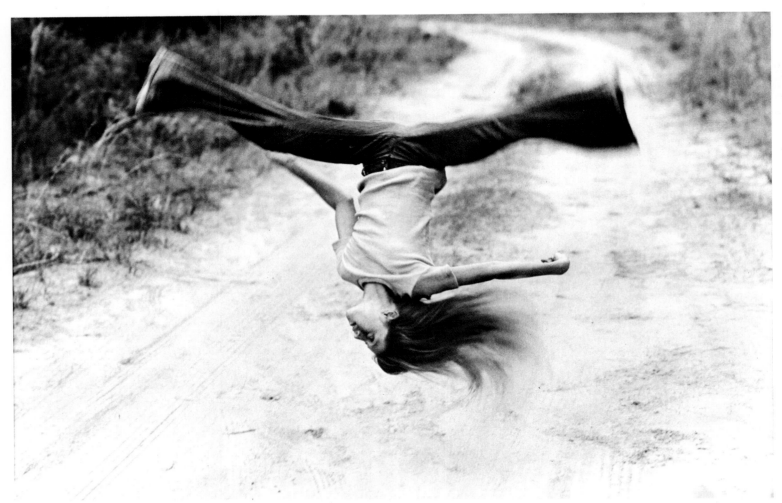

SUSIE FITZHUGH: *Payson's Leap*, 1974

"I am myself most relaxed when with children, so it's easier for them to relax as well," Susie Fitzhugh says of her preference for younger portrait subjects. This 13-year-old star gymnast, on vacation and clad in jeans rather than her usual leotard, demonstrated her skill by turning repeated aerial somersaults while the photographer crouched atop a car, shooting from an angle that heightens the gravity-defying look of the girl's feat.

Portrait of the Child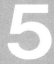

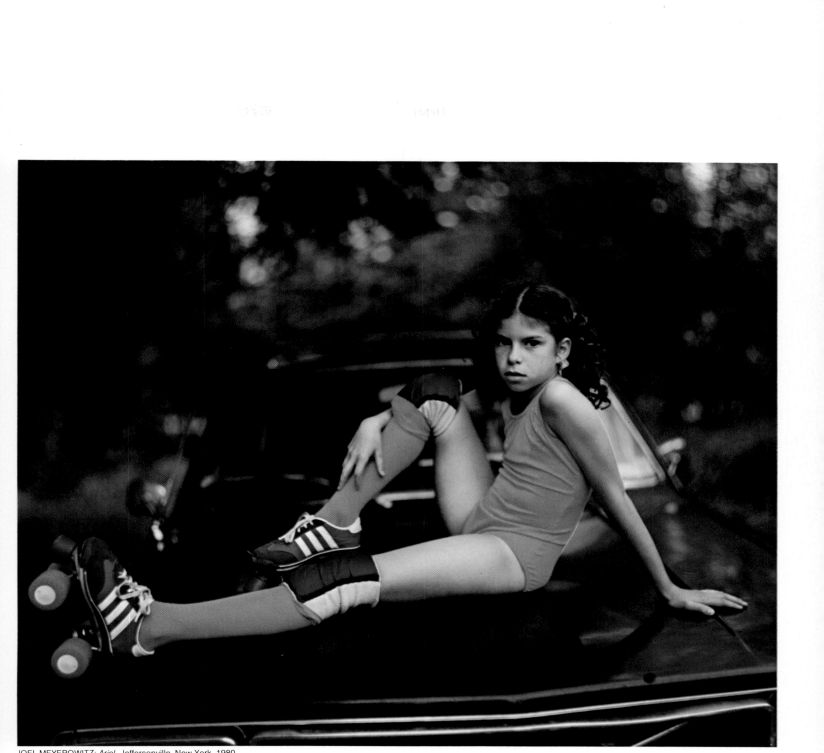

JOEL MEYEROWITZ: *Ariel*, Jeffersonville, New York, 1980

Revealing the Signs of Character and Mood

It is almost a truism that children are frequently photographed but seldom portrayed. Millions of snapshots attest to the parental proclivity for preserving a record of their offspring's childhood. Yet few of these family-album photographs do more than catch a glimpse of the child in a moment of time; what the child was really like at that time is still left to memory.

The true portrait must also catch that evanescent element that reveals the child as well as the moment. The feat does not depend alone upon focus or exposure setting, on lens or lighting. The actual photograph might show a little girl's face or the back of her head. It might be a literal likeness or an ideal one. It can set a small boy against a complex backdrop or spotlight him starkly in a void. It may catch him unaware or record a histrionic performance. And the depiction of character may be plain and clear or elusive and puzzling — but it must be there.

By definition, portraits should tell something more about their subjects than that they were young at the time. On canvas and on film, for five centuries and through countless changes of style and emphasis, proper portraits of children have made them instantly recognizable as the young individuals they were. But the best portraits have provided an added insight into a child's special nature — an insight that, because human traits are universal, is perceptible even when the child is unknown to the viewer. If, beyond all this, a photograph has a pictorial quality that makes it a work of art, the photographer has achieved the potraitist's highest ambition.

Portrait photographers start with an advantage when their subject is a child. And it is, oddly, a comparatively recent advantage. The English critic John Ruskin observed in the 19th Century: "The singular defect of Greek art is its absence of children." It took the world of Western sculpture and painting some 16 centuries to remedy the defect. Photographers were not so tardy; the camera was no sooner invented than it was trained on children. In one respect the photographers have had an easier time of it, since the camera is quicker than the chisel or the brush and need not tax the patience of a small and energetic model. (In fact, Norman Rockwell frequently used a camera on his young models and worked from their photographs to produce his famous paintings of effervescent American youth.) The childish haste of a young Parisian schoolgirl *(page 163)* and the fleeting expressions of a group of young boys at a fair *(page 180)* could only have been recorded by the camera's lightning reflexes.

The sheer volume of photographic child portraiture is impressive. Professional portrait photographers estimate that half of their sitters are children, whose parents have them photographed several times in infancy and once a year thereafter until they reach their teens — while the parents themselves have their portraits taken once a decade or less. The average camera-carrying parent probably uses more than half of his film for pictures of his children.

There are good reasons why this is so, apart from parental pride or even the desire to record each fast-vanishing stage of youth. Children simply make fascinating portraits, because they are so spontaneous, so curious, so unfettered in their emotions and in the play of their imaginations.

The good portrait requires a combination of skill and luck. Good portrait photographers may have an image in their mind's eye, but that image often changes according to the response they get from their model. Response and image may be as casual and impromptu as Joel Meyerowitz' pig-tailed girl with roller skates, on the preceding page, or as planned as Robert Mapplethorpe's formal portrait of a young pianist on the next page. Meyerowitz snapped his daughter Ariel sprawled on the hood of the family car after her frustrated attempts to skate on the grassy lawn of their vacation farmhouse. The Mapplethorpe picture is at the other extreme — carefully composed and posed to bring out the serious demeanor of a young musician.

Neither picture is that cliché, the "flattering" portrait, for this chapter generally seeks to avoid the obvious in favor of some more revealing, not-so-obvious ways of portraiture. The photographers whose work appears on the following pages have used all the tools at their command, from infrared film to wide-angle lenses, in order to respond to an elemental challenge: Children, in all their unending variety of character and impulse and mood, deserve portrait photography at its best. □

The Direct View

One way to make a portrait of a child is the direct way, placing the child in front of the camera and taking the photograph head on. But a revealing portrait requires the photographer to do more than that, as the pictures in this chapter show.

Props, pose and costume are often appropriate in the portraiture of children, because many children use props and costume casually and imaginatively in their everyday lives. The careful setting of these elements against a planned background can be used to convey the character and mood of the young subject. In this spirit, Robert Mapplethorpe used special costuming, props and posing to make his perceptive portrait of an art dealer's musical daughter *(far right)*.

But most of the photographs shown on these pages are the simple, direct and unadorned views that come naturally to children. Tamarra Kaida, whose work appears at right and several other times in this book, tends to use minimal background and props, shooting her subjects in poses that are as straightforward as snapshots. Fascinated by children and their behavior, Kaida finds that her portraits reveal as much about her own feelings of growing up as about the children themselves. Yet, Kaida says, "As much as I understand them, I cannot join them. Time and experience separate us."

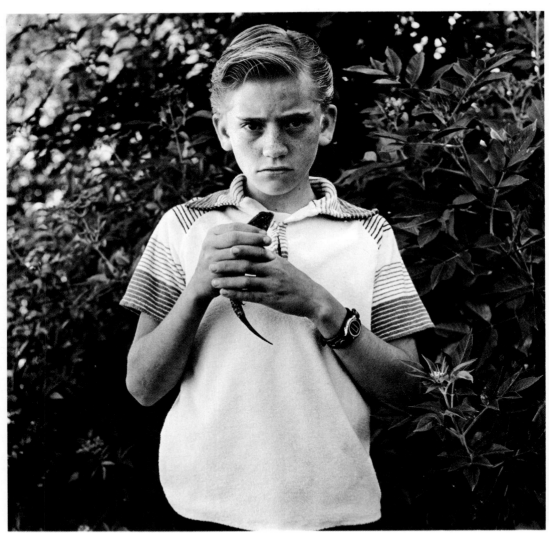

TAMARRA KAIDA: *Glen and Lizard,* 1980

A boy holding a lizard frowns into the camera, his eyes focused less on the photographer than on his own inner world. According to Tamarra Kaida, who took this picture of her beetle-browed young neighbor one morning before he left for school, the boy seemed a withdrawn, unhappy child—characteristics eloquently reflected in this portrait.

Her hands resting on the keyboard as if in mid-chord, a young pianist gazes gravely out at the world in a portrait commissioned by her father. Sarabelle told Robert Mapplethorpe that her father wanted her to pose at the piano, but she decided what dress to wear for the session. "She is a very composed little girl," Mapplethorpe says. It certainly shows. ▶

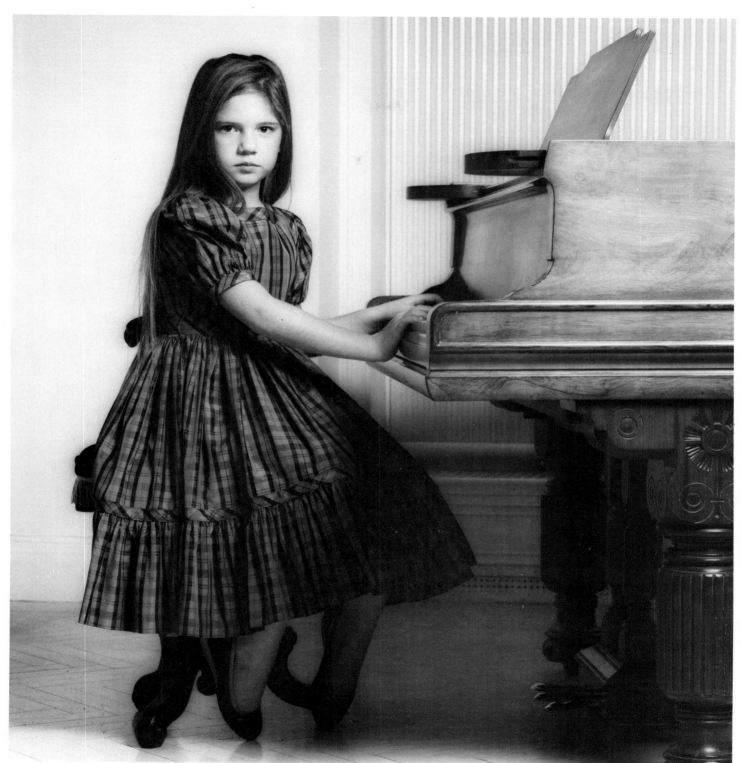

ROBERT MAPPLETHORPE: *Sarabelle*, 1981

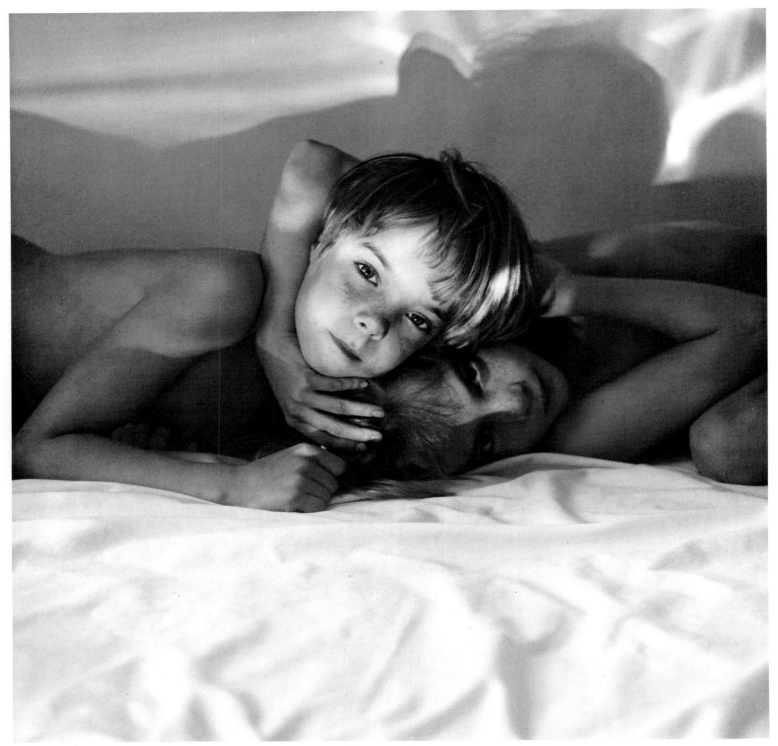

FRANCES MURRAY: *Twins: Star and Rebecca*, 1980

◀ Taken by the girls' mother, this double portrait of twin sisters emphasizes the differences in character and temperament that even identical twins often exhibit. The girls gaze into the camera with equal intensity; but the one whose face is more brightly lighted seems to challenge the viewer, while the other — her arm around her sister's neck and her face obscured by shadow — seems rather shy.

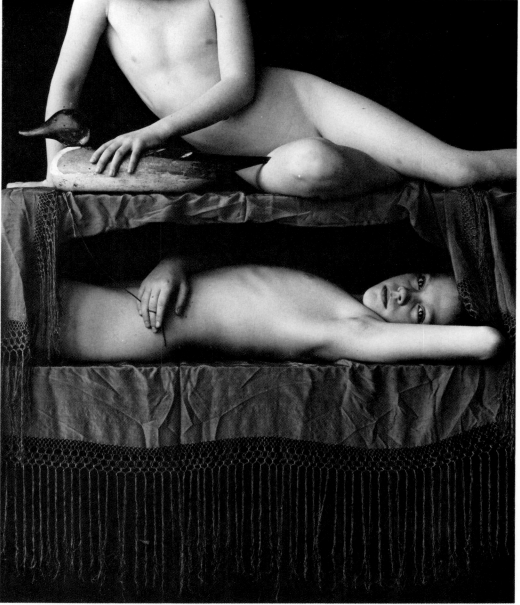

A different pair of sisters, a different emphasis: Here only one face is shown, and the photographer's intent is less to delineate character than to celebrate the glowing beauty of young bodies. The unbending nature of the wooden duck and the narrow wooden shelves contrasts with the girls' soft contours, their youth with the old-fashioned, Victorian air of the fringed draperies.

MARSHA BURNS: *From the Stacked Nude Series,* 1976

A seven-year-old boy draped in a man's shirt directs a startled glance at the camera in this striking portrait of a delicate child. The boy's features are perfectly framed by the dark plush wing chair, a prop the photographer decided best suited his model.

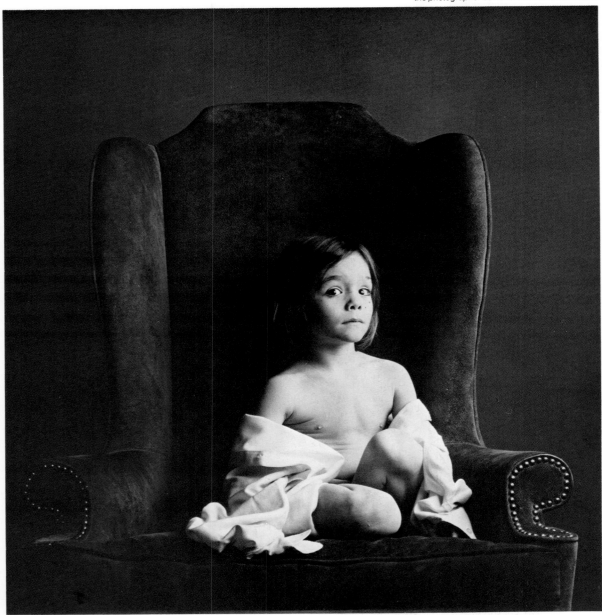

LAWRENCE ROBINS: *Portrait of Monte,* 1974

With the nonconformity of early adolescence, a 12-year-old boy faces the camera upside down and unbuttoned to the waist. Kroun himself dictated the pose and costume, but the photographer's lighting enhanced the moody, sensuous effect.

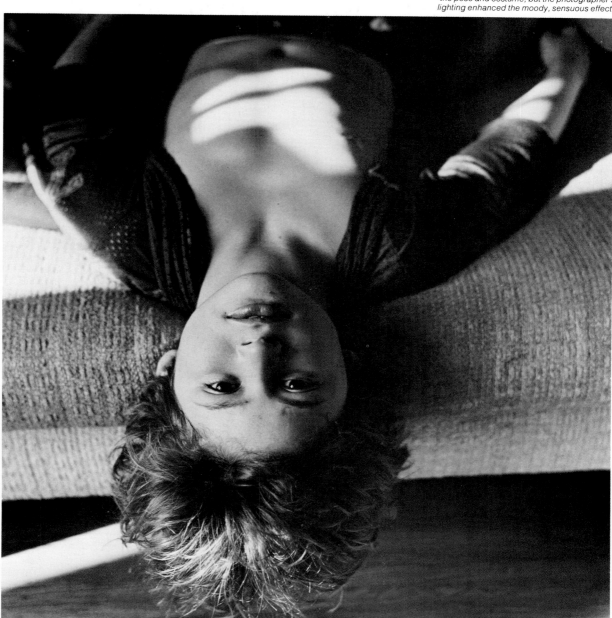

TAMARRA KAIDA: *Kroun,* 1979

Portrait of the Child: The Direct View

In one of the classic poses of the female nude, the photographer's 11-year-old daughter faces the camera with the poise of a practiced model, her calm-eyed, adult expression contrasting with the spare lines of her still-childish body. The picture is from a series of portraits of his daughters that Johnny Alterman made between 1976 and 1980; another from the series appears on page 164.

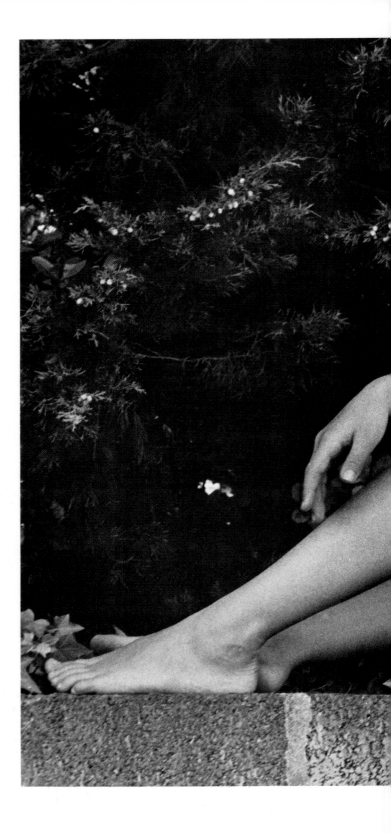

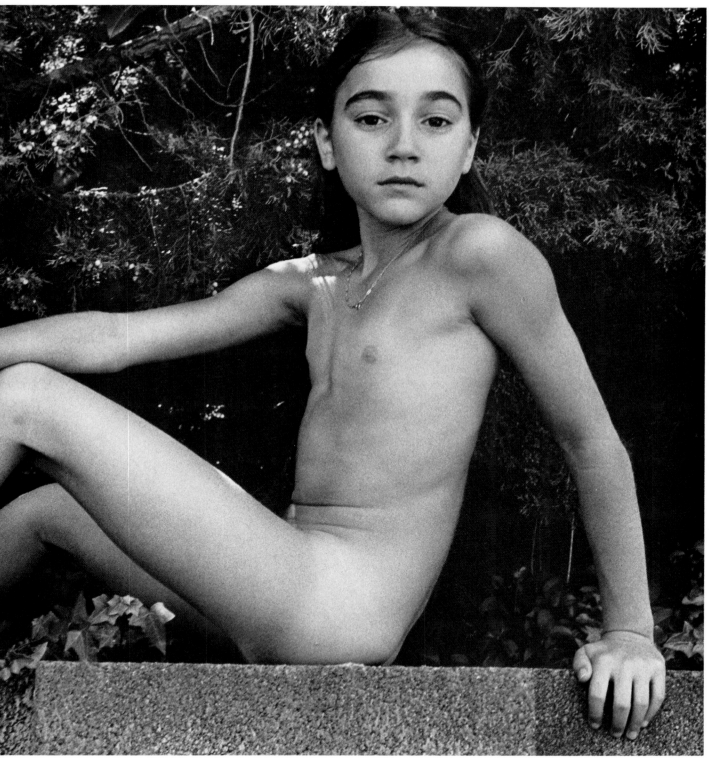

JOHNNY ALTERMAN: *Child of Dignified Bearing*, 1979

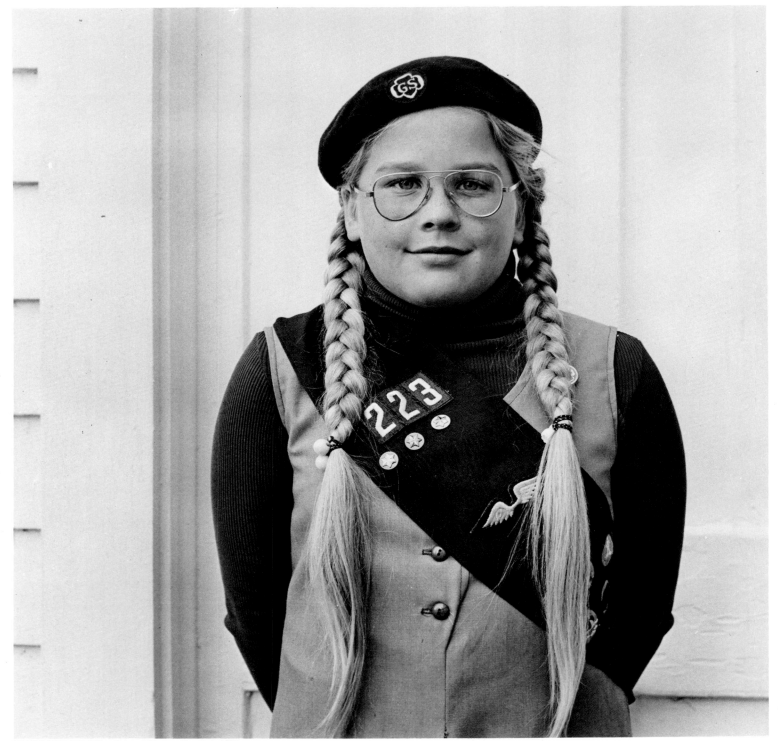

MARK GOODMAN: *Willow Pulver, Millerton, New York, 1974*

156

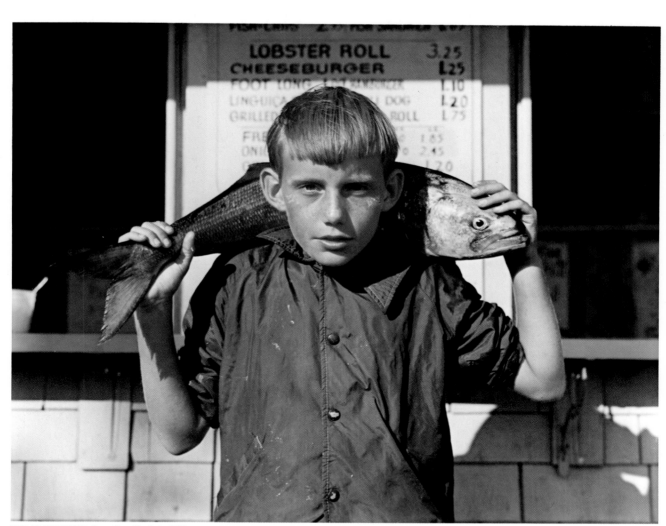

JOEL MEYEROWITZ: *Boy with a Bluefish*, 1980

◄ A small-town girl with glasses and heavy braids stands proudly in her Girl Scout uniform. The straight-ahead portrait, taken in front of the girl's white-painted clapboard house, transcends both caricature and impersonal document, revealing one child's life—and her sense of her own worth.

The red-haired boy in a blue jacket was photographed just as Joel Meyerowitz came upon him—carrying a fish slung behind his neck "like a baseball bat." Though taken by a professional with an 8 x 10 view camera, the image has the candid look of an amateur's point-and-shoot snapshot.

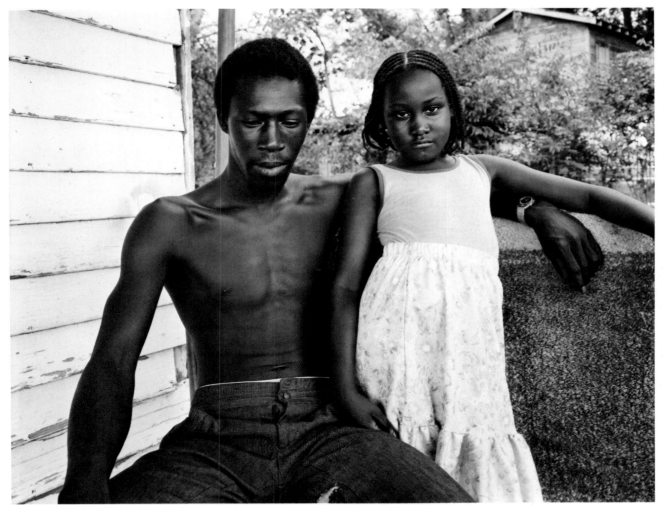

NICK NIXON: *Yazoo City, Mississippi, 1979*

In a small Mississippi town, a young girl and her uncle react quite differently to the camera of a stranger from the North. Neither of them smiles; but while her uncle looks down and away, mistrusting the venture, the girl relaxes in his arm and looks straight at the viewer, her caution leavened with curiosity and childish bravado.

In this dual portrait of the winners of a mother-daughter beauty contest, the mother's pose—both manicured hands cupping her hips—is tense and stylized, and her wide, fixed smile seems weary. The daughter, in contrast, is casual and at ease, eyeing the photographer with a slightly cocky grin that reflects the insouciance of youth. ▶

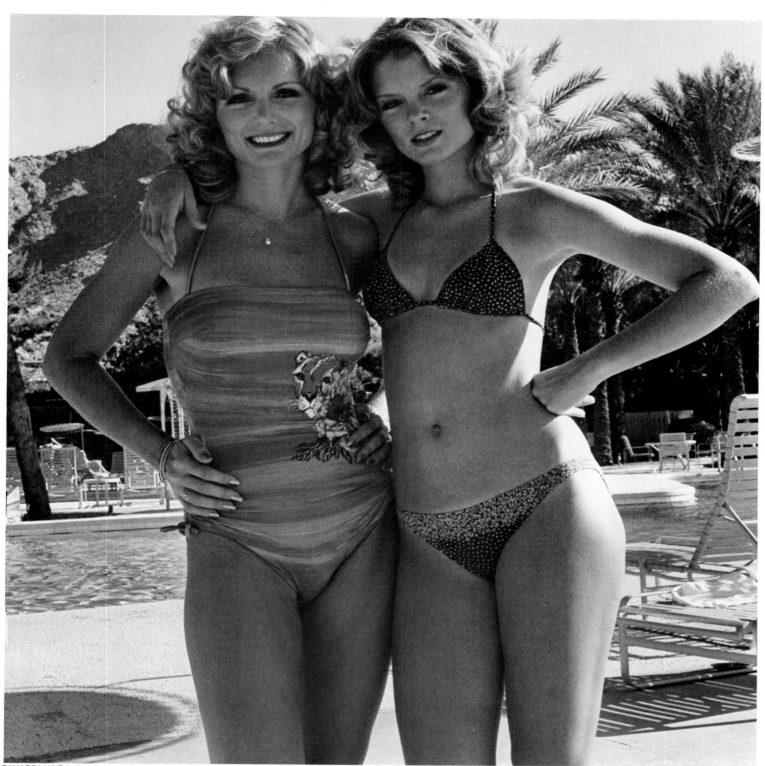

TAMARRA KAIDA: *Winners of the National Mother and Daughter Beauty Pageant, 1980*

The Unexpected View

Walk down a street several yards behind a little boy you know, and you will be able to tell who he is even if he never turns in your direction. Not only will the contours of his head, shoulders, torso and limbs be distinctive and familiar, but so will his gait, his stance if he halts, the cant of his head, the movements of his hands and arms.

Such facts have a direct application to portraiture, for the observant photographer can make fascinating portraits by recording the varied traits and gestures that bespeak—as tellingly as the face and its expression do—the uniqueness of the child. Far more than adults, children make such indirect portraiture easy to do, for much of the time children are altogether unselfconscious, and even when they ham for the camera they exhibit a distinctive combination of worldliness and innocence that makes interesting and endearing pictures.

Gently or boldly, the photographs of children that follow challenge the conventional definition of the portrait. In their use of postures and expressions, possessions and settings, they are not at all what the portraitist traditionally has assumed a portrait should be. Yet they are true portraits all the same, inasmuch as they make significant statements about the nature of their subjects. Such is certainly the case in the picture at right, the portrait of a reflective little girl whose father came upon her at the beach. Whether she is contemplating the water, happily examining the reeds she has found or having a good cry over some mishap of childhood, the viewer cannot know. But certainly she is a person absorbed in her own important thoughts.

The photographer and his family were visiting a friend in the country when he saw his five-year-old daughter communing with herself, and he aimed his camera without her knowing it. To those who know her, the child is instantly recognizable by the tilt of her head, her pigtails, the shape of her body and the placement of her small feet. But even to those who do not, she has lent herself to a charming portrait of childish contemplation.

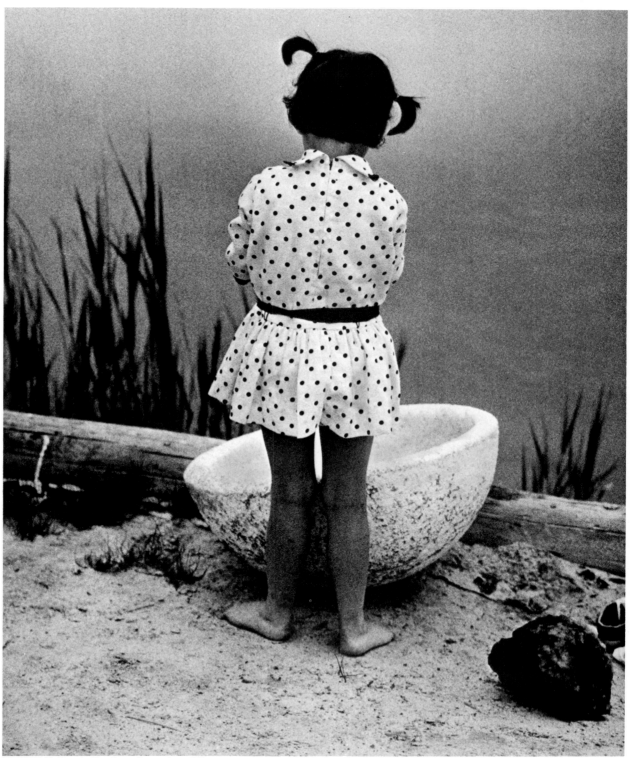

ERNST HAAS: *Victoria*, Woodbury, Connecticut, 1969

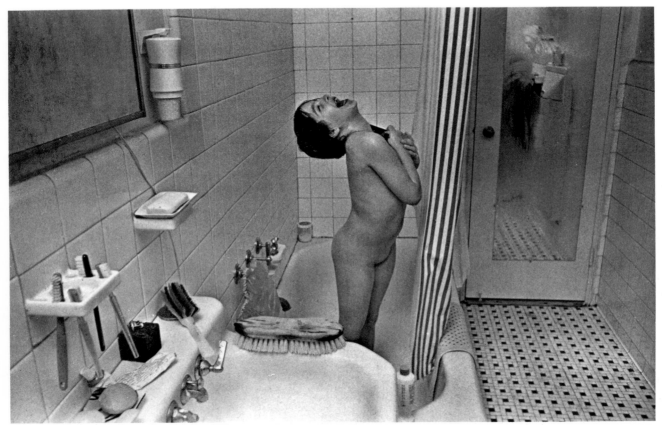

ARTHUR FREED: *Erin in the Shower,* New York City, 1970

*The simple pleasure of a bedtime shower evoked
this demonstration of sheer delight in the
photographer's nine-year-old daughter. To get
sharpness of detail he stopped down his lens and
used an electronic flash, bounced off the ceiling,
to provide sufficient light for the small aperture.*

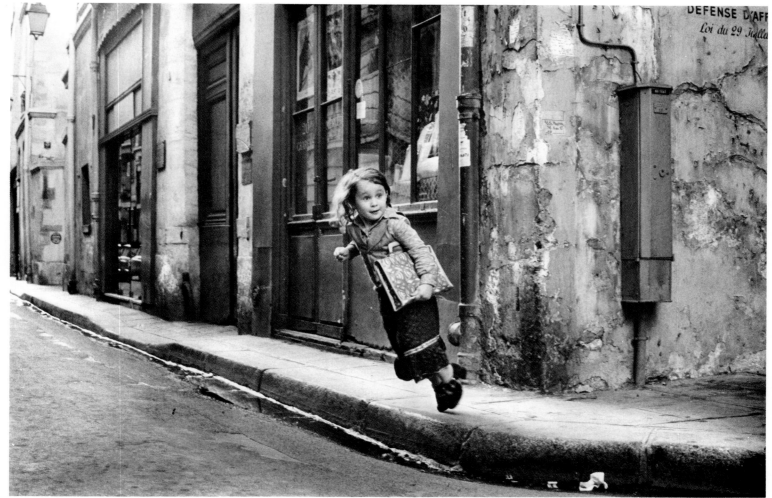

VALERIE CLÉMENT: *Late Again*, 1976

A very young lady of Paris clutches her book satchel
and glances belatedly for oncoming traffic as she
virtually flies off the curb. Valérie Clément made this
portrait of a friend's daughter for a photo essay
on French children who are always late for school.

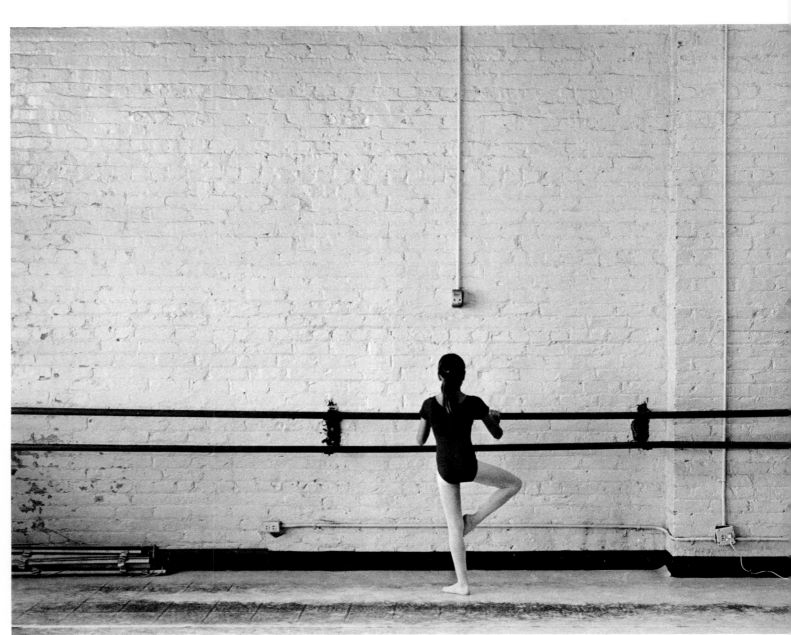

JOHNNY ALTERMAN: *At Barre,* 1979

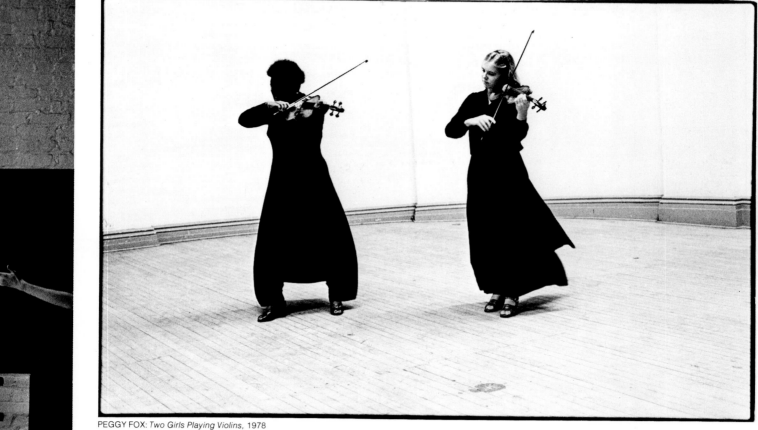

PEGGY FOX: *Two Girls Playing Violins,* 1978

◄ *Even with her back to the camera, a young ballerina radiates concentration as she executes a step at the barre. At first glance she appears to be alone in the stark classroom, but from the right comes the gesturing arm and hand of an instructor – introducing an unexpected note into an otherwise straightforward image of youthful dedication to art.*

Youthful intensity is again the theme in this portrait of a pair of student violinists dressed in billowing black and lost in the music they are creating. The girls at first merely posed for the camera; but once they began to play, says photographer Peggy Fox, they "seemed to forget I was there." Only then did Fox snap the picture.

The vibrant hues of the fairground and the delight
of children in playing make-believe are combined in
this picture of a towheaded boy in a clown mask.
The image — one of a series taken at Midwestern
fairs — is a 27 x 27-inch gum-bichromate print
for which Stephen Livick made his own emulsions.

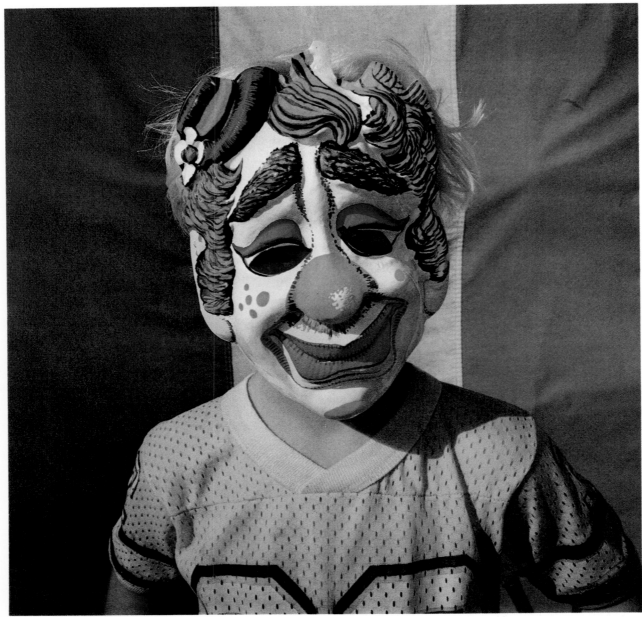

STEPHEN LIVICK: *Coshocton, Ohio,* 1980

A half-grown girl, still young enough to enjoy
a sprinkler shower on a hot day, epitomizes the
childhood pleasures of summer. The brightly
colored photograph would not have the same impact
in black and white—if only because the small
rainbow at center would blend into shades of gray.

STEPHEN SCHEER: *Summer Rainbow*, 1980

DUANE POWELL: *Cameron*, Carbondale, Illinois, 1981

Duane Powell used infrared film and a 20mm lens to create this otherworldly portrait of his son Cameron brandishing a pair of toy pistols. The film gives the boy's skin an eerie pallor that emphasizes his dark eyes, and the fisheye lens seems to pull one gun virtually into the viewer's face.

MELISSA SHOOK: *Krissy,* 1972

On a rocky beach in Nova Scotia, Krissy stretches out to sunbathe. The dark glasses give her a womanly air, but the solicitous way she has covered her doll with a towel reveals the little girl who still enjoys playing the games of childhood.

JOHNNY ALTERMAN: *Girl Descending Vertical Walkway*, 1982

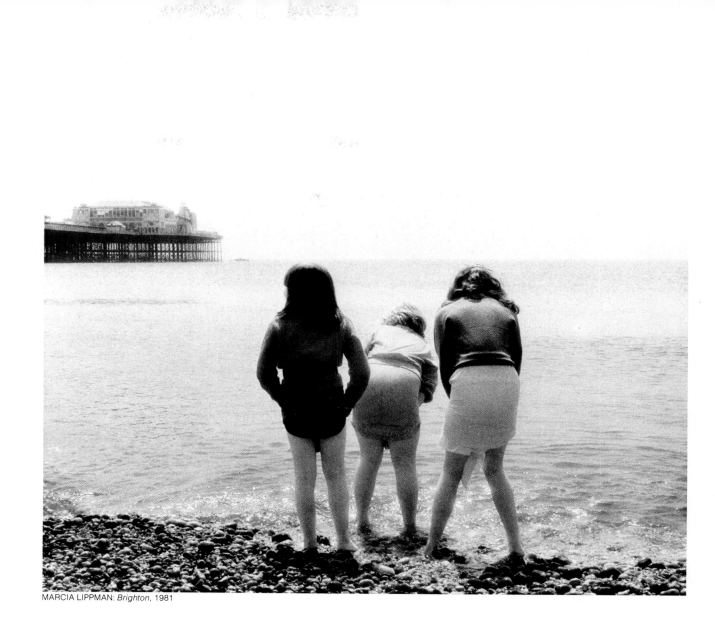

MARCIA LIPPMAN: *Brighton*, 1981

◀ A massive stone staircase and thick,
encroaching ivy seem to be the focus of this somber
photograph—until a solemn-faced little girl is
noticed in the center. The camera has stopped her
in her descent just as she reached a wide
supporting column, so that her small torso seems
to emerge directly from the stone.

On a chilly spring day, three English
schoolgirls—one gazing off toward a deserted
amusement pier—gingerly wet their feet in the
calm waters at Brighton Beach. Though the water is
only a few inches deep, the girls hike up their
skirts as if expecting a tidal wave. Infrared film gives
the image its dreamlike—and universal—quality.

MARSHA BURNS: *Nude with Spiral Parasol,* 1981

In this poetic seminude study, an adolescent girl stands in a shaft of sunlight with an open parasol at her feet and a dreamy, half-awake expression on her face. Both the kimono tied artfully at her waist and the slightly awkward angle of her arm emphasize her budding sexuality by first revealing it—and then shyly concealing it.

While one little girl plays delightedly with ▶ something on the floor, another stands with her back to the camera, apparently gazing out the window. Elisabeth Wackman faced directly into the sun when she shot this charming vignette of childish self-absorption, using the added light to enhance the softening effect of infrared film.

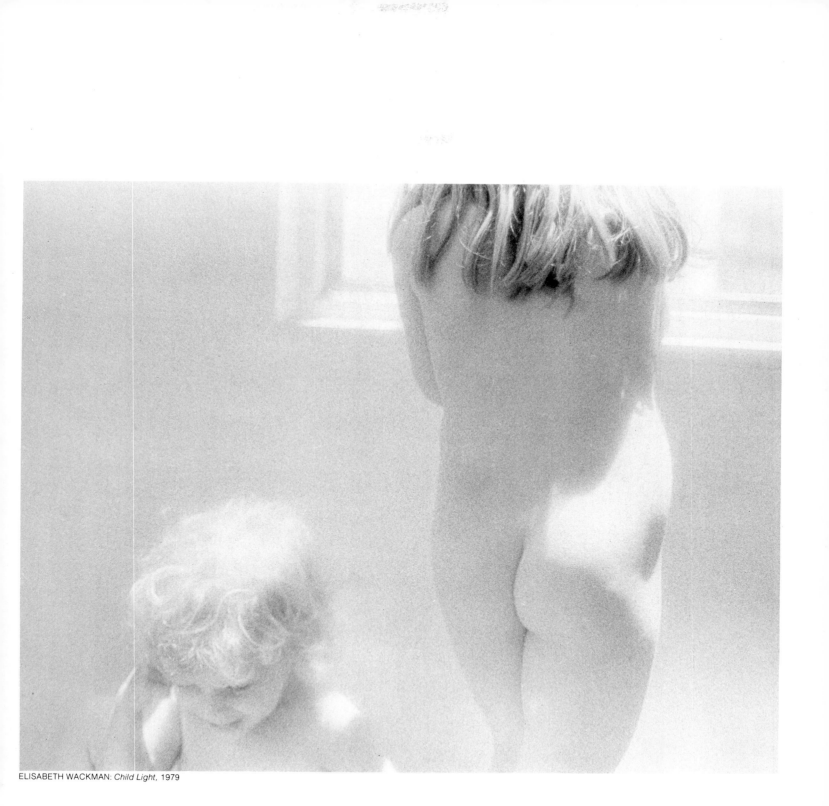

ELISABETH WACKMAN: *Child Light*, 1979

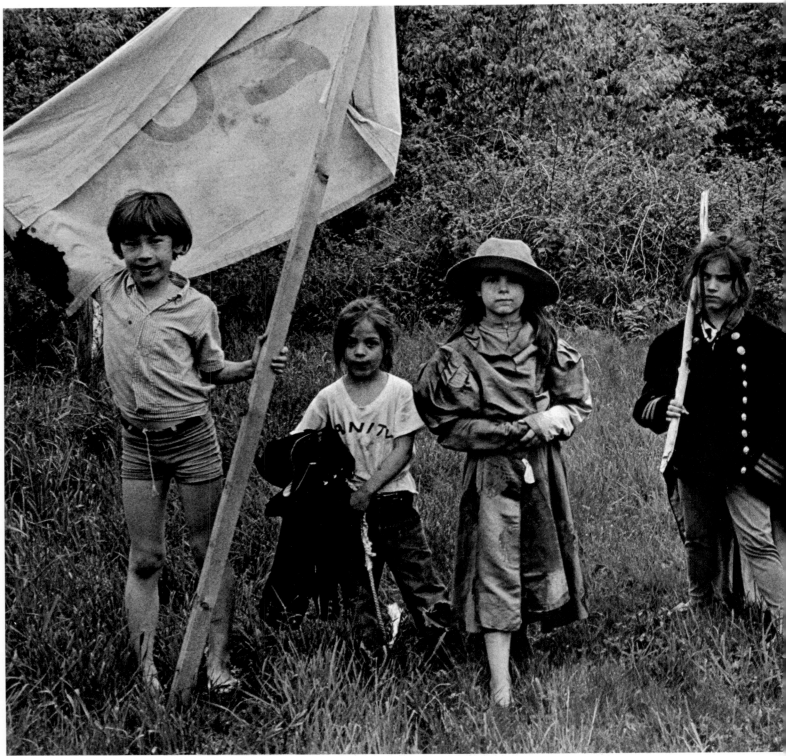

LILO RAYMOND: *Children at Play*, Cherry Plain, New York, 1968

The Gang's All Here

Photographing children in groups is both simpler and more complicated than photographing them singly. It is simpler because children's groups seem to be everywhere—adults segregate them, and children themselves virtually invented the concept of the gang. The gang may consist of a group of siblings, a group of cousins, a group of neighbors; a school class or a group within a class; a group at camp or a group of scouts at home.

In all their groupings children have at once a cohesiveness and an individuality not common to adults in groups. And the very nature of the groups often tells much about what the children are like. In addition, the activities they engage in—from climbing trees to hanging out on the front porch—provide the photographer with an almost infinite variety.

For all that, photographing the group has its own difficulties. In a single portrait the only relationships to be considered are between sitter and photographer or sitter and viewer; in a portrait of a group the figures relate to one another as well. And the setting, although it may help to hold the group together, must for the sake of the photograph be a part of the group's *raison d'être*.

Still, as they do separately, children in groups often assist the photographer—unwittingly or on cue. Sometimes a game in progress provides a picture; at other times an interruption is in order. The children at left were playing a game of their own invention with a motley assortment of props when the photographer, who was visiting in the neighborhood, found them and got their attention. They obligingly struck their poses, unwittingly telling the viewer things about themselves, about the game they were playing and, by extension, about childhood.

A small army pauses between skirmishes in a backyard in upstate New York. The improvised flag and weapons and the outsized costumes denote the seriocomic nature of the game and its participants, who are upper-middle-class children sufficiently privileged to spend their summers in the country whiling away the lazy afternoons at make-believe—the American idealization of how childhood should be spent. Even grouped, the children retain their separate identities, as shown in their varying looks, from four-year-old coquetry to 10-year-old sophistication.

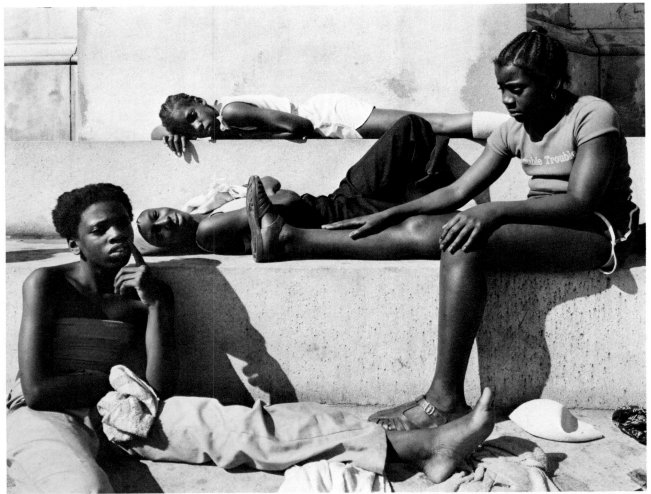

NICK NIXON: *Boston Common*, 1978

Caught unaware by the photographer, four friends
brood and dream on the steps of a city park wading
pool. The shared activity of the pool brought
them together, but now they are mentally miles apart.

Four children from neighboring families at a ▶
summer resort face the camera head on, completely
ignoring — as only children could be expected to
do — the fact that they have no clothes on.

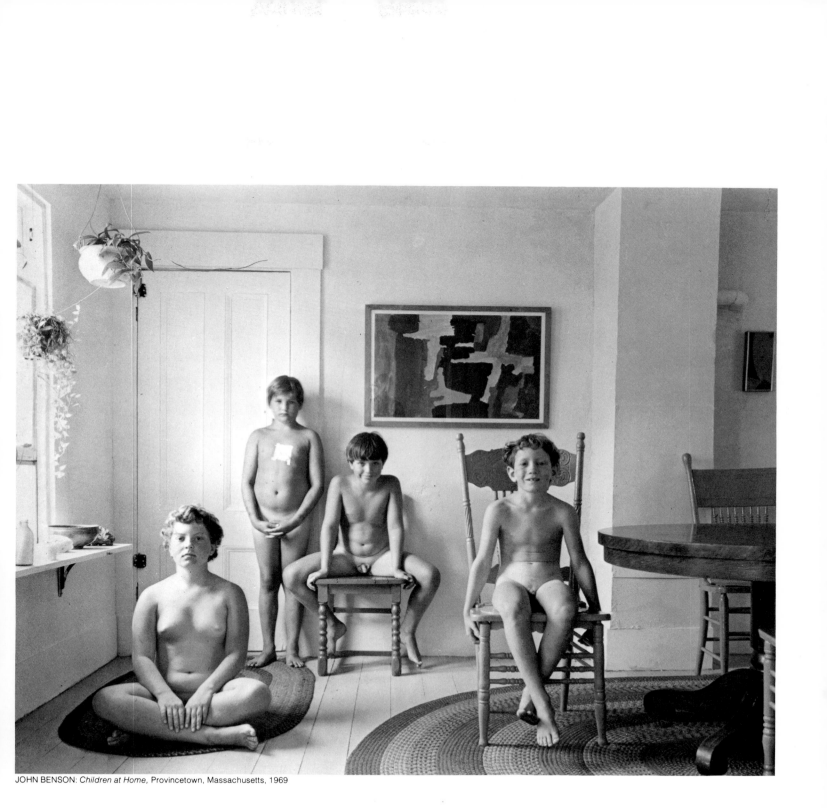

JOHN BENSON: *Children at Home*, Provincetown, Massachusetts, 1969

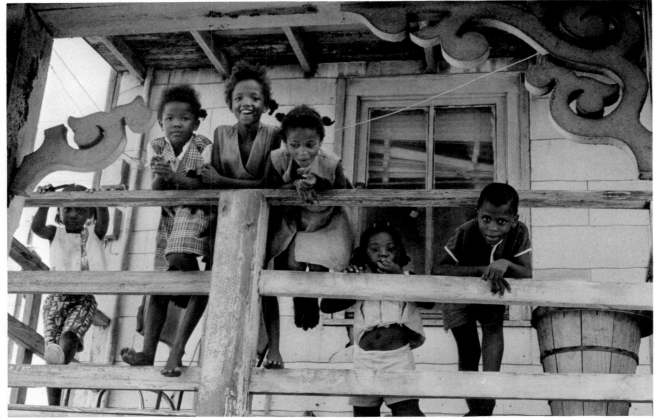

DANNY LYON: *On a Porch*, Galveston, Texas, 1967

Framed by the railing they are draped on and the gingerbread trimming overhead, six children peer at the photographer with the curiosity children generally accord a stranger to their neighborhood — and with a range of expressions and postures portraying their individual natures, from the cautious peekaboo at left to the come-hither smile at right.

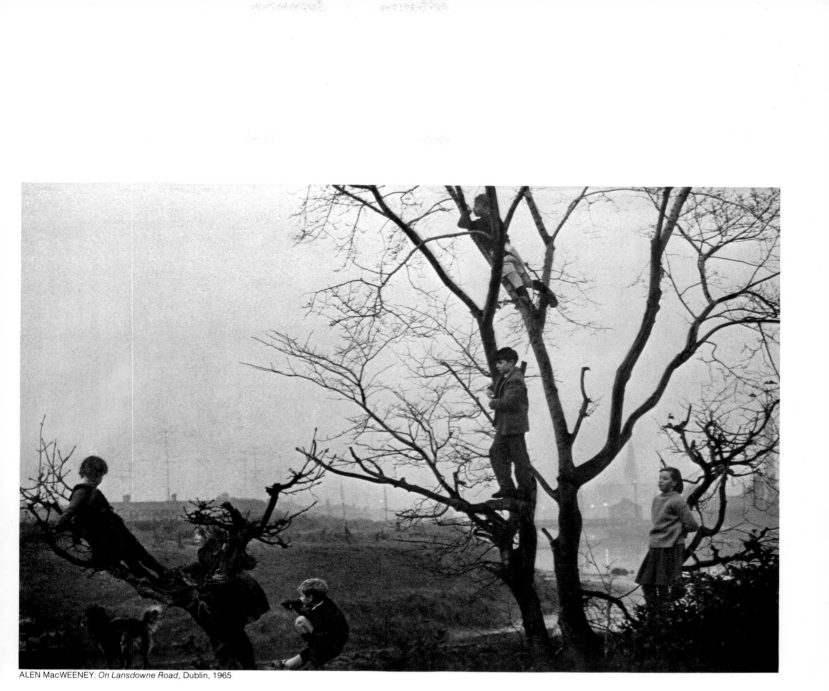

ALEN MacWEENEY: *On Lansdowne Road*, Dublin, 1965

The trees of a wooded park give these six children in tweeds and knits a view of Lansdowne Road Stadium (background). By their absorption in the game, the children reveal their city-bred sophistication —for them neither strangers nor cameras are curiosities. The leafless trees and the autumn sky are a striking background for the shot.

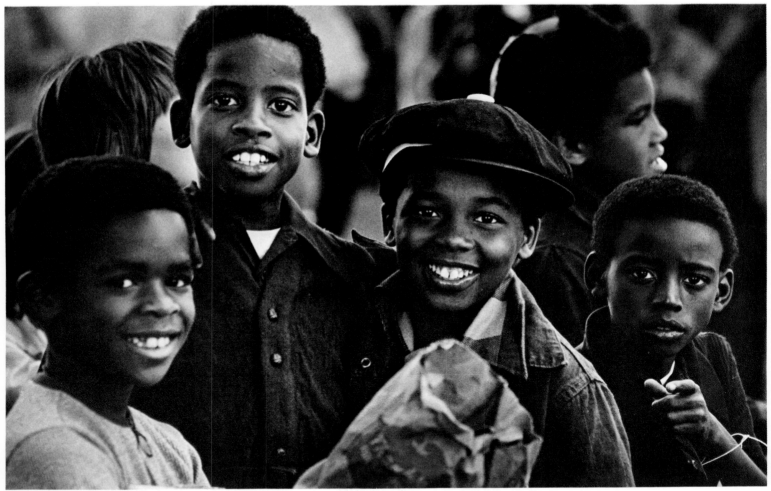

TOM WHITTINGTON: *Brothers,* 1974

Three youngsters at a fair in Indiana clown for this portrait while a fourth seems to have been caught by surprise. Tom Whittington decided to take the boys' picture because they looked as if they were having fun. When they spotted him and his camera, their reaction was instant —and visible —glee.

This informal shot catches three friends in various attitudes and stages of growth. The little boy, Ruomi, is still cutting up; but Naima flashes her prettiest smile for the camera, and Krissy — caught in between — makes faces like Ruomi but half turns toward Naima as if seeking guidance.

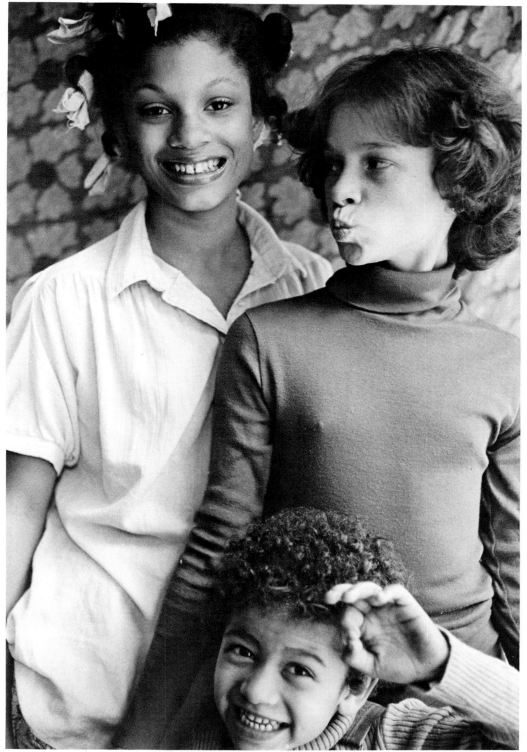

MELISSA SHOOK: *Naima, Krissy, Ruomi — New Year's Day,* 1979

181

Expressions of frowning impatience and weary cooperation range across the faces of four nursery-school children in California who were asked to pose for a visiting photographer. The little ones got fidgety during the hour-long session; but instead of ruining the shot, their candid displays of boredom turned the photograph into a universal statement on the short attention span of four-year-olds.

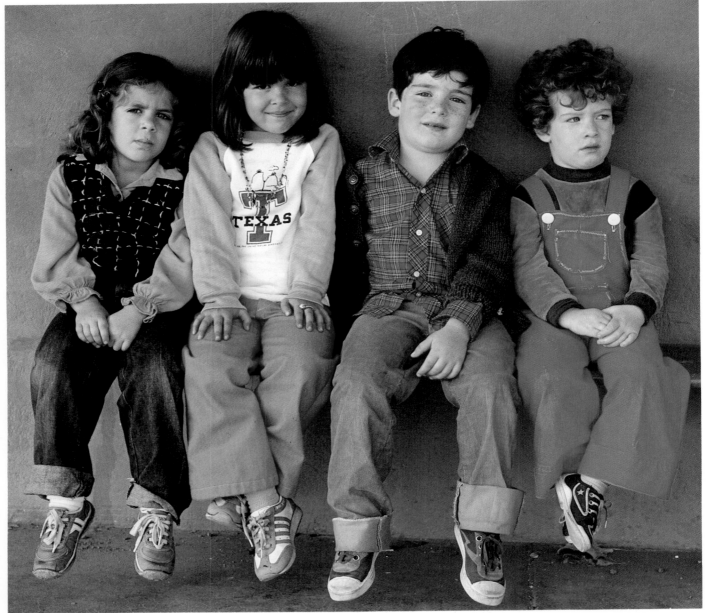

EVELYN HOFER: *South Peninsula Hebrew Day School*, Sunnyvale, California, 1981

Ten Photographers' Ways with Children 186

BERNARD WOLF: *Kingston, Jamaica,* 1968

Ten Photographers' Ways with Children

No subject is more obviously appealing to professional photographers than children. Full of spontaneity, with their enthusiasms and disappointments and second thoughts clearly written on their faces, children seem consummately photogenic. They are also innocent subjects, at least in the sense that no barrier of adult inhibitions has yet been erected to come between the child and the camera.

"Children are more natural," in the view of George Krause, who began refining his sensitive artist's eye by taking photographs of youngsters in the late 1950s. "It's easier to see something and to convey it with them." Mary Ellen Mark, a photojournalist who has portrayed people of all ages all around the globe, took many pictures of children at the outset of her career. "Children gave me confidence," she says. "They are easier to approach than adults. Perhaps it's simply because I'm bigger than they are."

Everything about photographing children seems easy. Perhaps too easy, for among the millions upon millions of beguiling youngsters and cute babies who smile out of their photographs, only a few are portrayed with real artistic power and conviction. Few photographers manage to evoke in the viewer that special excitement that marks a truly great photograph.

What is the elusive quality that creates this kind of impact? It is not magical. Technical excellence is part of it, certainly—the perfect compositon, the sensitive use of colors, the expressive combination of shapes and tones that produce a well-made photograph. More important, it comes from the unique personal interpretation of what photographers see and record, the special attitudes and ideas with which they approach their work. In short, their style.

The photographers whose works are shown on the following pages present children in distinctively different ways. Sometimes the style may come from the techniques and equipment chosen, as when Marie Cosindas uses Polaroid film to produce the rich, muted colors of her consciously nostalgic portraits. Part of it derives from the rapport that photographers develop with their subjects. Tamarra Kaida finds, surprisingly, that she must often cajole her young sitters out of the formal façade they want to present to the camera and into more revealing expressions or gestures. On the other hand, Bernard Wolf, who photographed the young girl at right—as well as the soaring diver on the previous page—often uses a telephoto lens to catch his subject unaware.

Sometimes photographers may heighten the impact of their pictures by deliberately manipulating them. Depending on the effect he wants, Jan Saudek surprints, tones and hand colors his photographs. More fundamentally, style grows out of the way each photographer approaches photography itself. The work of these 10 photographers ranges from the forthright documentary statements of Mary Ellen Mark, through the startling surrealistic fantasies of Arthur Tress, to the enigmatic allegories of Ralph Eugene Meatyard. In each case, the photographer has managed to record on film a personal vision of the world in general, as it is perceived through the particular world of children.

All the charm of childhood radiates from this young girl, with her easy pose and gap-toothed smile. But the photograph is more than just a cute picture, for the photographer has brought to it an eye for bright color and balanced design—and an alertness that caught the girl's smile at its most fetching.

BERNARD WOLF: *Pico Island, Azores,* 1970

Bernard Wolf

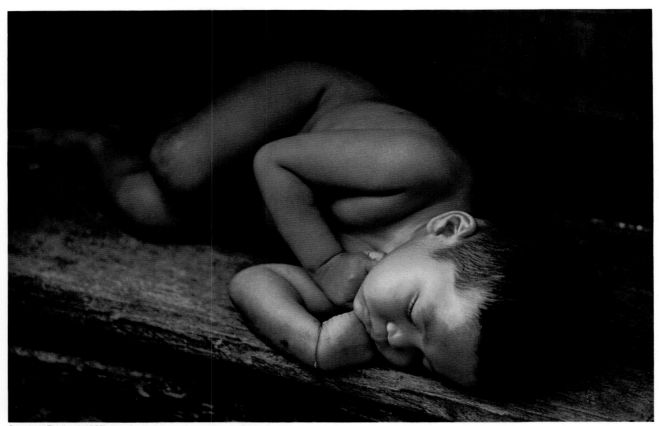

Bangkok, Thailand, 1969

Bernard Wolf is a photojournalist who concentrates on capturing the natural look of the children he frequently photographs. On his assignments to remote and exotic lands, Wolf tries to show people—including children—as they are, "immersed in their environment and culture." Almost never does he pose a child, or consciously intrude into the scene. Instead, he prefers to stroll about, armed with three 35mm cameras, each with a lens of different focal length and each with exposure preset so that he can respond instantly to whatever catches his eye—a child sleeping in a doorway, a bright smile on a youthful face or even a harmonious blend of shapes and colors, as in his picture on the preceding page.

For all their freshness and spontaneity, Wolf's pictures show a masterful control over composition and color. One of his hallmarks is a fondness for combining bright and contrasting hues; the bright pink of the child's shirt in the picture opposite makes an interesting combination with the yellows of the costumes worn by the two other figures. But sometimes, as with the infant above, he uses subtle modulations of a single color to bring out shapes and textures. In either case, the effect is one of total naturalism.

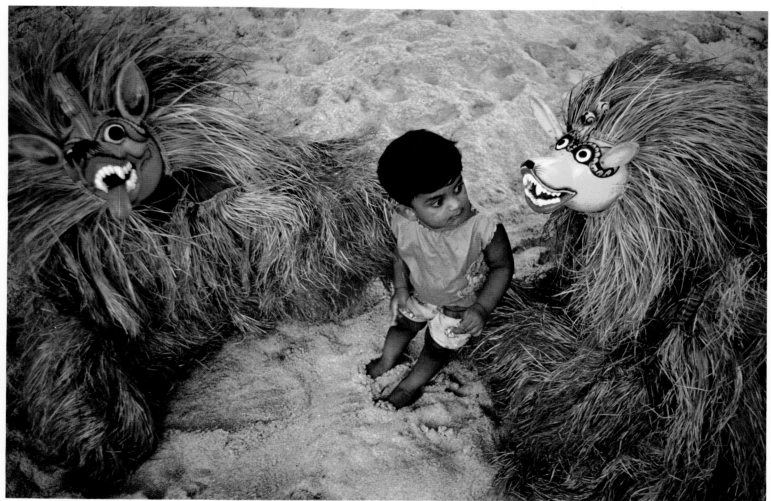

Ambalangoda, Ceylon, 1969

◄ The soft, golden skin tones of this sleeping infant, curled up on a doorsill alongside a street in Bangkok, caught the photographer's eye as he wandered through the city on assignment for a travel magazine. Though the picture is rendered in monochrome, color is one of its most expressive elements: Its rich mocha browns seem as warm and enveloping as sleep itself.

Like a visitor in an Asiatic Land of Oz, a child sits between two performers dressed as animals for a folk dance in a Ceylon village. The child had crawled between the make-believe beasts after the performance, and Wolf deftly turned the situation to pictorial advantage, framing the child between the dancers and catching the moment when the child was as bug-eyed as the beasts.

Arthur Tress

Arthur Tress is a documentary photographer whose major themes are social conditions, problems of poverty and regional folkways. The pictures shown here, for example, were taken in tenement neighborhoods in the New York area. But each one goes beyond the usual straightforward portrayal of slum children and penetrates into a realm of fantasy. For the reality that Tress documents in the city is not simply the physical reality of littered asphalt streets and run-down buildings, but a state of mind. "My photographs," he says, "exist in that strange borderland quietly hovering between the real and the unreal." He has called the approach "social surrealism."

Children fit perfectly into the surrealistic landscape of his pictures, Tress feels. Their natural playfulness turns them into ready allies in creating visual tricks like the boy-on-a-sofa illusion opposite. Often they even seem to sense intuitively the mood that he is trying to capture with his camera and will fall into an appropriate pose without being directed to do so, as did the boy at right. Tress felt that the monstrous leather hands, so out of scale with the young subject, should somehow convey a sense of prayerful meditation—which is precisely the attitude the boy struck. "The image just happened between the two of us," Tress explained.

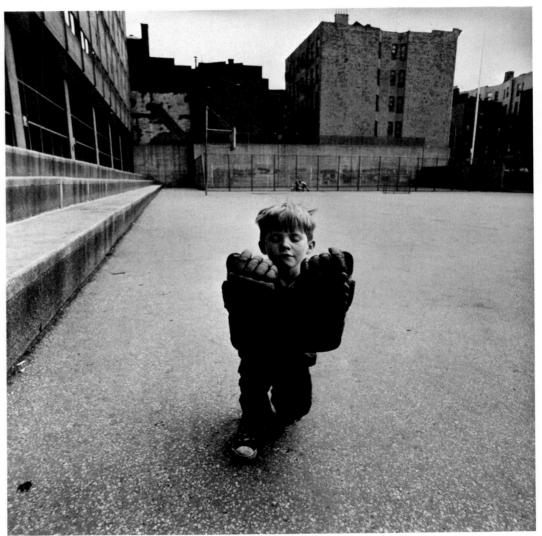

Boy with Ice Hockey Gloves, 1970

Encased to the elbows in his older brother's hockey gloves, this young New Yorker wears a soft and almost beatific expression that contrasts with the stark lines of the playground and tenements. The scene is in Hell's Kitchen, long one of the tough neighborhoods of Manhattan.

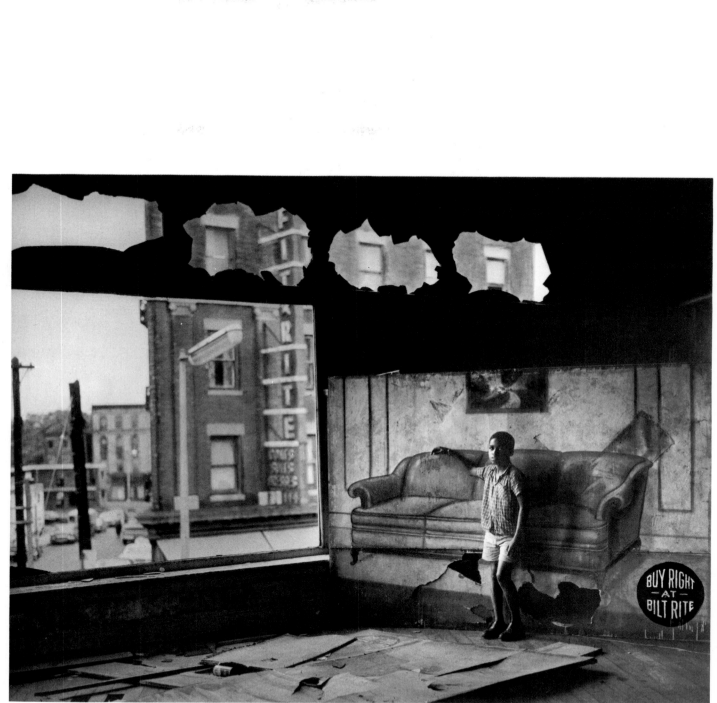

Boy in a Fire-Bombed Store, 1969

In a burned-out store in the black section of Newark,
New Jersey, a youth pretends to rest against
a sofa depicted on an advertising poster.
The picture was taken two years after the area had
been devastated by riots; local children were
still using the unrepaired shops as playgrounds.

Tamarra Kaida

Photographer Tamarra Kaida has made childhood, adolescence, and children's relations with their parents primary concerns in her work. "The little child is still very much alive in me: I'm still trying to find out what being an adult is," she says. "With the photographs of the children, I'm trying to see their outside and their inside at the same time."

Most of her subjects are the children of friends and have been photographed by her many times over a number of years — sometimes alone, sometimes with their parents. The portraits are usually carefully posed, but Kaida also tries to capture a fleeting gesture or expression that will reveal a child's personality despite the role or façade projected for the occasion. She does not wait for the revelation to occur by chance, however. Rather, she coaxes and exhorts until — from a combination of unease and boredom — the child lets go and there is a subtle but telling shift. The result is characteristic of her images: Though seeming to reveal all, the child retains the quiet dignity of a slightly foreign visitor "whose customs and habits are familiar and yet strange."

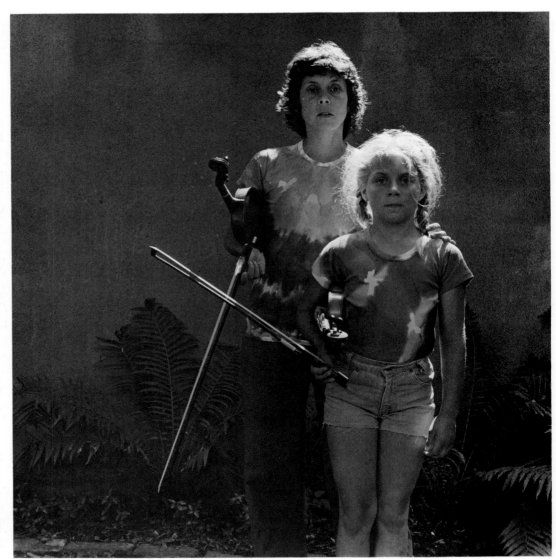

Nine-year-old Kate and her mother, violins tucked under their arms, face the camera with solemn expressions. The mother's hand rests protectively on Kate's shoulder, but the accidental crossed-sabers effect of their violin bows suggests the competition that often arises between children and their parent of the same sex.

Beth and Kate, 1980

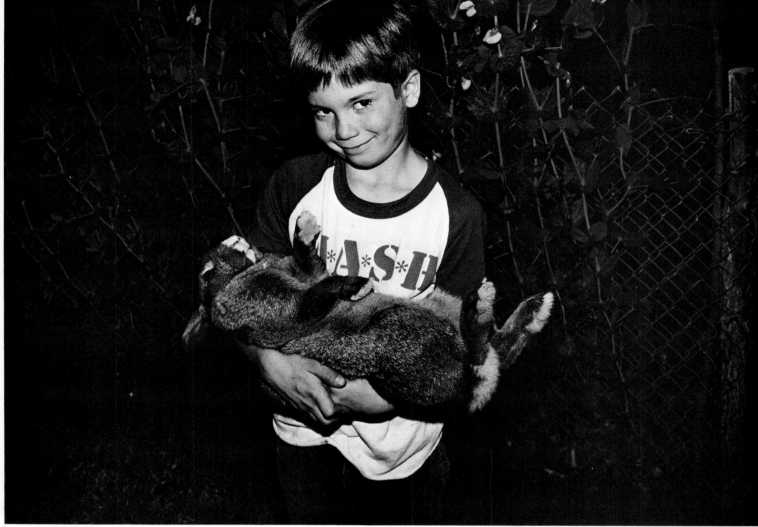

Sweetness and unconscious cruelty meet in this portrait of an impish-looking little boy who cradles one of the rabbits that his family raises for food. The stark, spot-lighted quality was achieved in this daytime shot by using flash and a small aperture.

Sam and His Rabbit, 1982

*Although her bedroom, with its stuffed toys
and romantic poster, reflects the contradictions
of adolescence, the teenager herself seems
at ease with her emergence into womanhood: Juliet
faces the lens calmly, with just a hint of a smile.*

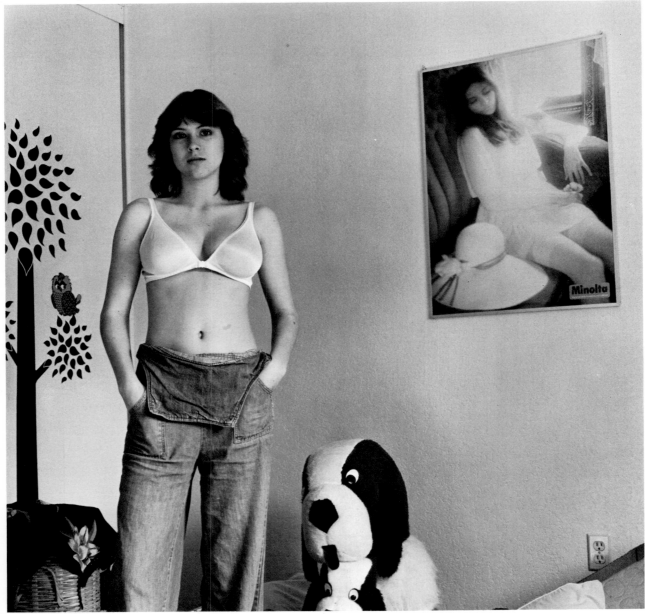

Juliet, Age 16, 1979

After undressing both herself and her doll on a hot day, Kate keeps only a bow-tied ribbon in her hair as a reminder of the fancy dress she has discarded. Her clear-eyed gaze is as direct as it is in the picture on page 192, but here Kate is three years younger.

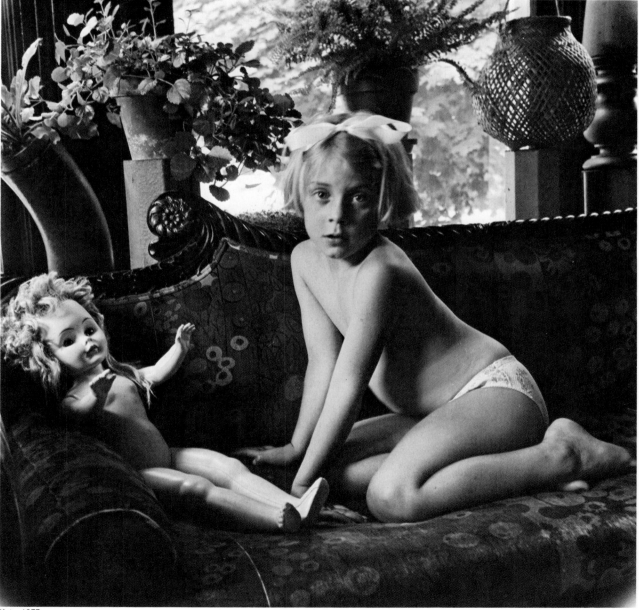

Kate, 1977

Emmet Gowin

Emmet Gowin photographs the things that are closest to him—his family and friends, his children and their play-mates. These are everyday subjects, seemingly rendered in an everyday, almost casual manner. Yet there is something disquieting about a Gowin photograph, a sharp edge of incongruity suggesting that his situations are not as ordinary as they seem. "I like a photograph to show something unexpected," Gowin says, "to reveal the ominous potential in the ordinary moment."

When taking pictures of children, Gowin turns photography into a game. He sets up his 8 x 10 view camera on a tripod, gives the children a little direction and then lets them improvise.

Not surprisingly, Gowin does not always know how his photographs will turn out. "What really excites me is when I get more than I thought was there," he says. Sometimes the extra ingredient is an unexpected incident as in the picture opposite. Sometimes, as in the picture at right, it is a quality of suspense that forces itself into the record of a commonplace moment.

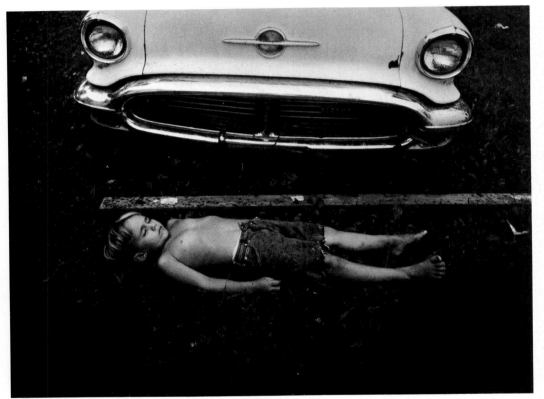

Richie and Car, 1967

Two perfectly innocent images—the front end of a parked automobile and a child lying on the grass—conjure up a distinctly ominous set of circumstances when seen together. The photographer had been taking pictures of children in various positions around the car, and on a whim asked one of them, his nephew, to lie down in front of it.

A strange visual coincidence makes this picture ▶ *interesting at the outset: Everything comes in pairs. There are two boys, two turkeys and two inverted buckets. The boys had asked the photographer, a neighbor, to take their picture with the turkeys. The buckets were for the boys to sit on. Then a turkey scratched one of the boys on the face, and his companion rushed to console him—thereby providing an immediate, slightly puzzling relationship between birds and boys.*

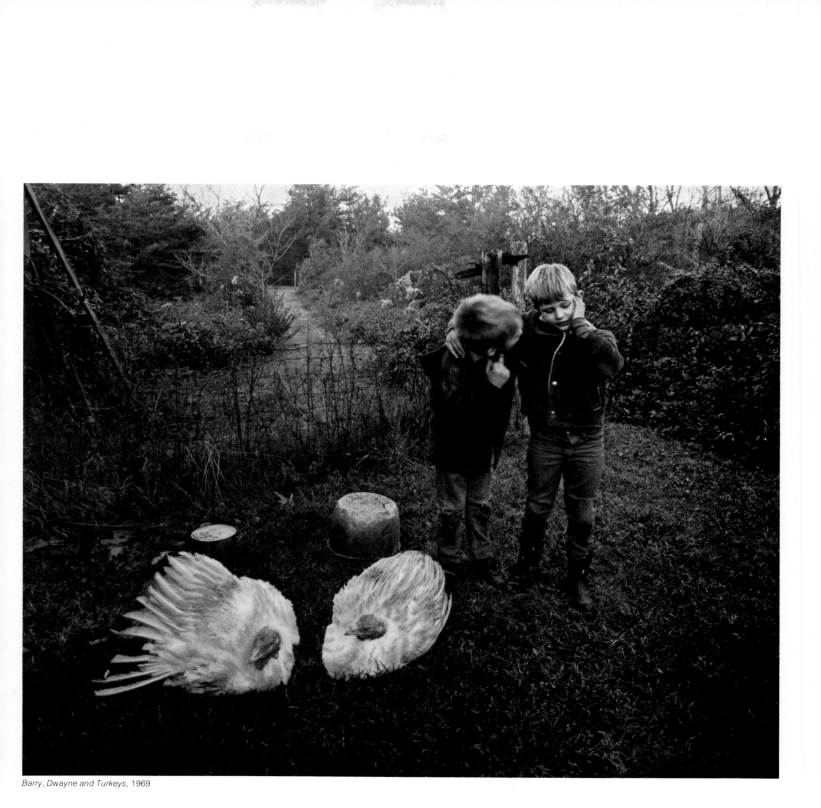

Barry, Dwayne and Turkeys, 1969

Mary Ellen Mark

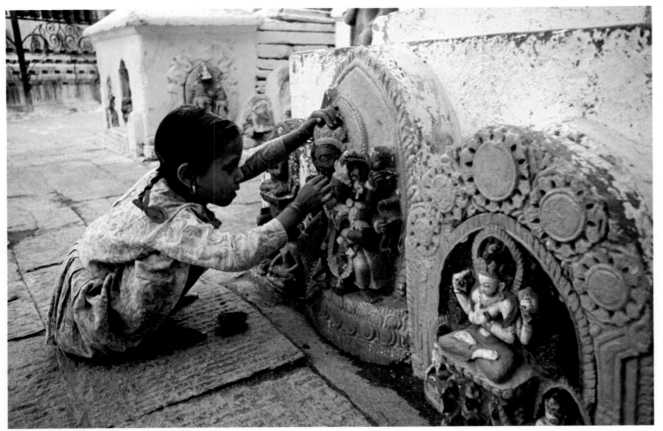

Girl Coloring Sculpture, Katmandu, Nepal, 1970

"I'm interested in kids as people, when they're doing something really revealing, not just something cute or obnoxious." So says Mary Ellen Mark, who has turned her inquisitive reporter's camera on people of all ages in all parts of the world. Her approach to photographing children is to regard them not as a special species requiring special care, but as full-fledged members of the human family.

As with most of her subjects, she pictures them on location amid their own surroundings, in photographs that usually convey a strong feeling of place and atmosphere. There are times when she captures even more—an attitude, a gesture, a situation so characteristic that it serves, as Mark describes it, to "peel the skin off something."

Mark hunts for that universal quarry of

photojournalists, the revealing moment. She often tries to take the moment by surprise. The child above, for example, is so caught up in her own work that she does not realize she is being photographed.

At other times, when the moment is slow in coming, Mark steps in to help it happen. The result can be a direct and memorable encounter between subject and camera, as in the picture opposite.

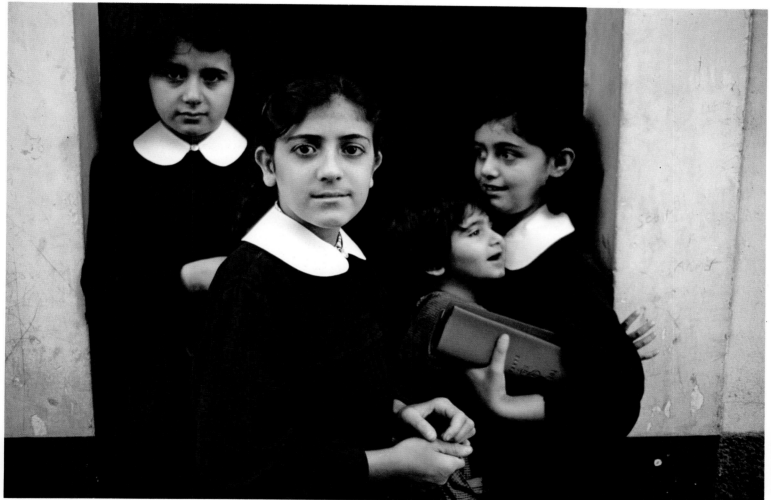

Schoolgirls in Trabzon, Turkey, 1965

◄ In the courtyard of a Buddhist temple in Nepal's capital city, a young worshipper carefully applies pigments to an outdoor shrine. It was not just the little girl, but the entire scene that struck the photographer as "a pretty, charming thing," with its unusual combination of colors, the shrine's intricate carving, the Nepalese costume, and of course the child's preoccupation with her task.

On a visit to Turkey early in her career, Mary Ellen Mark photographed hundreds of children such as these schoolgirls. Like many other beginning photographers, she simply found children less intimidating than adults. She spotted these girls, dressed in their prim school uniforms, standing in a doorway after class. Two turned to face the camera, providing the photographer with the moment she sought—in which gestures, facial expressions, composition and color all come into perfect balance.

George Krause

Like many other contemporary photographers who frequently work with children, George Krause treads close to the edge of fantasy. Yet he never steps completely over. No matter how moody or evocative his pictures, or how deeply they stir the imagination, they are always too firmly rooted in the real world to seem unnatural or contrived. "Fantasy is like a tightrope," he says. "It can't look forced." Instead, Krause relies on a feeling of atmosphere, a sensuous play of light and shadow, to free the viewer's imagination.

The natural look of Krause's pictures comes, paradoxically, from the photographer's gentle but deliberate control over every step of the picture-making process. Many of his photographs, like the two shown here, are discreetly posed. Then, during the developing and printing, Krause employs a complete arsenal of darkroom techniques to balance contrast, deepen shadows and emphasize forms or obliterate shapes in order to bring out the mood—half real, half fantasy—that he seeks. "I want to leave an after-image," he says, "something that you can't quite get out of your mind."

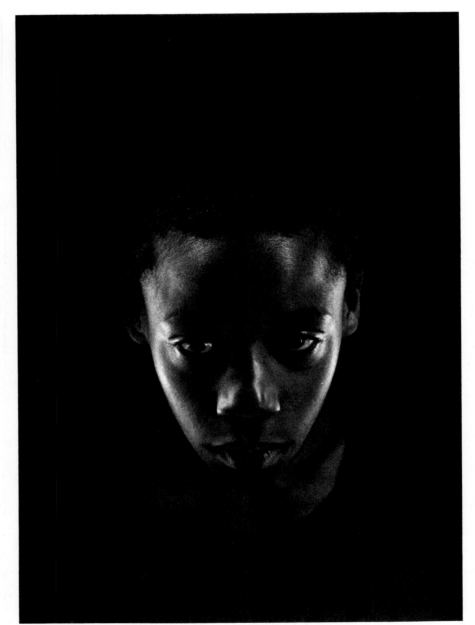

By carefully posing this boy in a spot where the light struck his features only from the sides, the photographer made the face swim mysteriously out of the picture's shadowy depths. The effect was intensified by a printing technique that darkened the background to eliminate all detail.

Submariner, 1958

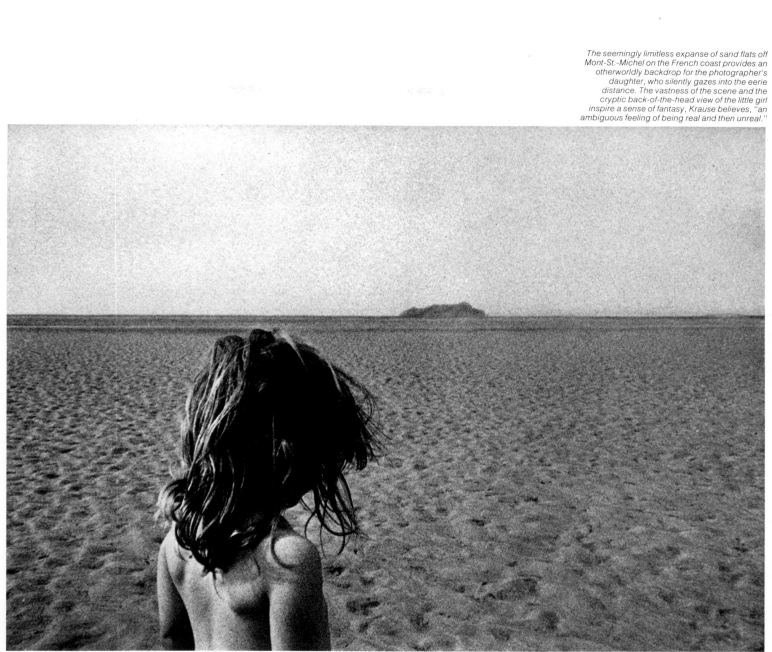

The seemingly limitless expanse of sand flats off Mont-St.-Michel on the French coast provides an otherworldly backdrop for the photographer's daughter, who silently gazes into the eerie distance. The vastness of the scene and the cryptic back-of-the-head view of the little girl inspire a sense of fantasy, Krause believes, "an ambiguous feeling of being real and then unreal."

Katy at Mont-St.-Michel, 1968

Comedy and Tragedy, 1964

Krause noted these two child portraits—one laughing, one sobbing—as he walked past the display window of a dilapidated photography shop in Spain. By taking his own photograph of the faces in the ornate double frame and darkening the background when making his print, he invested the two pictures with a special meaning, transforming them into diminutive masks of comedy and tragedy in a kind of infant's theater—the very earliest of all fantasy worlds.

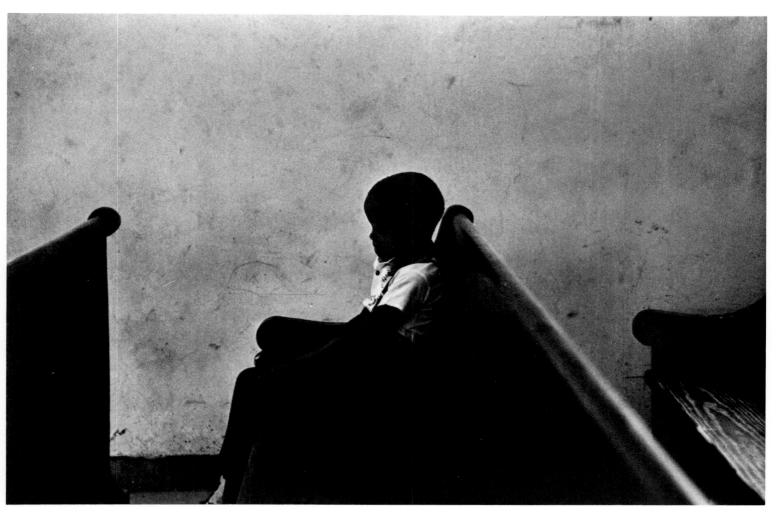

Sanctuary, 1958

Most of Krause's early pictures, like this quiet portrait of a boy in a rural South Carolina church, show the photographer's growing preoccupation with composition and design. He posed the boy so the shape of the head contrasted with the severe lines of the pews. But the picture's impact exceeds its formal values, capturing some of the profound calm of the simple country church.

Starr Ockenga

Starr Ockenga made a novel entry into photography. One night she dreamed she owned a camera; the next day she bought one and started taking pictures. From that time, neighborhood children and the children of family members and friends have been among her favorite subjects. "They were patient and willing," she says, "when I was learning to expose and compose. They were always game, always interested."

For Ockenga, taking photographs of youngsters is a way to rediscover her own childhood, and the small viewfinder on her camera is like "a keyhole back into time." Part of the dreamlike quality of her work is a result of her choice of film. Sometimes, as in the luminous portrait of her nephew seen on page 206, she uses infrared film in order to soften the image. Frequently, however, she works in color, relying on Polaroid's instant SX-70 film for the muted tones of her fanciful creations. The children, she has also discovered, love being able to see the results of their collaboration in such short order. And because of this collaboration, Ockenga says, "a trust has grown between us over the years that makes us free to play, act and be deadly serious together."

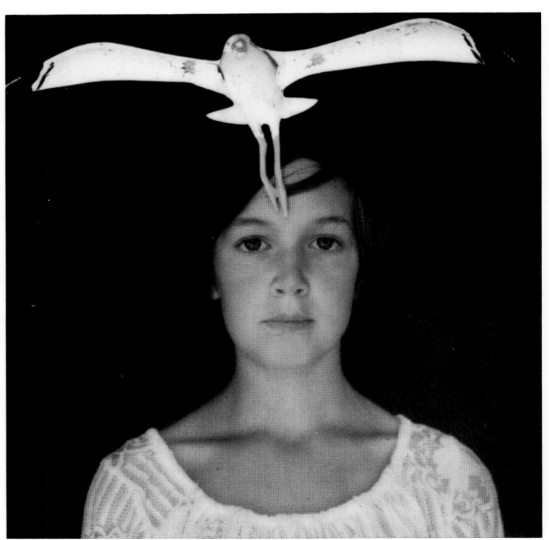

In this diffuse and textured portrait, a bird appears to rise from the brow of a somber and somewhat remote adolescent. Ockenga obtained the striking effect by shooting the 12-year-old girl through a screen door decorated with a plastic seagull.

Sarah and the Seagull, 1977

Sarah and Rosie, 1976

Jacob and My Father's Portrait, 1976

*Hand resting on a harp, like some haughty
apparition from heaven, Starr Ockenga's nephew
imitates the upright bearing of the grandfather
wearing clerical robes in the portrait behind him.
Jacob, just in from skiing, had stripped to his
underwear when Ockenga conceived the shot, using
infrared film to create the ghostly highlights.*

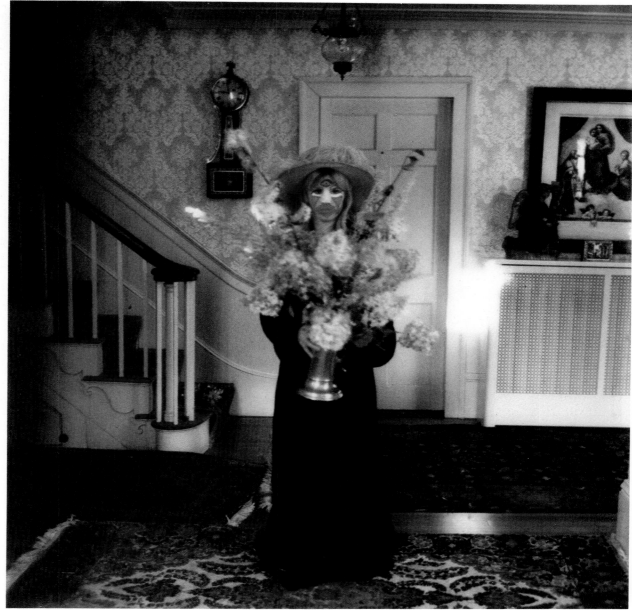

This Halloweenish portrait of a friend's daughter is one of a series in which Ockenga—who as a child loved dressing up—encouraged youngsters to devise greasepaint masks and don fanciful costumes. Here the photographer supplied Maellen with a prop that recalled her own youth—her grandmother's feathery broad-brimmed hat.

Maellen in My Grandmother's Hat, 1976

Ralph Eugene Meatyard

Most viewers, looking for the first time at the deeply symbolic works of the late Ralph Eugene Meatyard, are totally mystified by them, or at least made uncomfortable. Who are these shadowy people who seem to materialize, like ghosts, from the dark recesses of his photographs? After looking at some of Meatyard's work, the poet Wendell Berry exclaimed, "My basic assumptions about reality are being tampered with!"

Behind each of Meatyard's photographic puzzles there is a form of reality, deliberately tampered with by the photographer's use of his own private set of symbols. Each picture is a carefully thought-out vignette that illustrates a universal theme, whether it be the recurring cycle of birth, growth and decay, man's place in the natural world or man's faith in God.

Meatyard's initial inspiration was usually a setting, almost always one near his home in Lexington, Kentucky. Meatyard then assembled ideas, props, costumes and characters, often using his own children as models.

Like many photographers who deal in fantasy, Meatyard found that children have a special passport to the world of the imagination. Also, because they are more malleable than adults, less camera-shy and easier to direct, they allowed him more control. And control was essential to his approach. In fact, he once declared, "I never will make an accidental photograph!"

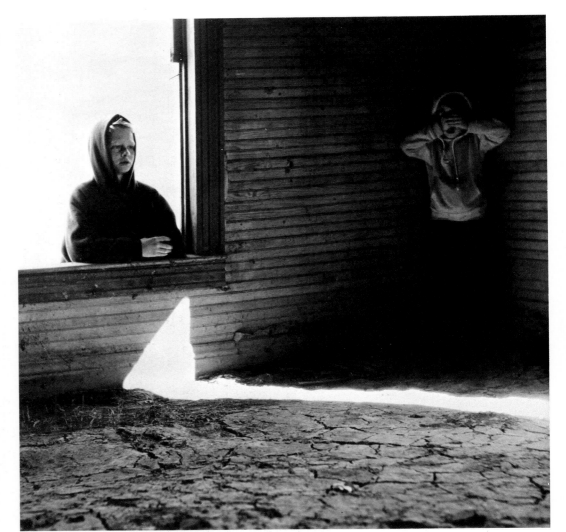

Rimose Meeting, 1962

Faith and despair are the themes of this picture of the photographer's sons in an abandoned house. The boy at the window, in monk's habit, represents faith; a shaft of light points at him. But the light slips past the boy in the shadows, who covers his eyes in fear and trembling. The title is not entirely cryptic; "rimose" refers to something with many cracks and fissures.

208

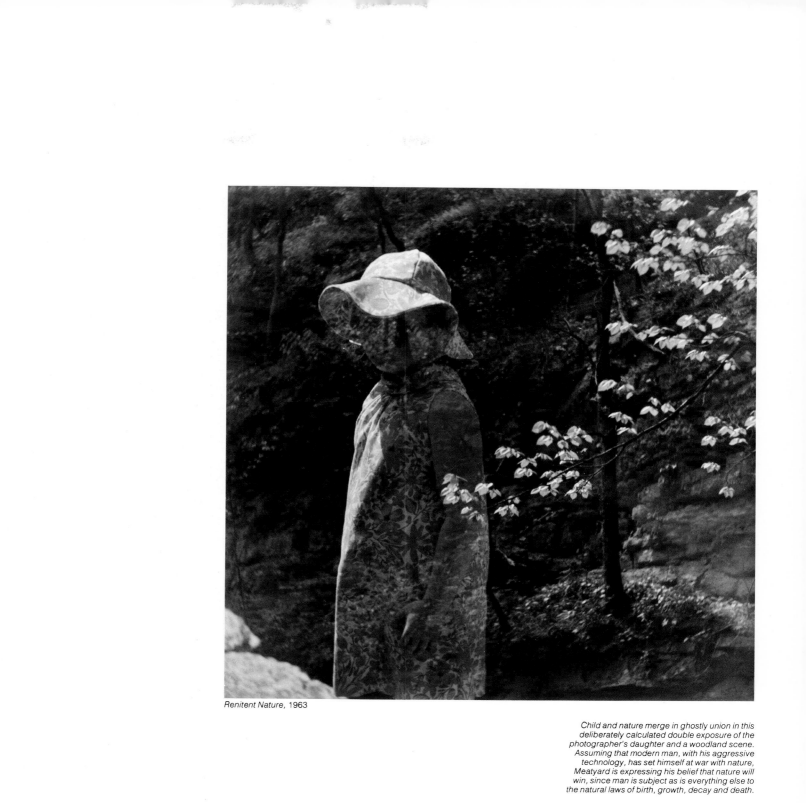

Renitent Nature, 1963

Child and nature merge in ghostly union in this
deliberately calculated double exposure of the
photographer's daughter and a woodland scene.
Assuming that modern man, with his aggressive
technology, has set himself at war with nature,
Meatyard is expressing his belief that nature will
win, since man is subject as is everything else to
the natural laws of birth, growth, decay and death.

Jan Saudek

Czechoslovakian photographer Jan Saudek, who works full time in a factory in Prague to support himself and his art, is more than usually cut off from the influences of his photographic colleagues. As a result he has evolved a distinctive, highly personal style, freely using manipulation in the darkroom and after—notably double-exposure printing, sepia toning and hand coloring—to achieve the image he envisions.

Children often play a key role in his surrealistic (yet oddly nostalgic) pictures, helping him zero in on the elemental human relations and emotions. Usually the perspective is paternal, as in the moving portrait of a newborn in his father's arms *(page 105)* and the eccentric father-son portrait at right.

Most of Saudek's carefully composed photographs are taken in his basement studio, a dingy room with crumbling walls and a single window that opens onto an air shaft. The seedy setting—an integral part of his allegorical imagery—is also an effective counterpoint to the artless innocence of his young subjects, as in the delicately tinted photograph seen on the opposite page.

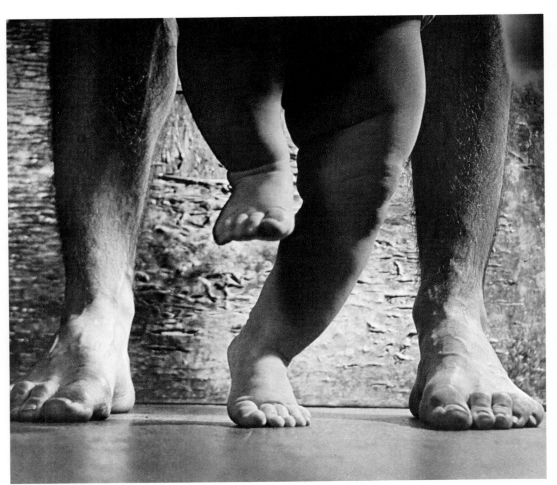

Image 9 (First Step), 1963

Framed by the gigantic feet of his father, a baby boy raises his leg to take a teetering step. The low angle that gives the picture its impact was obtained simply by placing the camera on the floor and triggering the shutter with a cable release.

Music coming through her headphones transports a ▶ young girl from the shabby present to a realm where clouds make patterns in the blue sky. Saudek created the effect by double-exposing during printing and hand-coloring the composite image.

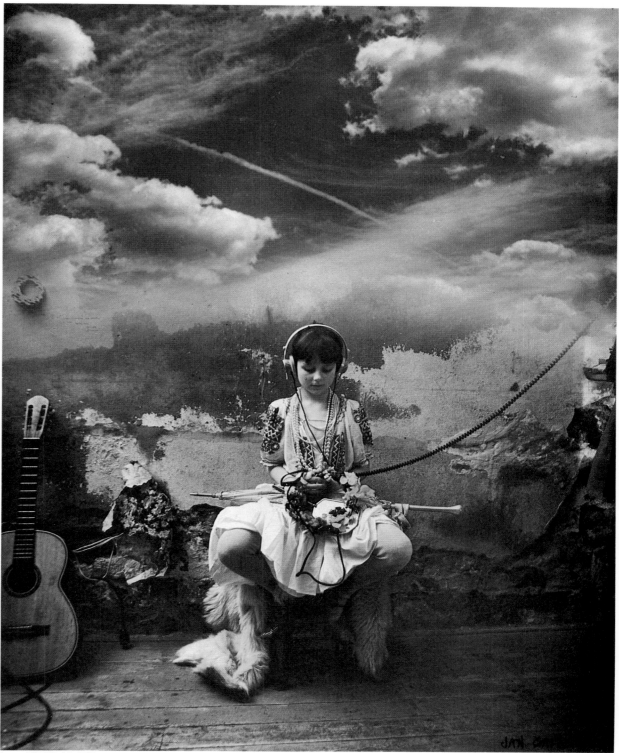

Image 180 (Music), 1980

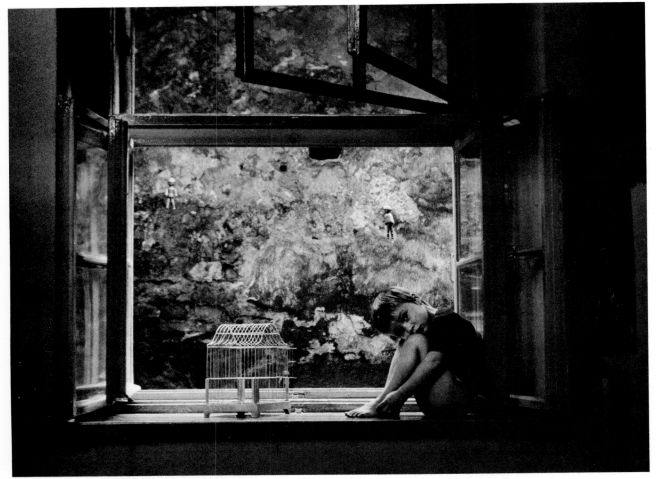

Image 104 (Boy, Cage and Open Window), 1970

*Beside an empty bird cage on a window sill,
a dejected small boy hunches over his knees. Jan
Saudek had just required his son to free a wild
blackbird. Though Saudek thought it a happy event,
the boy reacted as to the loss of a loved pet.*

*Two faces fill this sepia-toned self-portrait of ▶
Saudek and his first-born son (whose feet are seen
on page 210). The extreme close-up — revealing the
stubble of a beard on Saudek's face — conveys
the essence of a father consoling an unhappy child.*

Image 20 (Kissing Away the Tears), 1966

Marie Cosindas

With Marie Cosindas, the photography of children comes full circle—back to the ethereal visions reminiscent of an earlier era. But Cosindas does it with a modern invention, instant Polaroid film. Her camera is a 40-year-old view camera. She adds no artificial lighting and carries no more accessories than can be packed in an overnight bag. "I find Polacolor works well for children," she says, "because we can look at the pictures together and talk about what is happening. They feel very much a part of it all."

Marie Cosindas' hallmark is her use of muted colors. She came to her method quite by accident one afternoon when, to compensate for the fading light, she extended the exposure time and the developing time by several seconds. This affected the colors just enough to make them soft, without losing subtle shadings, and in portraiture the longer exposure gave her subjects a look of ease.

But more important than the technical aspect of her pictures is the spirit. "The best photographs," she says, "are the ones with rapport between the subject and the photographer. I find the more time we spend doing other things, like having tea parties or playing games, the better the rapport."

Maria, Mexico, 1966

A Mexican child in a frilly dress clutches a flower and stares apprehensively at the camera. "She was petrified," the photographer said, "and when I asked her to move her head she just sat there like a stone figure. It was a nice accident."

Paula, 1966

In this portrait of the daughter of a friend, the
child's direct, somewhat bemused expression and
the slight gawkiness of her legs place her firmly in
the present, while the flaglike drapery and the
scattering of feathers give the image a turn-of-the-
century charm. An easel left over from Cosindas'
days as a painter stands behind the child.

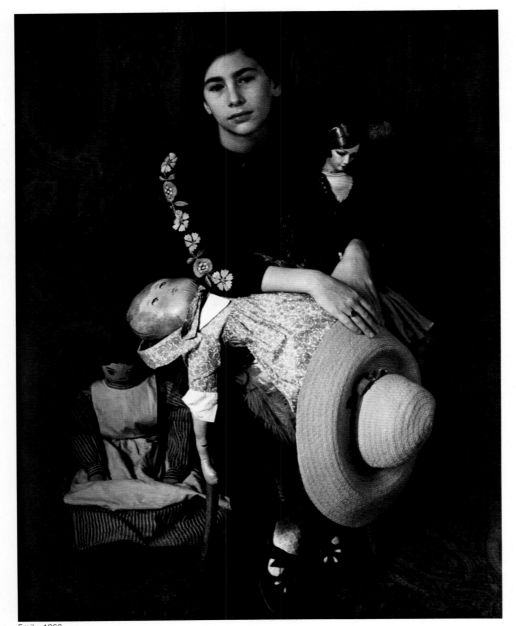

Like a figure from a quieter, less complicated time, a young sitter is revealed with all the gentle warmth of Marie Cosindas' fin-de-siècle style. The picture itself, a commissioned portrait, took two days to make. Props were assembled from the girl's collection of antique dolls, her dress was selected, and a brown paisley shawl was hung as a backdrop. Time was also needed for photographer and sitter to develop the rapport essential for a fine portrait. These leisurely preparations and the rich, muted colors combined to create the deep autumnal mood that distinguishes a Cosindas photograph.

Emily, 1968

Bibliography

History
Five Photographers. University of Nebraska, 1968.
Focal Press Ltd., *Focal Encyclopedia of Photography*. McGraw-Hill, 1969.
Gernsheim, Helmut:
 Creative Photography: Aesthetic Trends 1839-1960. Faber & Faber, 1962.
 History of Photography. Oxford University Press, 1955.
Gernsheim, Helmut and Allson:
 Creative Photography: 1826 to the Present. Wayne State University Press, 1963.
 The History of Photography: From the Camera Obscura to the Beginning of the Modern Era. McGraw-Hill, 1969.
Newhall, Beaumont:
 The Daguerreotype in America. Duell, Sloan & Pearce, 1961.
 The History of Photography: From 1839 to the Present Day. Doubleday, 1964.
 Latent Image: The Discovery of Photography. Doubleday, 1967.
Newhall, Beaumont and Nancy, *Masters of Photography*. Harry N. Abrams, 1969.
Pollack, Peter, *The Picture History of Photography*. Harry N. Abrams, 1969.

Photographic Art
*Carson, Rachel, *The Sense of Wonder*. Harper & Row, 1956.
Cartier-Bresson, Henri:
 Cartier-Bresson's France. Viking, 1971.
 The Decisive Moment. Simon & Schuster, 1952.
 The Europeans. Simon & Schuster, 1955.
 †*The World of Cartier-Bresson*. Viking, 1968.
Children At Play. School of Visual Arts, 1964.
David Seymour—"Chim". Paragraphic, Grossman, 1966.
Davidson, Bruce, *East 100th Street*. Harvard University Press, 1970.
†*Dorothea Lange*. The Museum of Modern Art, 1966.
Dorr, Nell:
 In A Blue Moon. G. P. Putnam's Sons, 1939.
 Mother and Child. Harper & Brothers, 1954.
Gasser, Manuel, *The World of Werner Bischof*. E. P. Dutton, 1959.
Gernsheim, Helmut:
 Julia Margaret Cameron. Fountain Press, 1948.
 Lewis Carroll. Dover, 1969.
Gutman, Judith Mara, *Lewis W. Hine and the American Social Conscience*. Walker and Company, 1967.
Heath, Dave, *A Dialogue with Solitude*. Community Press Publication, 1965.
Heyman, Ken, and Michael Mason, *Willie*. Ridge Press, 1963.
Hine, Lewis W., *Men at Work*. Macmillan, 1932.
Kertész, André, *Enfants*. Librairie Plon, Paris, 1933.
Kirstein, Lincoln, and Beaumont Newhall:
 †*Photographs by Cartier-Bresson*. Grossman, 1963.

The Photographs of Henri Cartier-Bresson. The Museum of Modern Art, 1947.
Lange, Dorothea, and Paul S. Taylor, *An American Exodus*. Renal & Hitchcock, 1939.
Lartigue, Jacques-Henri:
 Boyhood Photos of J.-H. Lartigue. Ami Guichard, 1966.
 Diary of a Century. Viking, 1970.
Levitt, Helen, and James Agee, *A Way of Seeing*. Viking, 1965.
Magubane, Peter, *Black Child*. Alfred Knopf, 1982.
Martin, Paul, *Victorian Snapshots*. Country Limited, London, 1939.
†Miller, Wayne, *The World is Young*. Ridge Press, 1958.
*Mitchell, Margaretta, *Gift of Place*. Scrimshaw Press, 1969.
Morgan, Barbara, *Summer's Children*. Morgan & Morgan, 1951.
Muybridge, Eadweard, *The Human Figure in Motion*. Dover Publications, 1955.
Ockenga, Starr, *Dressup*. Addison House, 1978.
Penn, Irving, *Moments Preserved*. Simon & Schuster, 1960.
Ralph Eugene Meatyard. Gnomon Press, 1970.
Reich, Hanns:
 Children and Their Fathers. Hill and Wang, 1962.
 Children and Their Mothers. Hill and Wang, 1964.
 Children of Many Lands. Hill and Wang, 1958.
†Steichen, Edward, *The Family of Man*. The Museum of Modern Art, 1955.
†*Werner Bischof*. Paragraphic, Grossman, 1966.
Wolf, Bernard:
 Jamaica Boy. Cowles Book Company, 1971.
 The Little Weaver of Agato. Cowles Book Company, 1969.

Special Subjects
†Ariès, Philippe, *Centuries of Childhood*. Vintage Books, 1965.
Better Homes and Gardens, *Baby Book*. Better Homes and Gardens Books, 1969.
†Clark, Kenneth, *The Nude*. Doubleday, 1956.
†Friedländer, Max J., *Landscape Portrait Still-Life*. Schocken Books, 1963.
Gesell, Arnold, M.D., *Studies in Child Development*. Harper & Brothers, 1948.
Ginott, Dr. Haim G., *Between Parent and Child*. Macmillan, 1965.
Homan, William E., M.D., *Child Sense*. Basic Books, 1969.
†Longford, Elizabeth, *Queen Victoria*. Pyramid Books, 1966.
Maas, Jeremy, *Victorian Painters*. G. P. Putnam's Sons, 1969.
†Mead, Margaret, and Ken Heyman, *Family*. Ridge Press, 1965.
†Mead, Margaret, and Martha Wolfenstein, *Childhood in Contemporary Cultures*. The University of Chicago Press, 1955.
Opie, Iona and Peter, *Children's Games in Street and Playground*. Clarendon Press, Oxford, 1969.
*Palfi, Marion, *Suffer Little Children*. Oceana

Publications, 1952.
Piaget, Jean, *The Child's Conception of the World*. Littlefield, Adams, 1963.
Queen, Stuart A., and Robert W. Habenstein, *The Family in Various Cultures*. J. B. Lippincott, 1967.
*Spock, Dr. Benjamin, *Baby and Child Care*. Pocket Books, 1971.
Stevenson, Robert Louis, *A Child's Garden of Verses*. Heritage Press, 1944.
*Walmsley, John, *Neill & Summerhill: A Man and His Work*. Penguin Books, 1969.
The World of Children. Paul Hamlyn Ltd., London, 1966.

Techniques
Croy, O. R., *The Photographic Portrait*. Focal Press, 1968.
Falk, Edwin A., and Charles Abel, *Practical Portrait of Photography*. Amphoto, 1967.
Gross, Józef, *Child Photography*. Fountain Press, London, 1965.
Nurnberg, Walter, *Lighting for Portraiture*. Amphoto, 1969.
Schneider, Josef A., *Child Photography Made Easy*. American Photographic Book Publishing Co., 1957.
Szasz, Suzanne, *How I Photograph Children*. Amphoto, 1966.

Periodicals
Album, Aldan Ellis and Tristram Powell, London.
Aperture, Aperture Inc., New York City.
Art News, Newsweek, Inc., New York City.
British Journal of Photography, Henry Greenwood and Co., London.
Camera, C. J. Bucher Ltd., Lucerne, Switzerland.
Camera Arts, Ziff-Davis Publishing Co., New York City.
Camera 35, U.S. Camera Publishing Co., New York City.
Camera Work, (1903-1917), Alfred Stieglitz, New York City.
Color Photography Annual, Ziff-Davis Publishing Co., New York City.
Creative Camera, International Federation of Amateur Photographers, London.
Infinity, American Society of Magazine Photographers, New York City.
Modern Photography, The Billboard Publishing Co., New York City.
Northlight, Arizona State University, Tempe, Arizona.
Popular Photography, Ziff-Davis Publishing Co., New York City.
The World of Jan Saudek Photographs, Jacques Baruch Gallery, Chicago.
U.S. Camera World Annual, U.S. Camera Publishing Corp., New York City.
Washington Photography: Images of the Eighties, Corcoran Gallery of Art, Washington, D.C.

*Available only in paperback.
†Also available in paperback.

Acknowledgments

The index for this book was prepared by Karla J. Knight. For the assistance given in the preparation of this volume, the editors would like to express their gratitude to the following individuals and institutions: Sven Andersson, Director, Tiofoto Bildbyrå, Stockholm; Thomas Barrow, Assistant Director, George Eastman House, Rochester, New York; Roloff Beny, Rome; Paul Bonner, The Condé Nast Publications Inc., New York City; Peter C. Bunnell, Curator, Department of Photography, The Museum of Modern Art, New York City; Mary S. Calderone, M.D., Glen Head, Long Island; Albert Delacorte, New York City; Dena, New York City; Susanne Goldstein, Rapho

Guillumette, New York City; Mary and Peter Donohoe, Alexandria, Virginia; Martus Granirer, New City, New York; Professor L. Fritz Gruber, Cologne; Robin Herron, Assistant Director of Public Relations, Alexandria Hospital, Alexandria, Virginia; Christine Hofmann, Bayerische Staatsgemaeldesammlungen, Munich; Philip B. Kunhardt Jr., New York City; Tom Lovcik, Curatorial Assistant, Department of Photography, The Museum of Modern Art, New York City; Risto Mäenpää, Helsinki; Grace Mayer, Curator, The Edward Steichen Archive, The Museum of Modern Art, New York City; Daniela Mrázková, Prague; Julie Pool, Curatorial Secretary, Department of

Photography, The Museum of Modern Art, New York City; Christiane Roger, Secrétaire Administratif, Société Française de Photographie, Paris; Jerry Rosencrantz, Magnum, New York City; Robert Sobieszek, Assistant Curator, George Eastman House, Rochester, New York; John Szarkowski, Director of Photography, Department of Photography, The Museum of Modern Art, New York City; Evangeline Tomlinson, M.D., Alexandria, Virginia; Catherine Whitworth, Research Assistant in the Photography Collection, Humanities Research Center, University of Texas at Austin; Anthony Wolff, New York City; John Woodside, M.D., Anesthesiology, Alexandria Hospital, Alexandria, Va.

Picture Credits *Credits from left to right are separated by semicolons, from top to bottom by dashes.*

COVER: © Nathan Benn, 1980, from Woodfin Camp, Inc.

Chapter 1: 11: John Minshall. 14: Dorothea Lange, courtesy The Oakland Museum. 15, 16: Anthony Wolff. 17: Ken Josephson. 18: George Krause. 19: Stephanie Maze. 20: John Yang. 21: Henri Cartier-Bresson from Magnum. 22, 23: John McDermott. 24: Johnny Alterman. 25: Henri Cartier-Bresson from Magnum. 26, 27: © Nathan Benn, 1980, from Woodfin Camp, Inc. 28: Cornell Capa from Magnum. 29: John Yang. 30: Sheila Metzner, copied by Henry Beville. 31: Charles Pratt. 32: James Carroll. 33: © Ulf Simonsson. 34: Danny Lyon from Magnum. 35: William Gale Gedney. 36: Patt Blue, © 1982. 37: Joel Meyerowitz. 38: Paul Schutzer for *Life.*

Chapter 2: 41: Roger Fenton, courtesy Gernsheim Collection, Humanities Research Center, The University of Texas at Austin. 44: Courtesy The Museum of the City of New York. 45: Courtesy Deutsches Museum, Munich, copied by Eric Schaal. 46: Julia Margaret Cameron, courtesy Gernsheim Collection, Humanities Research Center, The University of Texas at Austin. 47: Julia Margaret Cameron, courtesy George Eastman House. 48: Ludwig Silberstein, courtesy George Eastman House, copied by Paulus Leeser. 49: Antoine Claudet, courtesy Gernsheim Collection, Humanities Research Center, The University of Texas at Austin. 50, 51: Lewis Carroll, courtesy Gernsheim Collection, Humanities Research Center, The University of Texas at Austin. 52, 53: Edward Steichen, courtesy The Museum of Modern Art, New York. 54: Culver Pictures. 55: Courtesy Richard L. Williams. 56: De Meyer photograph for *Vogue,* © 1920, 1948, The

Condé Nast Publications Inc. 57: Bachrach Studios, courtesy Anthony Wolff. 58: Will Connell, copied by Paulus Leeser. 59: Courtesy Ione Wollenzein. 60: Constance Bannister. 61: Toni Frissell for *Life.* 62, 63: Joseph Szabo from *Almost Grown,* Harmony Books. 65: Mayer and Pierson from *Editions M.D.,* 1953, courtesy Madame Christiane Roger, copied by Jacques André and Louis Molinier. 66, 67: Frank M. Sutcliffe, courtesy Gernsheim Collection, Humanities Research Center, The University of Texas at Austin. 68, 69: Arnold Genthe, courtesy the M. H. de Young Memorial Museum, California Palace of the Legion of Honor; Frank M. Sutcliffe, courtesy The Royal Photographic Society of Great Britain, copied by R. Smith. 70, 71: Lewis W. Hine, courtesy George Eastman House. 72, 73: André Kertész; Jacques-Henri Lartigue from Rapho Guillumette. 74, 75: Dorothea Lange, courtesy Library of Congress; Henri Cartier-Bresson from Magnum. 76: © Cecil Beaton. 77, 78: David Seymour from Magnum. 79: © Barbara Morgan. 80: © 1982, Roland L. Freeman. 81: Veikko Wallstroem, Helsinki. 82: Irving Penn, © 1960, The Condé Nast Publications Inc. 83: © Lawrence Robins. 84: Arthur Tress. 85: Sarah Benham. 86: Joyce Tenneson.

Chapter 3: 89: © Starr Ockenga. 92, 93: Rhoda Baer. 94, 95: Mel Ingber. 97 through 101: Wolf von dem Bussche. 103: Bradley Hindson. 104: © 1981, Russell Banks. 105: © Jan Saudek, courtesy Jacques Baruch Gallery, copied by Luis Medina. 106: George Krause. 107: Jay Maisel. 108: Bill Binzen. 109: Walter Schels, Munich. 110: Rhoda Baer.

Chapter 4: 113: A. Doren. 116, 117: Henri Cartier-Bresson from Magnum. 118: © Melinda Blauvelt, 1981. 119: John P. Aikins. 120, 121: Dagmar

Hochova. 122: © Susie Fitzhugh. 123: William Eggleston. 124, 125: Marcia Lippman: Ken Josephson. 126, 127: Jack Schrier. 129: © Raimondo Borea. 130: Terry Bisbee. 131: Alena Vykulilová, Prague. 132: Peter Magubane. 133: Bruno Barbey from Magnum, Paris. 134: Thomas Ives, © 1982. 135: Melissa Shook. 136, 137: Armen Kachaturian. 138: Tamarra Kaida. 139: Peggy Fox. 140: Ronald Mesaros. 141: © Raimondo Borea. 142: © Susie Fitzhugh.

Chapter 5: 145: Joel Meyerowitz. 148: Tamarra Kaida. 149: Robert Mapplethorpe. 150: Frances Murray. 151: Marsha Burns. 152: Lawrence Robins. 153: Tamarra Kaida. 154, 155: Johnny Alterman. 156: Mark Goodman. 157: Joel Meyerowitz. 158: Nicholas Nixon. 159: Tamarra Kaida. 161: Ernst Haas. 162: Arthur Freed. 163: Valérie Clément, Paris. 164, 165: Johnny Alterman; Peggy Fox. 166: Stephen Livick, courtesy G. H. Dalsheimer Gallery Ltd., copied by Fil Hunter. 167: Stephen Scheer. 168: Duane Powell. 169: Melissa Shook. 170: Johnny Alterman. 171: © 1981, Marcia Lippman. 172: Marsha Burns. 173: Elisabeth H. Wackman. 174, 175: Lilo Raymond. 176: Nicholas Nixon. 177: John Benson. 178: Danny Lyon from Magnum. 179: Alen MacWeeney. 180: Tom Whittington. 181: Melissa Shook. 182: Evelyn Hofer.

Chapter 6: 185 through 189: Bernard Wolf. 190, 191: Arthur Tress. 192 through 195: Tamarra Kaida. 196, 197: Emmet Gowin. 198, 199: Mary Ellen Mark. 200 through 203: George Krause. 204 through 207: © Starr Ockenga. 208, 209: Ralph Eugene Meatyard. 210 through 213: © Jan Saudek, courtesy Jacques Baruch Gallery, 211 and 213 copied by Luis Medina. 214 through 216: Marie Cosindas.

Index *Numerals in italics indicate a photograph, painting or drawing of the subject mentioned.*